COLOR A COMPLETE GUIDE FOR ARTISTS

COLOR A COMPLETE GUIDE FOR ARTISTS

By Ralph Fabri

Watson-Guptill Publications/New York

This book is dedicated to all those
who realize that there's more to color
than their philosophy can understand.

Copyright © 1967 by Watson-Guptill Publications

First published 1967 in New York by Watson-Guptill Publications,
a division of Billboard Publications, Inc.,
1515 Broadway, New York, N.Y. 10036

Library of Congress Catalog Card Number: 67-13741
ISBN 0-8230-0700-6

Manufactured in U.S.A.

First Printing, 1967
10 11 12 13 14 15/86 85 84 83

Acknowledgments

Special thanks to Donald Holden and Susan Meyer, Editors,
whose suggestions, comments, corrections, additions
and, above all, requests for clarification,
were of immense help to me in the writing of this book.

Preface

Color...what about color? Color has always existed in the world, and will continue to exist until doomsday. It has been employed by man since he first depicted animals on the walls of his cave. We find prehistoric pictures in Africa, China, Siberia, Spain, Australia, New Zealand, the Americas—wherever man has lived. We can buy paints in all colors, all media, all quantities, in countless stores. We can apply them with brushes, knives, rollers, sprayguns, or with our fingers.

The primary colors

Most of us know from our schooldays that red, yellow, and blue are the primary colors; colors from which all other colors can be mixed. But not all of us know that, for thousands of years, people believed white was the simplest, purest of colors, the "beginning of it all." Sir Isaac Newton discovered that white sunlight is broken by a crystal prism into red, orange, yellow, green, blue, indigo, and violet, the colors blending into each other softly, but clearly, always in the same order. Since then, we consider white not the simplest of all colors, but a combination of *all* hues.

We may, or may not, be aware of the disagreement among physicists about primary colors. They all believe there are three, but Sir David Brewster (1781-1868) thought the three colors were red, yellow, and blue; Thomas Young (1773-1829) suggested red, green, and violet; J. Clerk Maxwell's experiments were based on red, green, and blue. In color TV, the colors are red, yellow, and green. In full-color printing, we use four plates: yellow, blue, red, and black, but black is used for strength, and to conceal minor lapses in registering the primary colors.

Color for the painter

The painter isn't a physicist. He mixes colors and he knows he can paint white only with white paint, never with a mixture of all the primaries. He knows that black is called "a lack of all color," but he has to have black paint in order to paint black cloth, or black paper, or black hair. He also knows he can never get blue from green

by filtering out the yellow part of the green, while he can produce green by mixing yellow with blue.

Color has many ramifications, new developments, and new uses. The days are gone when artists worked with a palette of six to ten colors. Until about World War II, the standard American apartment was painted buff with brown woodwork, and the doors were done in imitation woodgrain. Now, even the average housewife looks at rich color charts before deciding how to redecorate her rooms. Kitchens used to resemble operating rooms in hospitals. Today, their walls, cabinets, mechanical equipment, pots, pans, and dishes are selected on the basis of color as well as practicality.

Color is of great significance in every medium, and in all branches of painting: fine, commercial, and industrial. Painters had to use colors in all periods of history, but they painted shadows and lights on red, blue, green, and purple merely in darker and lighter shades of the same hues, without noticing reflections and other variations. Colors in the farthest background were the same as in the nearest foreground. In the Orient as well as in the Occident, painters worked mostly in line, for centuries, using colors only to make their works resemble nature as closely as possible. Until the end of the fifteenth century, western artists made precise outlines, painting the spaces in-between.

Although artists of the Renaissance and the Baroque achieved masterpieces of the highest caliber, there's no comparison between their colors and the ones developed since the early 1800s. Curiously, artists had a grasp of linear perspective since classic Greek times, but color perspective wasn't even noticed until the Renaissance. A full understanding of color came with the Impressionists and Post-Impressionists, from Constable and Turner, through Monet, to Cézanne and Seurat.

The purpose of this book

This book is not concerned with physics beyond what every painter ought to know about fundamental scientific principles affecting his work. The aim of the book is to give you as much information about color as possible: information about values, color perspective, warm and cool colors, and what they can do for you—or against you—in your art. It deals with optical illusions that surround us in everyday life, even though most people pay no conscious attention to them. Such illusions are of great importance to the painter, regardless of whether he works in the traditional, or in the nonobjective manner.

The book intends to show you how to achieve harmony or disharmony (if that's what you want); how to make your background go back, instead of "jumping out" of the picture; how to make objects and figures appear to move, merely by employing the correct colors and color combinations; how to obtain the numberless color effects—sunlight, moonlight, artificial light, reflections in water, and metal; how to express yourself in color. All this is examined and explained in the book, in everyday terms, rather than in long Graeco-Roman words you'd have to look up in a dictionary.

This volume is just as deeply concerned with practical matters, such as what

colors to use or not to use in every painting medium, and why or why not; what each color can do for you — on account of its inherent characteristics — in the actual painting; and how futile, how time-consuming it is to work in disregard of the natural properties of colors. I will give you tests you can easily perform for the sake of sharpening your perception and understanding of colors and color effects.

I have also included a brief history of color and the basic principles of painting, from the most ancient times to the present; the traditional meanings of colors; the use of heraldic and symbolic color. These subjects should give you a better comprehension of the present-day status of color in every technique and in every school of painting.

The painter is really a combination of chemist and magician. The mixing of colors is chemistry, even though not as precise and painstaking as the work of a pharmacist. Magic comes into the picture, so to speak, because an artist not only mixes literally innumerable colors and shades — a task any person, or even a mechanical gadget, could perform — but, at the same time, the artist can put colors together in such a fashion that the result, realistic or not, is an image he has created. This image can almost unbelievably duplicate real objects, scenes, or figures; or the image can be born from his own mind, with no exact counterpart on this earth; the image can resemble actual scenes and events, but in a mood, a concept, of high individuality. The goal of this volume is to help you find the best, most reliable, most suitable method of achieving your own particular esthetic aims, by the proper choice and the correct handling of colors.

About the color plates in this book

Color has to be seen to be understood. You cannot describe colors to people unfamiliar with them the way you can describe forms, sizes, and many other features. We are including a large group of color plates which have been published, over a great number of years, by *American Artist* magazine. These plates constitute a truly remarkable cross-section of painting done in the United States by outstanding artists, from magic realist, to semi-abstract and abstract works, in practically all media and all techniques.

These color plates are not illustrations deliberately prepared for the text. They stand as individual works of art, in which the composition of color and design must speak for itself. The purpose is to show you how many different possibilities exist, in subject matter, esthetic approach, emphasis, mood, harmony or disharmony, sense of drama or poetry, softness or hardness. You can see how a little difference in color, or in the emphasis on one particular color, can create a novel effect. You can see how certain artists stick to reality, but make reality more glamorous than it really is; how others use their imagination in color and in composition or pattern; how an everyday subject may be transformed into something original and memorable by an experienced artist.

Such artists don't wonder what color to paint where. Once you comprehend the principles of color, you'll act quite spontaneously, just as a person who speaks a language well doesn't hesitate about the next word or the next sentence he is going

to say or write. Without a full knowledge of the grammar, you are at a loss, bound to make serious or odd mistakes. This is true in painting, too, where color is a fundamental part of the artist's grammar. Some art students worry about losing their individuality by following principles established in the past. Stop worrying about your individuality. It will come out into the open as soon as you learn how to use it.

Contents

Color Illustrations

1. Color in History

Color, like everything else, has a history. This history offers understanding, and valuable information to anyone and everyone interested in color: to artists, designers, decorators, who work with color, and to the innumerable lay persons who see, wear, or use colors, in one way or another.

Earliest use of color

Man probably became truly different from other mammals, when he began to wonder about the strange, often frightening, phenomena around him, and when he first attempted to control these phenomena. He felt he would have power over anything he could make with his own hands in the form of an image. He modeled clay, or carved bone and stone, into forms resembling huge beasts; and he drew pictures on the walls of his caves. He believed he would thus acquire power over all such animals. The more realistic the images were, the greater his power. He soon found it possible to add color to three dimensional figures and to outline drawings by employing the diverse colors of the earth on which he walked.

Earth has many shades of buff, yellow, brown, gray, green, and red, almost exactly the colors man saw in the animals that meant so much to him. Some animals were threats to his safety; others became his friends; he needed many of them for food, clothing, and tools. Manifestly, the first purpose of color was to make images more realistic, and, thereby, to imbue them with more magic power. Color appears in human handicrafts since the most ancient times. Besides the colors he found in the soil, early man also used the colors of fruits and plants. He added water to all colors in order to be able to apply them to walls and articles.

As he learnt to roast meat, he found that the fat dripping from the meat gave the soil an interesting and practical quality: the paint this fat created was easier to apply and did not deteriorate the way fruit and vegetable juices and just plain water-mixed soil did. The fat acted as a binder: a substance which makes the color, what we call the pigment, adhere to the surface on which it's applied. In the course of time, he discovered, accidentally, or deliberately, other binders for colors, such as egg-

white, wax, linseed oil, glue, gum arabic, casein, and polymer. Some binders worked on one surface only; others caused the color to stick to several surfaces. Some binders proved to be permanent, others turned out to be unreliable. Thus, some colors remained intact through thousands of years. Others have vanished or pealed off, with only a few traces left in corners or crevices. The search for permanent colors and binders is still going on.

Color in ancient Egypt, Mesopotamia, the Far East

In ancient Egypt, colors, like all other features of art, were strictly connected with religion. They had to be used in an absolutely prescribed manner, without any personal freedom. Unaware of, and unconcerned with, light and shadow, Egyptian artists used flat, bright colors to paint their statues, architectural decorations, furnishings for the living and the dead, mummy cases, papyrus scrolls, hieroglyphics, countless figures and objects on the walls of their tombs. Indoors, the bright colors were easier to see. Outdoors, on temple walls, the bright hues broke up the blinding brilliance of the sun. The medium they used, as far as we know, was egg tempera; or at least they used an egg varnish over water-thinned colors.

In the less extreme climate of Mesopotamia, Babylonia, and Assyria, artists employed color on the glazed brick façades of their palaces and temples. They also had much color in their fantastically ornate and heavy ceremonial garbs.

In the Far East, too, colors were magnificent in garments worn by priests, the aristocracy, the warriors. Much color was employed in furnishings. Paintings were mostly scrolls of ricepaper, or silk, in black lines with only a few spots of color. Such paintings were to be enjoyed in small, intimate homes, or shrines, by the light of soft lamps or lanterns. Subtle colors added to the elegance of rich, intricate, diversified designs.

Color in ancient Crete

It has taken Western artists more than thirty centuries to discover all the ramifications of color in every field of art. The search for color and art in the West began with the Cretan civilization, in which art was created for art's sake, without any religious connotation. Paintings were to make the interior of a house brighter; they served as picture windows. The style was free, the colors were always gay, whether they were applied to remarkably realistic, almost impressionist themes, such as flying fish, or to bold, spiral patterns of pure ornamentation on walls, pillars, and ceilings.

Color in ancient Greece

Although we usually trace our ancestry to classic Greece, painting, as we understand the term, was never as great in Greece as sculpture and architecture. True,

their murals have disappeared; all we have are descriptions by contemporary travelers, and small-scale reflections of their pictorial achievements in the thousands of beautifully decorated vases. Many of the superb figures are known to have been inspired by Attic muralists. Those vases seldom have more than two or three colors, besides the black glaze on the brick-red clay.

The Greeks, however, had colors for painting their stone, bronze, and marble statues realistically. They painted the triangular wall of each tympanum, and the flat background of every high-relief on their temples, a deep blue or red, in order to make the statues stand out clearly. They left the white marble or yellowish stone of the buildings unpainted; the shadows between the columns broke up the dazzling white or pale yellow.

As great philosophers and theoreticians, the Greeks understood the rules of perspective, but they did not turn this theoretical knowledge into practice. Practical knowledge came with ancient Rome.

Color in ancient Rome

With their magnificent temples, palaces, and luxurious villas, the Romans demanded paintings and mosaics on walls, as well as mosaics on floors. Most of their paintings were done in encaustic, pigments mixed with hot wax. The mosaics were made of stone or marble in a vast number of colors and shades, almost like full color paintings. We have found many wall paintings in Pompeii, and Herculaneum, and also in the city of Rome. Above all, we have discovered huge numbers of mosaic floors in perfect condition, especially in the North African colonies of the Roman Empire. Those mosaics depict urban and rustic scenes, mountains and harbors, battles, civic activities, business, commerce, sports, mythological and historical subjects, all executed with supreme skill, incomparable craftsmanship, in a great diversity of colors.

The mosaic chips are often so tiny that, from a few feet away, the work appears to be a painting done with brushes. The mosaics were situated in rooms where they could be seen and admired like paintings in our own living rooms. Subtle shading and fine details were of paramount importance. These pictures were conversation pieces and, judging by the similarity of certain themes and craftsmanship, one can easily guess that ancient Rome had some popular artists, whose works all the citizens "in the know" tried to own. The purpose of pictures in color was twofold: to brighten up the usually small rooms, which, like present-day houses in hot climates, had only a few windows, if any; and to make the rooms look fashionable by providing them with elaborate pictures, whether those were executed with paint and brush or in mosaics.

Color in early Christianity

The early Christians of Byzantium (Istanbul) worked with glass mosaics, rather than stone and marble chips. Their sole aim was to make the supranatural visible to

illiterate pagans and Christians alike. No longer were the mosaics intimate pictures of worldly scenes. They were usually placed high above the floor, done with bold outlines, less detail, and more striking color combinations. Biblical personages and scenes had to be viewed from a distance, in a semi-dark place, or at night by flickering oil lamps. The stronger, less realistic color contrasts and patterns, the sparkle of glass mosaics — many of them backed with gold leaf — the glittering gold halos, bejeweled crosses, and crowns created an atmosphere of mystery and awe.

In the western half of the defunct Roman Empire, Roman temples, baths, and basilicas (meeting halls) were transformed into Christian churches. Painters of the new era imitated Roman art, Roman apparel and facial expression in Christian subjects. Colors were as natural as the artists could make them, but perspective and proportions were naive, childlike. Here, too, painting served strictly religious purposes for many centuries.

With the solidification of Christianity, the Gothic period brought forth daring experimentation in painting, and in architecture. Gradually, there appeared a belief that life can be joyful. There was a wealth of detail and an increased variety of colors in Gothic painting. Done on wood panels, these paintings were again on a small scale, to be viewed from nearby. Facial resemblance to donors, the richness of gold embroidery, rugs, garments, and furnishings were now more important than the mysterious quality expected by the early Christians.

Color in the Renaissance

It was not until the fourteenth century that artists began to explore new approaches, new vistas in painting, first, merely by achieving more and more realism. They evolved an amazing knowledge of perspective, light and shadow, correct proportions, and they used colors with an increasing artistic freedom. Still, the procedure was largely a matter of preparing a perfect outline drawing, and coloring each section in the neatest possible manner.

In an age when art was in great demand, artists had assistants and apprentices. Technical as well as esthetic knowledge was handed down from older to younger men. Painters were experimenting with new pigments and binders, just as clothmakers were always looking for newer and better dyes for the sumptuous garments worn by the church hierarchy and the aristocracy.

The High Renaissance, around the turn of the sixteenth century, was the culmination of all these efforts. Individuality in art was at last established. Composition, color, the entire concept of a painting, were more and more individualized. You could see the mentality and temperament of the artist, as well as his talent and his skill, in his paintings.

Color in the seventeenth and eighteenth centuries

In seventeenth century Holland, Protestantism all but eliminated biblical, mythological, and historical paintings, and restricted artists to easel paintings designed

for the walls of small rooms in narrow houses. Landscapes, still lifes, genre pictures, and flattering portraits of individuals and groups were produced in all possible detail, in bright colors, in a somewhat idealized style. The purpose of art was to delight the middle class taste. In subject matter, color, and technique, the artist strived for the commonplace, the average, the unsensational. The one painter who eventually defied this trend, Rembrandt van Rijn, almost literally starved to death.

Everywhere else in Europe, the seventeenth century means the Baroque, a period of unrest, turmoil, experimentation, the beginning of what we choose to call "the age of reason." Dramatic, flashy paintings were required by uninhibited churchmen, erotically inclined aristocrats, and the expanding capitalist class which now had the money that enabled it to live on a high scale. Collecting art, attending auction sales, became a hobby among those who could afford it. Powerful personages were not afraid of kidnapping, hijacking, or plain stealing, in order to acquire the works of celebrated artists. There was no limit to subject matter, color, fantasy, and taste, outside The Netherlands.

The second half of the Baroque, the eighteenth century, is called Rococo, a veritable explosion of forms, colors, ornamentation. Everything seemed to be in perpetual motion. Ceilings were torn open, visually, by bizarre effects of perspective. Walls were painted to resemble terraces. The *trompe-l'oeil* (eye-cheating) method came into vogue after it had flourished in Pompeii and Herculaneum some eighteen hundred years before, but now it appeared on a colossal scale.

Color in the Classic Revival period

The French Revolution was predicated on ancient Greek and Roman ideas of freedom of speech, the rights of man, the right to vote, the right to complain, the republican form of government, "The Senate and the People," the abolition of kings and tyrants. Painters, as well as writers, used scenes and concepts from classical history to spread the revolution. The end of the eighteenth century, and the first quarter of the nineteenth, constitute the Classicist, or Classic Revival period. Paintings were again meticulously drawn, and systematically colored. Subject and draftsmanship were all-important. Every article, each person had to be purified, idealized.

The Académie Française established and promulgated through Europe the belief that great art can be reduced to formulas which any intelligent artist can learn by heart. This so-called academic concept tried to turn all forms of art into a kind of definite procedure, a concept still in existence, despite the many events that occurred in the world of art during the past hundred and fifty years.

Color was subservient to outline drawing in this classicist period. Perfect realism of the most ideal kind was the goal. In the United States, the Hudson River School, in the first half of the nineteenth century, was an outgrowth, or development, of this Classicism. Fortunately, however, the Hudson River School concentrated on the beauties of nature. Its idealized, spotlessly clean, dreamlike rusticity had, and still has, a charm not shared by the spotless nudes and other classicist figures mechanically created by European and New World artists of the Classic Revival period.

Color in Impressionism

There is constant change, a continuous overlapping, in history. Early in the nineteenth century, when the Classic Revival period was still rampant, John Constable and Joseph Mallord William Turner were painting in England. These men, like all true Englishmen, loved fresh air, and went outdoors to paint on the spot, rather than in the cold sanctuary of their studios. Working from direct observation, they omitted small details and concentrated on color, motion, and mood. In the 1820 s, Constable's paintings, more sparkling with colors than anything seen before, were shown in the exhibition of the Salon de Paris. Young French artists suddenly became aware of new possibilities of turning to nature. Constable and Turner are generally considered the founders of Impressionism.

Previously, painters made sketches outdoors in silverpoint, pen-and-ink, or crayon. Later, they added washes, usually sepia (a rich, brown pigment prepared from the secretion of various cuttlefish); but occasionally they used some other colors to achieve a better light-and-shadow effect in their sketches. All major works, however, were executed in the atelier, never outdoors. Colors were mostly pure; highlights and shadows on green, red, and other surfaces were merely lighter or darker shades of the same hue.

Stepping back to the Renaissance for a moment, few people realize that the true significance of Leonardo da Vinci's famous *Mona Lisa* lies in the fact that the master pioneered in the use of color: there are no outlines in this painting; the cold precision of much early Renaissance and pre-Renaissance painting is gone. Leonardo introduced the gentle blending called *sfumato*. Despite the strange errors in perspective, and the curious lack of coherence between the two halves of the blue-green background, the painting is a milestone in Western art.

Tiziano Vecelli (Titian), the most "painterly" painter of the Renaissance, worked in the same style as da Vinci. El Greco, in a slightly later period, was not afraid of painting flaming yellows against ominous grays and vivid purples in bold strokes, not at all in keeping with the age in which he lived.

But it was the Impressionist school, around the middle of the last century, which discarded lines and decided to work entirely in color. Impressionists would depict the same view three times on the same day and paint the view again in different seasons, in order to show how colors change from the cool yellow of the morning sun to the warmer yellow of midday, becoming the orange tint of the setting sun. They showed how different colors appear on a rainy, snowy, sunny day. Critics and public alike derided and denounced these "paint-throwers" as freaks or fakers. Artists, however, went on with their new idea: color, painted *alla prima* (at once), trying to put the right colors on the canvas directly, without changes, without blending. All they wanted was a general effect, an *impression* of what they actually saw.

Color in Post-Impressionism

Paul Cézanne, not satisfied with the spontaneous painting of the Impressionists, returned to careful composition, the deliberate arranging of colors as well as forms.

This is what we call Post-Impressionism. Cézanne was the first artist consciously trying to achieve effects by juxtaposing certain colors. He found that a lemon looks brighter with a blue outline, and a red apple appears to be more brilliant if you paint green around it. The climax of this search for color effects was reached by Georges Seurat, who introduced *Pointillism*. In this quite scientific approach to color, the artist doesn't paint the grass green. He paints hundreds of blue spots and hundreds of yellow spots with the tip of his brush, and from a short distance away, the grass appears green.

Color began to inspire many artists from this point on. Paul Gauguin went to the South Seas and rendered the natural beauty of Tahiti and its inhabitants in brilliant hues that seemed crude to his contemporaries, who were accustomed to the subdued, traditional tones of Classic Revival paintings. Henri de Toulouse-Lautrec, a finer draftsman and designer than he was a painter, created marvelous posters by applying uncommon color combinations to interesting, though simple drawings. Artists became fanatical about exploring the realm of color, not only in representational paintings, but in abstract, cubist, futurist, dadaist, and nonobjective works as well.

"Isms" in art overlap each other, come and go so fast that the critics, the public, and the artists themselves, are bewildered. What happened to perspective, composition, proportions, recognizable subjects? Now we see them, now we don't. But there's one thing we do see: colors. Strong, baffling, frightening, if you will; hard, repulsive, perhaps even nauseating in some paintings; delicate, poetic, entrancing in other paintings...but color, color is everywhere; color in which the artist achieves results never seen before; colors that sing, shout, whisper, or just speak. You merely have to listen.

But you must learn the language of colors, exactly as you have to learn any language. The first lesson is to let your eyes be the judge. Artists who create paintings and people who look at paintings should give their eyes free rein, instead of shackling them with brassbound ideas that were conceived before Galileo Galilei discovered that the Milky Way wasn't made of milk.

2. Color Terminology

Color terms are used, brandished, thrown around so often and so fast that it might be a good idea to find out what they really mean. By learning the terminology, you'll be better equipped to understand the principles discussed later in this book.

Hue and color

According to the dictionary, *color* is a visual quality *distinct from light and shade*, such as the red of a rose. *Hue* is the name of a color: yellow, green, orange, brown, blue-violet, and so forth. Actually, *hue* and *color* are synonyms. Artists prefer the word color, but hue sounds impressive, and it's less monotonous to alternate the two words.

Paint

Paint is the substance, the so-called medium, which the artist, or anyone else, applies to the paper, wall, canvas, or some other support. The result of applying paint can be a work of art, or a fresh coat of wall paint. The quality of the paint differs, of course, but not the substance. An artist never asks what paint you're using, but what color you're using. The word *paint* ordinarily refers to household paints.

Value

Value is not the price, or monetary worth of a particular color, but the proportion of light or dark in the color. Physicists say that white is a combination of all the colors of the rainbow, and black is a total absence of color. This has no relevance to the artist, who can only work on the basis that white is the lightest, and black is the darkest hue our eyes can perceive. For the artist, all other colors are between these two extremes. The palest of the so-called pastel shades is still darker than white.

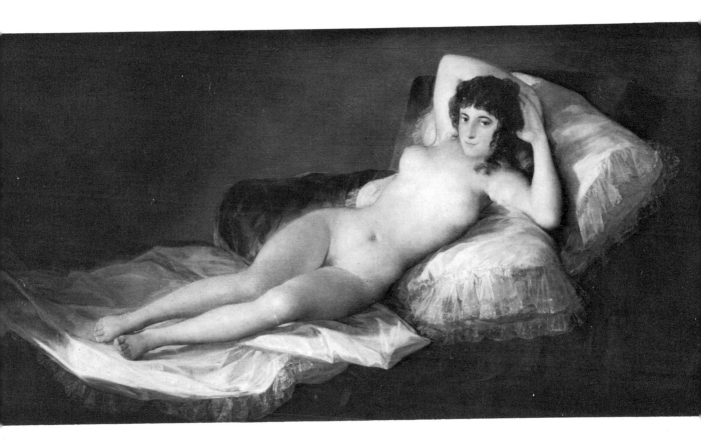

Maja Desnuda by Goya

In his celebrated Maja Desnuda (Naked Maja), *Goya achieved the effect of a live woman reclining on a couch by rendering all colors and values in a perfectly realistic manner. The lightest flesh color is still darker than the white pillow. Note that there are no lines in this painting. It's a painting in the truest sense of the word. Values tell the whole story. Photo, courtesy The Prado Museum, Madrid, Spain.*

Color Terminology 23

Consider Goya's famous *Maja Desnuda* — *Naked Maja* — a luminously white woman reclining on a couch. Even in a black-and-white reproduction, the flesh of the woman is darker than the white sheet, or pillow, on which she is depicted.

Take clothing, books, or any other articles of various colors in your home, and place them next to each other. You'll see that the darkest blue and purple are not as dark as black; the lightest pink, yellow, and green cannot be as light as white. Old masters, notably Rubens, never failed to have a white object, perhaps just a piece of clothing, in their paintings. Such a white article helps the artist to determine the values of light colors in his painting. For example, a yellow normally looks lighter than a green, and it always looks very brilliant next to black, or some other very dark color. If you can compare it with white, however, you'll quickly see whether the yellow is as light as you really want it. Darker tones, on the other hand, should be compared with black, because a certain shade of blue or red may seem very dark next to white, but too light when placed next to black.

There's a wide range of lighter and darker shades (even in yellow and pink, the two colors usually considered lightest next to white). The variety of values is even greater, more dramatic, in darker hues. For example, blue can be very light at one end, when mixed with much white, and very dark — the so-called midnight blue — at the opposite end, when employed full strength. Yet, the palest blue is not white, and the deepest blue is not black, ever. The closer a color is to white, the higher its value; the closer it is to black, the lower its value. Value can only be judged by this kind of comparison. Value in color is not the same as value in money. You can tell the value of a coin or paper money at a glance, by the numerals on it. The full significance and use of value in color is explained in the chapter on color perspective.

Exercise in values

Each color has literally countless values. The simplest way of explaining this fact is by drawing, or cutting out a number of squares of the same size; paint the first one white, the last one black, the others in various shades of gray. Place them next to each other, in a sequence of darker and darker shades as you go from the white to the black. In order to make the difference easier to perceive, show only four or five shades of gray. The popular word *shade* — we often hear someone look for a material "two or three shades lighter or darker" — actually has the same meaning as *value*.

You must realize that while values are usually shown from white, through many shades of gray, to black, the same range of values exists in every color. Try the following exercise...

Cut out six pieces of white cardboard, each about two inches square. Paint one piece a very light pink, just a little darker than pure white; paint another square the darkest red you have. Paint the other four squares various shades of the same red, by mixing it with more and more white. Place them next to each other, starting with the lightest, then the darker and darker shades, ending with the darkest red.

Do the same with blue, green, brown, and any other color, adding more and more white to each, and placing the lightest of each color on the left, the darkest

Color Values. *The lightest color the human eye can perceive is white; the darkest is black. There are countless shades of gray between these two extremes. Every color has literally innumerable shades. The relationship of any of these shades to black or white is what we call the* value *of the color. The closer a color is to white, the higher its value; the closer to black, the lower its value. Blue, red, brown, green, orange, pink, and so forth, are different hues, but they can all be of the same value, or each color can have many values. The value of each color is of great significance in painting.*

on the right, the other shades in-between. If you paste the sets of squares on a large sheet of cardboard or matboard, one set below the other, you'll have a pretty good idea of values.

Saturation or intensity

Saturation in color means a state of being completely filled, penetrated, or soaked with color to the point where a hue is as strong, pure, unadulterated, as it can ever hope to be. For example, the finest colors of the best manufacturers are fully saturated. Cheaper grades, scholastic sets, in any painting medium, are unsaturated; that is, they are weaker in tone and in covering power. A cheap grade of red still looks red, but lacks the brilliance of the better grade. Such colors have fillers — some cheap substance to increase their bulk — instead of pure pigments. They may be good enough for students, but a conscientious painter ought to work only with the best materials.

Intensity is a somewhat misleading term. It may refer to the enthusiasm and dedication with which the artist works. In painting, however, the words *saturation* and *intensity* are interchangeable. The stronger the hue, the greater its intensity — or saturation. For example, orange, squeezed from a tube, used in full strength, is of full saturation, or intensity. It is a powerful color, recognizable from quite a distance. If you mix this orange with white, brown, ocher, or any other color, it loses its saturation or intensity. Every color has a point of ultimate saturation, or intensity.

White, however, cannot be anything but white; black can never be anything but black. There is no such thing as a lighter black, or a darker black. White and black have no shades, no saturation, no intensity.

Brilliance

Brilliance, according to dictionary definition, is the measure of variations among shades of gray. The lighter the gray, the greater its brilliance, and vice-versa. The same differences exist among shades of all colors. This *suggests* that brilliance is the same as value, and dark hues do have a lower brilliance, as well as a lower value, than light hues. There is one considerable difference, though: every shade of every imaginable color has a value, that is, a definite position between white and black; but not *every* shade of *every* color has brilliance. Artists never speak or think of the brilliance of a dark color; only bright, light colors have brilliance.

To understand the meaning of brilliance, you must simply think of what you would call brilliant, anywhere. A diamond, or a crystal, a gold ornament, a strong electric light, fire, an orange silk gown, and colors which resemble such articles, are brilliant. You'll see, though, that value, intensity, and brilliance of a color depend largely upon the surroundings of the color. A red apple is more brilliant when placed in front of light green material than when it's in front of a vivid orange backdrop; a yellow banana is insignificant on a light yellow or white sheet; the same banana practically lights up the room if you put it on a medium-blue tablecloth.

Primary and secondary colors

As I mentioned in the preface, every physicist agrees that there are only three basic or primary colors, that is, colors which cannot be mixed from any other existing colors, but must be found in nature, or produced by man. Artists have accepted the Brewsterian primary colors: red, yellow, and blue, proposed by Sir David Brewster in 1831. Anyone who has ever tried to mix colors knows that these three colors must be available for mixing other hues. Secondary colors are produced by mixing any two primaries. You can mix red and yellow into orange; yellow and blue into green; blue and red into violet. These are the three secondary colors. Depending upon how much of each primary is in these mixtures, the result can be a yellow-orange, or a red-orange, a yellow-green, or a blue-green, a blue-violet, or a red-violet.

Tertiary colors

Any two secondary colors mixed together form a tertiary color. In practice, each of these tertiary mixtures is almost exactly the same brown hue, except insofar as one, or the other, primary gives it a slight difference. Thus, a tertiary color may be reddish-brown, or bluish-brown.

Consider that when you mix violet and green, you actually mix red and blue with blue and yellow. A mixture of orange and green consists of red and yellow, and yellow and blue. A tertiary obtained from violet and orange contains blue and red, mixed with red and yellow. In other words, each tertiary contains two portions of one color, and one portion each of two other colors.

Complementary colors

One of the purposes of the color star illustrated in this chapter — sometimes it's called a color wheel — is to locate *complementary* colors. The colors directly across from one another on the star (or wheel) are called complementaries.

Examining the star, you'll find that blue and orange, yellow and violet, red and green are all complementaries.

In physics, two colors are called complementary if they turn into white light when passed through a crystal prism. In everyday life, we see complementary colors when we look into a strong light — such as the sun or an electric sign — then suddenly turn toward a darker surface. On that surface we see the same shapes — in totally different hues — dance and jump. In painting, any two complementary colors can be mixed into a neutral gray.

Remembering complementaries is important for two reasons. First, the best way to reduce the intensity of a color — to *mute* or *gray down* a color — is to add a touch of its complement. Second, the way to make a color *look* more intense — without actually adding another hue — is to place its complementary nearby. Complementaries, placed side by side, seem to intensify one another. Place a stripe of blue next to a stripe of orange; the blue looks bluer and the orange looks oranger.

Chromatic and achromatic

Reds, blues, greens, purples, browns, pinks, and so forth, are called chromatic. Literally, the word means *of or pertaining to color*. Black and white, and the numerous shades of gray we can mix from black and white, are called achromatic. Literally, this means *colorless*, even though, in everyday life, as well as in painting, we do speak of black, white, and gray as colors. Here's one of the discrepancies between theory and practice.

A black-and-white photograph, etching, or drawing, or a painting executed entirely in gray tones, *en grisaille*, is achromatic. The same photograph, drawing, print, or painting in brown or blue is chromatic. The word *chromatic* is employed in music more often than in the fine arts.

Polychrome and monochrome

Polychrome or polychromatic is anything done in several colors. Monochrome or monochromatic is anything executed in one color, or shades of one-and-the-same color. Since, theoretically, black is not a color, pictures done in gray tones shouldn't be called monochromatic. They are generally called black-and-white. Painting in gray tones was quite popular during the Classic Revival period, but few artists do it today. The term, *black-and-white*, usually refers to drawings, etchings, woodcuts, lithographs, and printed reproductions, known under the collective name *graphic arts*. Because a painting or drawing is monochromatic doesn't mean it's dull. Wonderful effects can be achieved in one color.

Warm and cool colors

Reddish and yellowish colors are considered warm, because they remind us of fire and flame. Bluish and greenish tones are cool, because they are reminiscent of ice. Colors containing a larger proportion of red or yellow are warm; colors with a greater amount of blue or green are cool. This is easy to understand. Seeing a woman dressed in light blue on a blazing-hot day, you are inclined to exclaim: "Gosh, you look cool!" Dressed in orange or red, on a ski-slope, the same woman looks as if she were ready to melt the snow with the hot color she's wearing. All hues can be made warmer by adding a touch of red, orange, or yellow. Hues can be made cool by adding white, blue, or green.

Regardless of how much of this is psychological, and how much of it is factual, one thing is certain: warm colors tend to come forward in a painting, while cool colors recede. Distant parts of a scenery do look bluish; and even fresh snow has a yellowish tint in the foreground when the sun is out.

Understanding warm and cool colors is imperative in realistic work because it helps you show spatial relationship, and helps you avoid the frequent problem of having certain parts of your painting seem to be jumping out of the picture. It's also important for artists working in any of the contemporary nonobjective styles. In all types of painting, the artist must comprehend the visual effect of each color he applies. He must know how to create a feeling of depth by employing the right hues and shades in the right places.

Cool and warm colors are of great significance in interior decoration as well. A room painted a light Nile-green, or very pale blue, looks bigger and more peaceful than its actual size and surroundings would make you expect. On the other hand, a large, ungainly room can be made to appear smaller, cozier, by painting its walls a deep red or maroon. Moreover, any room can be turned, unwittingly or deliberately, into a restless, even nerve-wracking, chamber of horrors by painting its walls and ceiling a combination of canary yellow and rosepink, or green and orange, to mention but a couple of disturbing possibilities. Theory and practice often go hand-in-hand. Even if you don't know the theory, your eyes are bound to see the result. Theoretical knowledge can help you avoid costly or unpleasant mistakes.

3. Color Perspective

We know that looking at objects, scenery, political or historical events in perspective helps us determine the total, over-all image and importance of whatever we are observing. In the pictorial arts, perspective is the optical, visual appearance of whatever we're planning to depict. We speak of two kinds of perspective: linear perspective and color perspective. Color perspective used to be called aerial perspective. The term *aerial* means everything pertaining to the air, the atmosphere. One might easily think that aerial perspective refers to the often staggeringly beautiful views we have from high-flying aeroplanes. In art, therefore, it's better to speak of *color perspective*, unless you're referring to a bird's-eye view.

In reality, everything around us is three dimensional; in drawing and painting, however, we work on a two dimensional surface. We have to observe objects as if they were flat, like our paper or canvas. This isn't easy, because most people have so-called memory pictures; that is, they think of objects as they are in a diagrammatic form, straight in front of their eyes, like a building in an architectural drawing. In reality, we usually see things from an angle, rather than from straight ahead. From an angle, a round chair or plate looks elliptical; a square appears to lose all its right angles. Horizontal lines appear to slant upward or downward; all forms look smaller and smaller the farther away they are.

This linear perspective was understood, theoretically at least, by the ancient Greeks. In practice, the Romans were the first to leave us murals in which perspective was employed with remarkable eye-cheating effects. Then, as now, some artists knew more about perspective than others. The knowledge was lost during the Dark Ages, but, by the fourteenth century, Western artists had rediscovered the rules of linear perspective, and were able to render three dimensional space in their paintings.

Color perspective, which refers to changes caused by distance and atmospheric conditions, doesn't seem to have been grasped by artists until the late Middle Ages, when we first see an attempt at indicating distance by employing blue tones in the far background of paintings. Even then, the blue was the same all over a small section of the picture, with every tiny detail carefully drawn and painted. All round this small segment of bluish scenery, the painting was always equally strong in color, without any gradual diminishing of values towards the far background.

Is color perspective important?

It may be interesting to note that even though a few basic principles of linear perspective were known to Far Eastern artists a long time ago, they never tried to go beyond them. Color perspective remained unnoticed in the greatest Oriental art until recent times, when artists of the East began to have access to Western art. Does this suggest that perspective in general, and color perspective in particular, can be of no real significance? Not at all.

Oriental art differs from Western art just as Oriental music, manners, food, drama, and way of life do. In fact, color perspective may be *more* vital to the three dimensional kind of painting developed in the West than linear perspective, because, in the last analysis, it is the colors, the tonal values, that create the illusion of depth. This illusion of space is dear to the hearts of many abstract and nonobjective painters, as well as realistic artists.

The biggest role of color perspective is generally in landscape painting (scenery, seascape, cityscape), because greater distances and spatial problems are encountered in these subjects than in figure painting. Nonetheless, even in figures and portraits, the background is important, whether it's a plain backdrop of color, such as a wall or a curtain, or a more definite and complex background, such as the interior of a room, a garden, or the kind of romantic scenery Leonardo da Vinci painted behind the *Mona Lisa*. A background, whatever its nature, must look like something in back of the figure—not as if the figure were pasted on a sheet of cardboard, or, worse yet, as if the figure were merely looking through a hole in a wall or in a curtain.

Distance affects all colors

Colors change as much as lines and shapes do, according to distance. Faraway hills and objects are not only smaller than similar objects closer to us, but they are also bluish. Very bright hues, such as orange and red, seem bright in the distance, too, but they are invariably lighter and hazier the farther away they are. An orange-colored poster on a gray wall two hundred feet away may seem just as bright against the gray of the masonry as the same poster on the same kind of wall ten feet from you. Comparison, however, proves that both the gray wall and the orange-colored poster in the distance are much hazier than the wall and poster nearby.

Weather affects all colors

On a cloudy, rainy day, all colors become grayish. Yet a red barn still appears to be red and grass still looks green, as long as there's enough light for you to see, and as long as you know what you're seeing. This is important to realize.

Beginners usually paint colors equally bright, no matter how far or how near they may be, and no matter what kind of weather they are painting. They simply go by the name of a hue and not by its actual appearance, its value. They'll paint the red barn, the green grass and foliage, as seen from close-by, in bright sunlight. Begin-

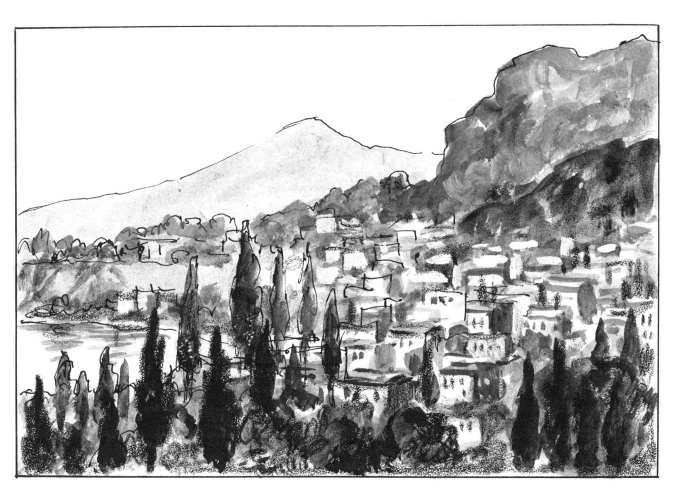

View of Taormina

Values in nature can best be judged by observing a vast panorama, such as this view of Taormina, Sicily. The distant mountain is just a couple of shades darker than the sky. Hills, houses, trees become stronger in value, as well as bigger in size and more detailed, the nearer they are to the viewer. Everything becomes not only lighter, but hazier, bluish or violet in tone, in the distance. Don't go by what you know about the actual colors of houses, roofs, trees, roads, and so forth. Paint them the way they look from a distance.

ners merely paint the sky blue on a sunny day, gray on a rainy day, dark blue towards evening.

Studying color perspective

The mental approach toward color perspective is identical with the approach to learning linear perspective. A beginner in painting sees a newspaper as he remembers it: a rectangular object. At first it's difficult for him to believe that the rectangular paper looks different when you see it from an angle on a table. Artists must learn to see colors — as well as forms — from diverse viewpoints, in various lights, in different atmospheric conditions.

A distance of a few feet doesn't change colors in a noticeable manner. You need the outdoors for observing color differences. A view from the top of a hill over a vast panorama is the most striking proof of how hues are affected by distance and by weather. If at all possible, try to observe the same panorama on two different days: once on a bright, sunny day, and again on a gray, cloudy day. Take photographs of the same view on the two different occasions or, better yet, make color sketches, concentrating on shades of colors, rather than fine details.

Each row of hills or mountains is lighter in tone the farther it is from you, on any day. The last hill may be just a shade or two darker than the sky on a bright day; on an overcast day, it may literally blend into the sky. Details of rocks, meadows, houses, trees become vaguer and vaguer the farther away they are, and so do their colors. Each color becomes bluish, sometimes almost violet. You can still distinguish between a meadow and a wooded area, or between a winding road and a winding river, but distant scenery resembles something covered by smoke on a rainy day, covered by a light blue veil on a sunny day.

In a city, the differences in hues and values can best be appreciated on a straight avenue, where you notice that houses diminish in size and their colors diminish in intensity toward the opposite end. Buildings, however, are in so many colors — red, yellow, buff, gray, white, brown, in the United States, and many more in southern European towns — that comparison is not easy for the untrained eye. A brown house in the distance looks darker than a white house nearby. You must compare a red, brown, or gray house in the distance with a house of the same color closer to where you stand.

Exercise in color perspective

The following exercise may not be within your means to carry out, but try it, if you can. Take three or four sheets each of red, yellow, medium blue, and black cardboard, 28" by 44", or 30" by 40" in size (these are standard sizes), and set up one of each next to the other, close to where you are standing, in a garden, a meadow, or on a fairly straight country road. Set up another group, in the same order, fifty feet away; another group a hundred feet away, and so forth. You might lean them against rocks, or stakes, in such a manner that you can see all the cards clearly from where you are.

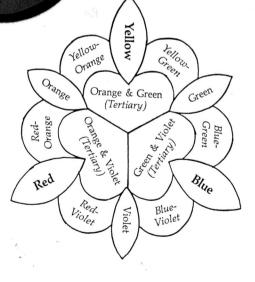

Color Star.

Red, yellow, and blue are the primary colors which cannot be mixed from any existing colors. Secondary colors are created by mixing any two primary colors to form orange, green, or violet. Secondary hues vary according to the quantity of primary colors in the mixture. Tertiary colors are formed by mixing together any two secondary colors, producing an infinite variety of hues.

Color Star 33

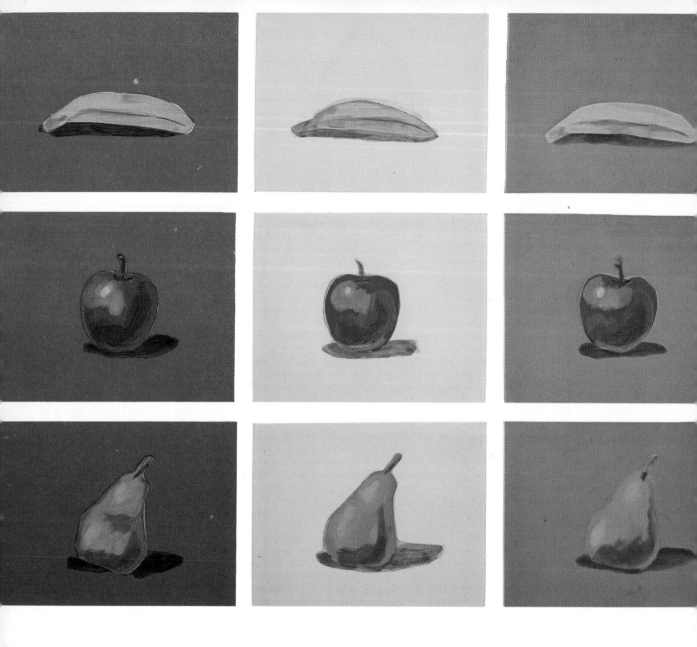

Color Effects

There are several reds, yellows, blues, greens, and so forth. The name of a color is meaningless until the color is in its right place, surrounded by other hues. Every color looks different when grouped with various other colors. Here, we have yellow bananas, red apples, green pears, and sheets of paper of various colors.

The yellow banana looks fine on a red background, bright on a green background, but it's hardly noticeable on a yellow backdrop. As a matter of fact, it looks like a piece of waste paper. The red apple is brilliant on yellow, all but invisible on red, and has a jumpy feeling on green. The green pear practically disappears on a green material, jumps out on the red, and looks bright on the yellow backdrop.

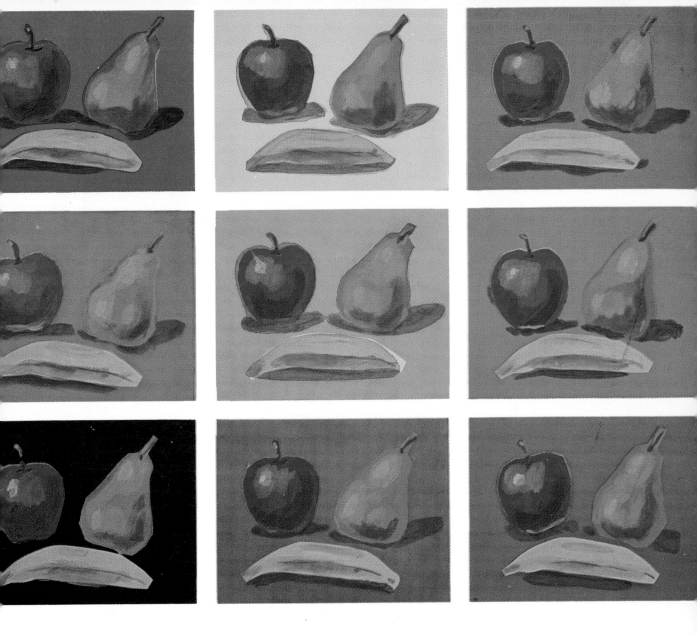

Placing the same three fruits, in the same arrangement, on diverse backgrounds, we find that one of the fruits, or the other, can hardly be discerned, and the total effect varies considerably according to the backdrop. It is a most valuable exercise to try all kinds of combinations of assorted construction paper and fruits or vegetables of all kinds and colors, in order to see what backgrounds can do for or against you.

Another noteworthy effect is that each fruit looks smaller on a light background than on a dark one. The fruits appear to be much bigger on the darker backgrounds, even though they are exactly the same size. The effect is the same as that of the white square on black, and the black square on white.

In the last analysis, it's the effect that counts. Your painting stands or falls by what you succeed in putting into it. A well handled optical illusion or an unplanned, unpleasant optical illusion can determine the final value of your painting.

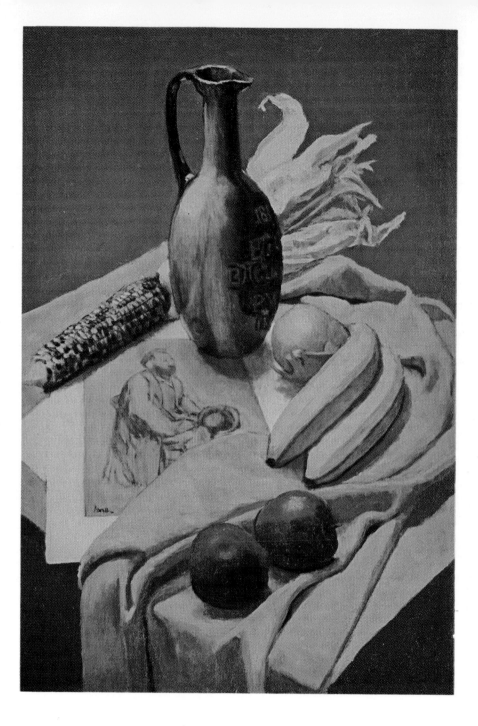

Black Jug and Degas Print by Herbert B. Turner. Oil. 22 x 15.

A perfectly realistic still life in oil proves the possibility of making a still life interesting by an unusual combination of objects, a novel pattern, and a good choice of colors. The diagonal design is counterpointed by the curving drapery and the upright jug. The colors are mellow, yet sufficiently varied: yellow, buff, brown, against white and soft green. The black of the jug is echoed by the cob of corn. Try to cover the two red apples with a piece of green paper. You'll be amazed to see that the picture would practically fall on its face without the apples.

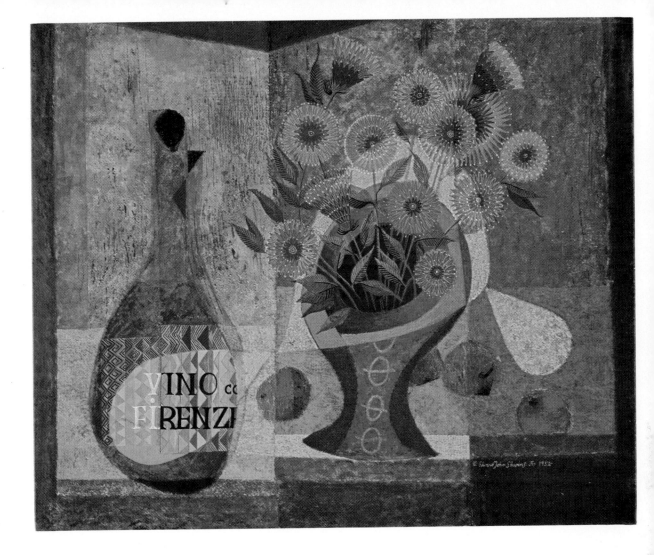

Italian Still Life by Edward John Stevens, Jr. Gouache. 18 x 22. (above)

The artist is noted for his exotic, embroidery-like paintings in often very thick gouache. He never loses track of his precise shapes and lines, in which every imaginable detail is drawn with the love of a meticulous silversmith doing filigree work. Each section is neatly delineated, but one form is combined with another, in a sort of fragmentation or as if everything were viewed through a neatly broken glass. The hues are rich, yet not exaggerated, and the tonal differences create a pleasing spatial relationship between objects. Courtesy Weyhe Gallery.

Oriental Poppies by Sygmund Menkes. Oil. 31 x 24. (left)

An artist best known for his figure compositions has manifestly enjoyed dashing off a still life for a change. Done in bold strokes, the work nonetheless reveals the knowledge of an experienced painter, who has a flair for achieving intricate patterns of vertical, horizontal, diagonal, and elliptical shapes. Reds, yellows, blues, and purples, buffs, and grays, lights and darks, alternate in a vibrant manner. Almost every brush stroke is a different hue. The artist didn't mix a big batch of paint for the background, and another batch for the poppies, and so forth. He observed each color separately. Courtesy, Associated American Artists Galleries.

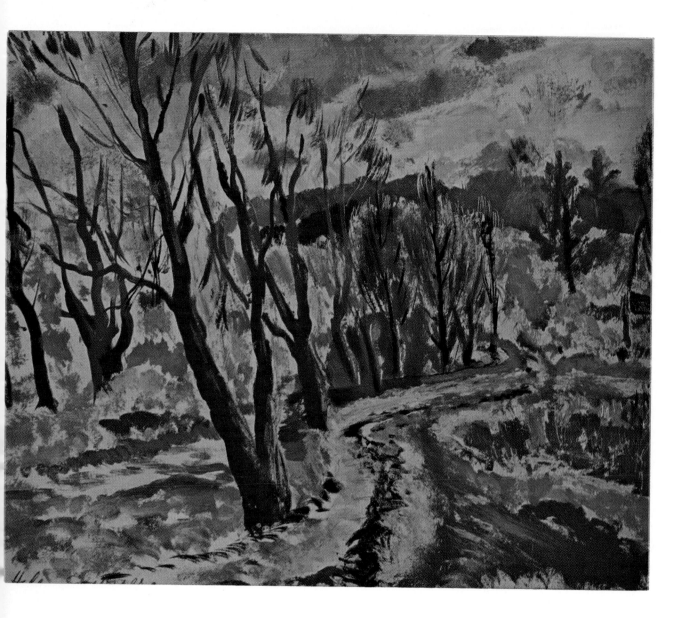

Landscape Mood by Helen Sawyer. Oil. 11 5/8 x 14 1/4.

Manifestly, a quick sketch, showing a dirt road, a number of small trees, this picture gives a good idea of how a painter begins his or her work. The main elements are immediately put on the canvas, with the interesting pattern of the winding dirt road leading toward the distant hills. Yellow-green and reddish vegetation, a blue sky with swirling clouds, hardly any detail. Yet the artist catches the mood of the subject, and conveys it to the onlooker.

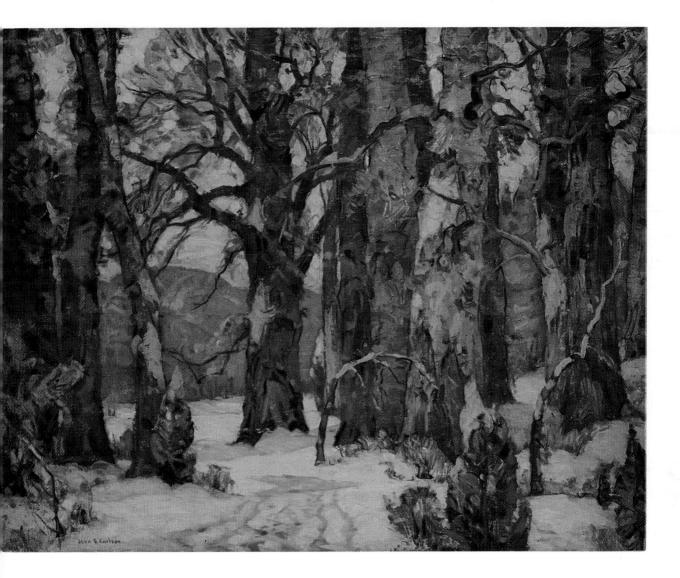

Quiet Grove by John F. Carlson. Oil.

A completely traditional oil: big trees, with red and brown leaves still on their branches, a few evergreens, after an early snowfall. Color perspective is far more important here than linear perspective, since the trees offer no problem in drawing. Distance is indicated by the use of lighter, cooler colors in the background. Even the snow has a yellowish tone in the foreground. Note how the curving trees on the right, and the left edge of the canvas carry the picture beyond the frame. The strong branches of a tree left of the center, radiating in various directions, break up the monotony of vertical shapes in the other trees. Courtesy, Grand Central Art Galleries.

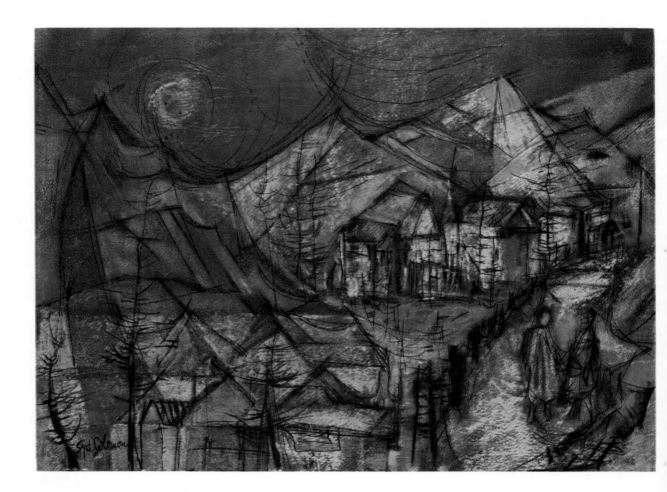

Summit by Syd Solomon. Polymer tempera. 21 x 30.

This semi-abstract, but easily recognizable oil, executed in rich greens, blues, reds, pinks, and yellows, seems to glow like enameled jewelry. The subtle variations of hues and the fine, almost pen-and-ink-like black lines all over the colors, lend this picture more depth than abstractions normally have. Hills, houses, road, and figures are coordinated in color, no less than in design.

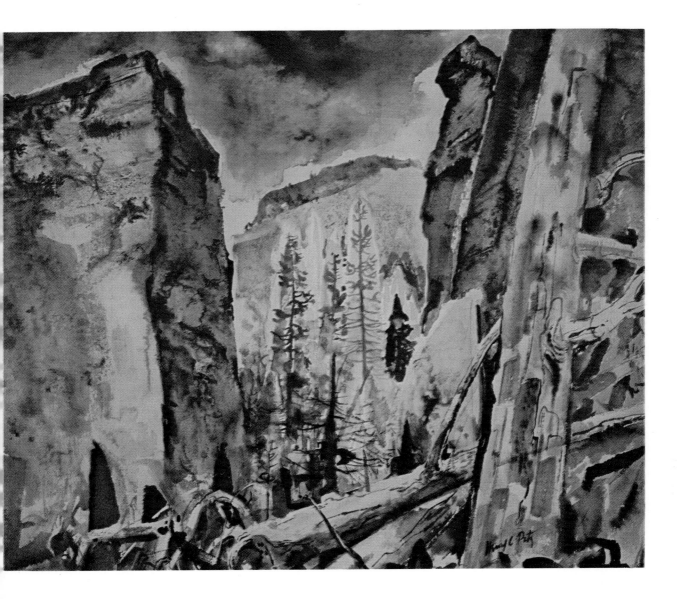

Hidden Valley by Henry C. Pitz. Watercolor. 22 3/4 x 30 1/2.

An aquarelle full of bright hues in front of a gray sky, many calligraphic details and quick, bold washes. Much of the paper is left white; wet-in-wet strokes alternate with dry brush strokes. Note, once again, the use of warm and cool colors: ocher against gray and blue, yellowish green against bluish red, creating a feeling of great height and space.

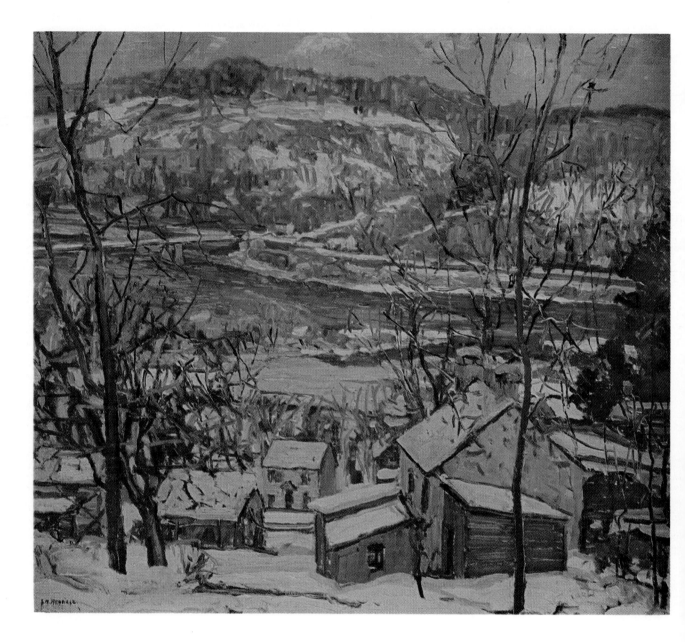

Mike Mullins Hill by Edward W. Redfield. Oil. 28 x 32.

A snowscape in which toylike houses behind tall, skeleton trees appear to be totally exposed to the cold day. The sun, trying to break through the clouds, casts an ocher light upon the entire scenery. The warmth of this sunlight is underscored by violet shadows. The whole picture is executed in countless individual brush strokes, rather than by covering large surfaces with flat colors. It's a true impressionist painting, atmospheric, and spontaneous.

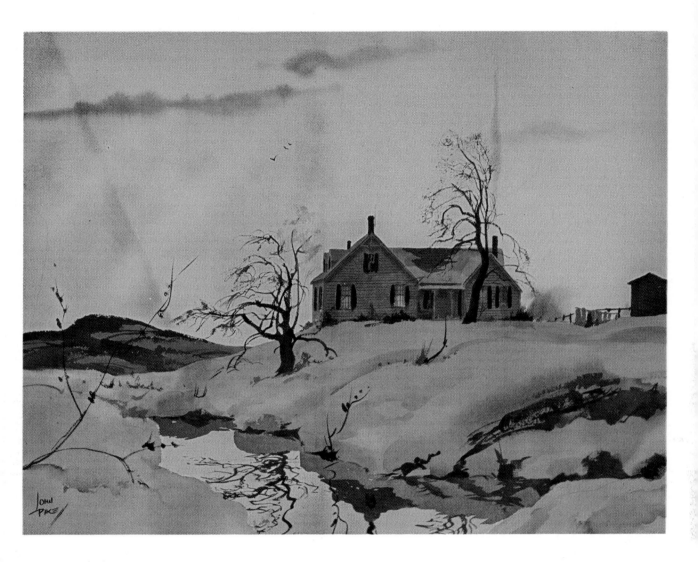

Winter Evening by John Pike. Watercolor. 21 1/4 x 28 1/4.

The moment you glance at this watercolor, you are enveloped in the cold but invigorating atmosphere of a wintry evening. The snow isn't white, the way most people think it is. It's blue, against the bright, pale yellow sky. The coolness of the sky is made more obvious by the use of warm, orange tones in the windows of the cozy house. The effect is achieved with only a few touches. There are also fine details, obtained mostly with washes, in the snow as well as in the wooden houses. The water in the foreground is calm, yet the reflections in it are rippled. The whole painting was done with the self-assurance of a highly skilled artist. There's no room for changes or corrections in a delicate aquarelle.

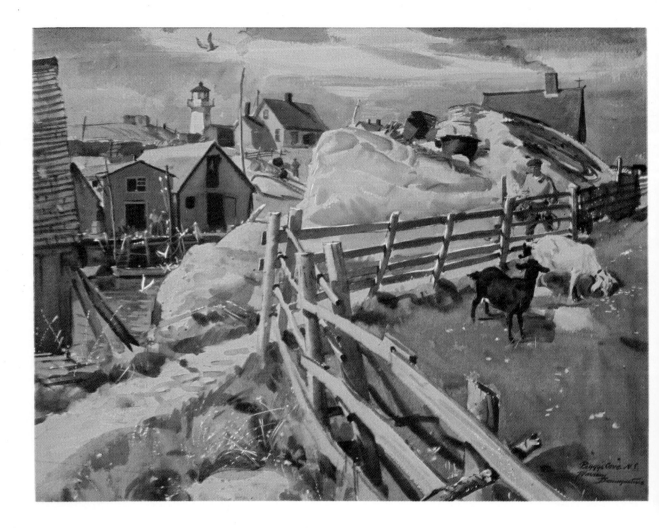

Peggy's Cove, Nova Scotia by Warren Baumgartner. Watercolor. 22 x 30.

This watercolor of a very complex subject required real draftsmanship, and a keen sense of composition. The zig-zag line of the wooden fence breaks the vast scene into diverse sections, each of which might make a good picture by itself. At the same time, however, the fence — with the help of the colors — holds the entire view together. Your eyes go back and forth, up and down, beholding houses, roofs, grass, road, clouds, humans, goats, seagulls, as if you were standing on a hill directly in front of this scenery. The soft sunlight gives every detail a golden glow. Commissioned by, and Courtesy of True Magazine.

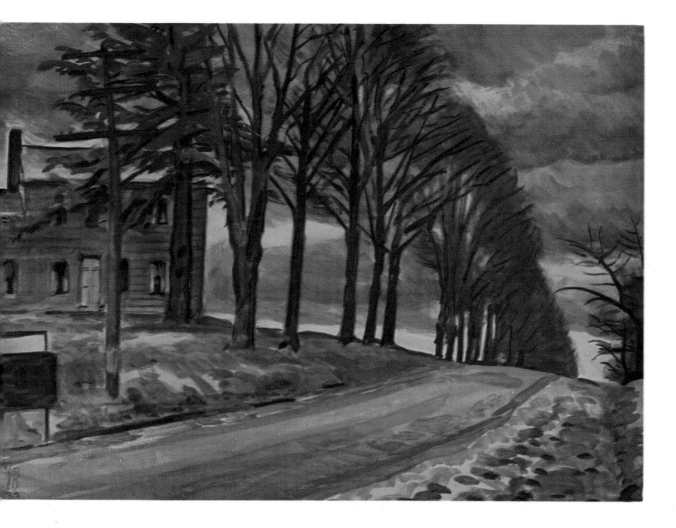

March Road by Charles Burchfield. Watercolor.

Done in his characteristically bold style, this painting by the noted watercolorist is more realistic than much of his work: the mood of a wet, nasty, chilly day is excellently conveyed by this dark-skied picture. The row of trees going beyond the hump in the road creates a sensation of infinite distance, independent of the colors. There's no very bright hue in this scenery, yet one feels that spring is not far away and that grass and foliage will soon be green, and the sky will turn blue. Collection, Mrs. R. S. Maguire.

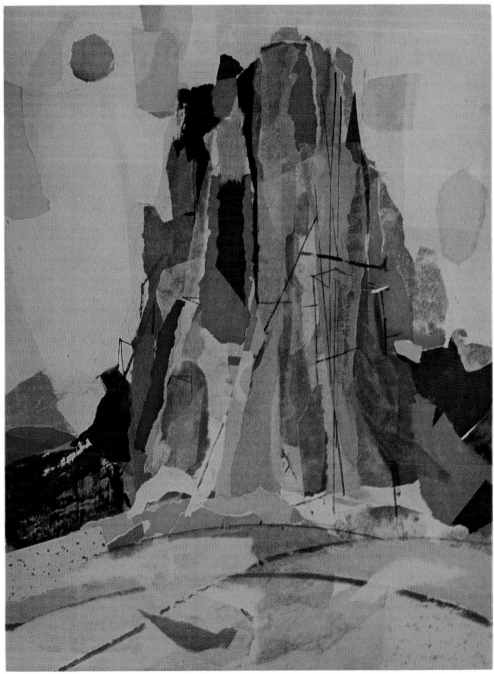

Western Mountain by Arthur Shilstone. Collage. 18 5/8 x 14 3/8.

This is a collage composed of cut or torn pieces of colored paper — some of which are transparent — built up gradually, and connected with a little brushwork and lines. The colors have been carefully chosen. No matter what style, medium, or technique you use, always combine lights and darks, cold and warm colors, and create a cohesion in design or color. In this picture, the result is a brilliant, grandiose geological formation. Try to change any of the reds into blues, or any of the blues into reds, and the effect will be lost.

Now, observe them honestly. By this, I mean forget that they are exactly the same sets. Don't listen to your memory telling you: "They're the same... they're the same..." Use your eyes. The colors are identical in fact, but not visually. They are lighter and hazier, the farther away they are. The degree of brightness between objects of the same hue decreases with distance in the same proportion as sizes do.

Color perspective in houses and figures

If you know anything about linear perspective, you won't paint a house and a figure as large in the background as you would in the middleground or foreground. You know that if a figure can walk through the door of a house nearby, the figure farther back can also walk through the door of the house in front of which it is supposed to be standing. The house, the door, and the figure are equally smaller in the distance.

The differences in colors are as great as the differences in size. If both houses are pink, and the doors and shutters of both are green, and both figures are dressed in red jackets and blue slacks, you must observe, and paint the perspective in colors as well. In other words, each color will be lighter the farther it is from you.

Color perspective in foliage

Probably the most difficult subject from the viewpoint of color perspective seems to be a forest, or any scenery with a great deal of trees and foliage. Green foliage and green grass look plain green to the untrained eye; lighter where the sun hits them, darker in the shade. It's easy to see the color differences in unusually light-and-bright-hued young trees, and, of course, you can distinguish trees with maroon or reddish foliage. It's not so easy to recognize color differences among all green trees and foliage. But there's much more difference between greens than you realize. You must learn to render the diverse shades of green not only lighter and darker, but reddish, yellowish, whitish, bluish, and grayish greens as well. If you don't learn these nuances, your forest will resemble a piece of material, a curtain, hanging straight down, instead of going back deep into the distance; your trees will look like green drapery thrown over wooden hatracks.

Importance of values in color perspective

In color perspective, grasping and perceiving values is of the utmost significance. You may follow all the rules of linear perspective but still make a mess of your painting by neglecting to compare color values. A shadow on a tree, on a house, on a road, or on any object isn't merely *darker* than the rest; it's darker according to nearness or distance. The brightest light on a green lawn faraway is not as brilliant as on the same kind of lawn near you. Not only are colors less bright in the distance; they are also more and more bluish in tone.

Compare the tones farthest away with the tones near you, and paint the shades between the two extremes proportionately. It's an excellent method to start your painting by applying the very darkest, and the very lightest colors first. Bear in mind that warm colors appear to advance, while cool colors recede. The more intense the warm color, the closer it comes to you; the less intense the cool color, the farther away it moves from you. Add a touch of red, orange, or burnt sienna to any color, and it will come forward. Add a touch of white, blue, or green to any hue, and it will move backward. You have absolute control over colors.

Avoid holes and jumping-out colors

Colors in the distance painted as bright as the same hues nearer to you, seem to be "jumping out of the picture," as we say, or look as if someone had pasted bright pieces of paper on it, perhaps mischievously. Even the casual onlooker feels that something is wrong with the picture.

Dark sections, painted just as dark in the distance as similar objects in the foreground, appear to be holes or gashes in the picture. They're fine if you want to paint actual holes or gashes; they're utterly wrong, however, if the dark hue is an accident, based on an oversight or on lack of understanding. Art students often paint tree trunks, and shadows under the trees in the same colors and values in the farthest distance as nearby, and in-between. Such trees and shadows appear to be standing in one row across the picture, rather than in depth as the artist had planned. And even real holes in the distance must be lighter in value than similar holes nearby.

Although these facts are most noticeable and damaging in realistic subjects, they're just as disturbing in abstract or nonobjective paintings. An artist working in any of these contemporary styles may wish to suggest a big hole, or something sticking out of the painting. Such color effects can then be utilized for esthetic purposes.

Light and shadow

Few fragments of Greek paintings survive, but the Roman artists knew practically all about light and shadow effects, as we can see in their often superb murals in Pompeii and Herculaneum, and in their great mosaic pictures. Light and shadow have been an integral feature of Western art for over two thousand years, and we can hardly imagine truly three dimensional appearance in any painting that has no light and shadow. For perfect realism, we must have linear perspective, color perspective, light and shadow. But not every part of the world agrees with us...

A very talented Japanese girl — in a watercolor class I taught — once had to paint geometric objects made of natural wood. She made a perfect outline drawing of a cube and a pyramid, then painted the visible sides of each, all exactly the same wood-color; she left the pencil lines between sides intact, which was quite an achievement in patience and skill. I asked her why she hadn't painted the shadows. "What shadows?" she asked. Why, the right-hand side of each of the two objects was in shadow; therefore, it had to be darker than the other sides.

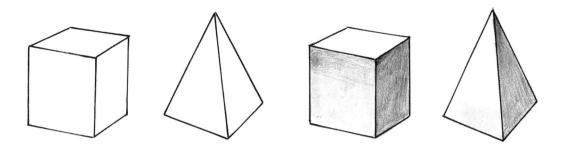

Shadows Are Important. *Any geometric object, or any other article, can be drawn in outlines, but, in a realistic painting, shadows are important, even though Far Eastern artists worked in lines only for many hundreds of years.*

The girl declared she didn't know what I was talking about. Surely, she said, I couldn't possibly be serious. How can certain sides of these objects be darker than others, when they're made of the same piece of wood? When I tried to convince her of the existence of shadows, she became almost hysterical. She grabbed both geometric forms, one in each hand, waved them, turned them around in front of me, and repeated loudly: "These things are made of the same wood; every side is just like the others, and that's the way I paint them!"

Suddenly, I understood the Oriental attitude. You must paint not what you see, but what you remember as the truth. Surely, the wood was the same all round. Japanese pictures are done in fine outlines, colored according to the artist's memory. This shows how totally different viewpoints can, and do, exist. Later on, I managed to convey to this Japanese girl the Western idea about light-and-shadow by showing her photographs, including a Japanese travel folder, printed in Japan, in which shadows could undeniably be seen.

There is a famous story about Earl George Macartney, Britain's first envoy to China. When he reached the court of the Chinese Emperor, about 1790, he presented a gift from King George III: several portraits of the British Royal Family. The Emperor and the Mandarins were shocked at the sight of the portraits. They asked if every person in England really had one side of the face darker than the other. They thought the shadow on the King's nose was either a natural, tragic defect, or, perhaps, some paint spilled by accident.

Chinese and Japanese art had occasionally reached Europe. Sir William Chambers (1726-1796), British architect, is credited with the creation of the "Chinese Style" which was enormously popular for a while. This style is usually called by the French word, *chinoiserie,* and it was restricted mostly to furniture and furnishings, chinaware, rather than to fine arts. Shipments of tea sometimes arrived wrapped in Oriental prints. It was not until Commodore Perry opened up Japan in 1853, that Japanese scrolls, woodcuts, and other forms of art began to reach Europe, and, later, America. Yet, even Whistler and Mary Cassatt, deeply influenced though they were by Japanese prints, could not and would not abandon light-and-shadow, one of the great accomplishments of Western artists.

Studying light and shadow

Lights and shadows must be studied like anything else. Train your eyes to see what's in front of them visually. Study the color of highlights (the sections most directly hit by the light). The assumption that the shadow on a red apple is a darker red, the highlight on the same apple is a lighter red, is erroneous. When the light comes from the sunny, blue sky, the lightest spot on the red apple may be a pale blue. The highlight may be yellow when seen by artificial light. The shadows may be any dark hue, depending upon where the apple is, its background, the table, and so forth. Neither the light part, nor the dark part of an article is ever one large mass of a single color. Each of them has shades. On a round surface, these shades blend into each other, and leave a reflected light near the edge. On a flat surface, the shadow or light has a sharp edge, but its intensity varies from one corner to the other. The highlight is a spot on a sphere; a straight line on a cylindrical or conical object.

The shape of a cast shadow is produced by the shape of the object which throws the shadow and the surface upon which the shadow is cast. Observe cast shadows; don't assume that they are dark, indefinite spots. The cast shadow of a cone, for example, is cone-shaped on a flat surface, such as a table. On a wavy surface, such as a wrinkled drapery on the table, the shadow curves according to the shape of the drapery.

The only time there is absolutely no shadow is when illumination comes from all possible angles. Public buildings and monuments are often illuminated by hundreds of spotlights. Such structures appear to be flat surfaces with some decorations. One of the weirdest of these is the Parthenon in Athens. Perched on top of the Acropolis, the ancient temple looks like a huge neon sign floating against the midnight-blue sky. It is a splendid fantasy, rather than a three dimensional edifice.

Highlights Are Different. *On a cylinder, the highlight is one line along the cylindrical body. On a sphere, the highlight is just a spot, the one nearest to the source of light. On a cone, the highlight is a line from the tip to the bottom of the cone. On round surfaces, the darkest shadow is not at the very edge, but slightly away from it, leaving a reflected light. If you paint the shadow up to the edge, the object will appear to be flat rather than curved.*

A rather amusing proof of what shadows do, and how difficult it may be to cope with them, is in stage, operatic, and film productions in which a person is supposed to have no shadow, such as *The Woman without a Shadow* by Richard Strauss. Whatever the reason or origin of the tale may be, it's impossible to stage it correctly. One figure might be standing on the stage so fully illuminated that he would have no shadow. But we cannot stage a scene with several persons in such a manner that one of them should have no shadow, while the others have their normal shadows. Fortunately, the audience is more interested in the music, and the action, than in the shadow of a person who isn't supposed to have any.

In painting, however, we can do what we want. For the most elementary degree of realism, you have to observe all lights and shadows in shape, size, color, and value. A shadow painted too dark looks like a hole; a light made too light appears to be a band-aid, or a slip of paper stuck onto the painting.

One of the best ways to study light and shadow is to look at black-and-white photographs. These pictures appear fully three dimensional. Take a photograph and touch it up with a light gray, wherever it's actually dark; and with dark gray, where it's supposed to be light. Such spots stick out like sore thumbs. Anyone can immediately tell that something is wrong with the picture. Learn to notice such extraneous spots in your full-color paintings as well. You needn't be photographic. Be as bold as you wish. Apply heavy strokes, omit small details, but don't forget the final, total effect. If you're not concerned with reality, but merely want to express yourself in color, you still ought to consider the effect of unplanned holes and unplanned patches; that is, holes and patches due to an erroneous application of colors and values. The word *art* implies a deliberate kind of work, done with appropriate craftsmanship, not produced by accident.

What Impressionism added to color perception

The Reformation and the French Revolution wrought drastic changes in European life. The artist was no longer busy working for the Church and the aristocracy. He was on his own, trying to find subjects he could sell to members of the expanding middle class. Smaller pictures were needed for simpler homes, and a large variety of tastes had to be satisfied. Early in the 1800s, two English artists, John Constable and Joseph William Mallord Turner, began to work outdoors and, by the 1830s, they inspired French artists, such as Camille Corot, Constant Troyon, and Jean-Francois Millet, to do the same. French artists established an art colony near the village of Barbizon, in the forest of Fontainebleau, with the aim of catching and painting the true colors of nature.

These artists concentrated on color as it appeared to the eye, not as it was understood by the academically trained artists of previous generations. The general effect of atmospheric conditions, distance, persons and carriages in motion, the rendering of the time of day, the sparkling sunlight between the leaves of trees and on the ground, were much more important than physical details and painstaking outlines. The work had to be done fast, in an hour or so, in order to be true to what the artist perceived. Who can really see your eyelashes, or count the spokes of a wheel on a

speeding carriage, from a distance of fifty or sixty feet? Artists used to paint such details not because they saw them, but because they knew they were there.

One of the first of the French artists working in the new style, Claude Monet, exhibited a painting, *Impression du soleil levant (Impression of the Rising Sun)*. This title gave a critic the opportunity to denounce the new movement as not art, but merely an *impression* of art. The name *Impressionism* soon became an international word.

Linear perspective still served as the foundation of Impressionist pictures, but color became more and more vital, as artists worked as directly as possible, applying dabs of paint, without worrying about blending. They observed colors and values more than anything else. They found that the boldly dashed-off colors led to a more realistic image than the previous system of precise drawing and painting, even though the Impressionist paintings looked sketchy, unfinished, to eyes accustomed to traditional art.

The importance of Impressionism is the introduction of on-the-spot observation; the idea that one color has to be compared with all the colors around it; that colors are as expressive as, or *more* expressive than, lines and forms.

4. Color and Perception

Perception means an awareness of things, obtained directly, through the senses, through keen observation, or by intuition. Some people are naturally aware of color; others make an effort to see and study color. Still others are perhaps capable of immediate cognition. As in all fields, perceiving color is probably a combination of natural talent, observing ability and, with the greatest artists, intuition.

Optical illusions

Having dealt with many hundreds of art students, I know that perception in art in general, and in color in particular, doesn't come as fast as I'd like. Time after time, I hear the exclamation: "But this doesn't look right!" or "This looks wrong. It looks impossible!" Invariably, what looks right to the average student is wrong to the experienced artist, and vice-versa. One of the most difficult problems is to convince art students that the world is full of optical illusions. Some of these optical illusions are pleasant, some unpleasant, some astonishing, others puzzling or amusing; a few are known to the general public, even to school children, while others come up in art only—every type of art.

The perception of illusions, whether they are illusions of lines, of forms, or of colors, is very significant to all artists.

The ancient Greeks, with their incomparable desire and ability to weigh, measure, and define everything, were past masters of controlling optical illusions in their architecture. They used their eyes and their minds. When they noticed that straight columns didn't look straight, they changed the shapes of columns until they found a certain curvature and a set of proportions of height and width, the right sizes for top and bottom of a column, so that, ultimately, the column *looked* straight, even though it wasn't. When horizontal steps seemed to be caving in, they built them in their large temples, such as the Parthenon in Athens, in a convex shape, so that they *looked* straight. Optical illusions were widely and most successfully practiced by the architects of the Renaissance, including Leonardo da Vinci, after the discovery, in the fifteenth century, of books by the classic Roman architect, Vitruvius.

In painting, more than in architecture, we must recognize, observe, and utilize optical illusions. After all, painting itself is a great illusion: an artist can create an illusion of depth on a flat surface; he can depict sunshine, moonlight, rain, hurricane, the waves of the sea, galloping horses, and anything else, on a mere sheet of paper or canvas. This is no mean achievement. It requires visual experience, perception, and technical skill.

Many present-day artists and students dismiss all knowledge as outdated, esthetically worthless, something for the birds. It's as if a modern author dismissed grammar as well as anything written in the past, or as if a student decided to discover all about biology without going to school. There's continuity in life, and art is no exception. In a perpetually changing world, nobody can go beyond what we have without knowing what came before. As a matter of fact, several schools of contemporary art are based on the keenest perception of color, and a complete utilization of optical illusions.

Exercises in optical illusions

Practically everyone is familiar with the optical illusion of two lines of equal length, one with regular arrows at each end, the other with inverted arrows.

Notice that the vertical line on the right looks taller; the lower one of the horizontal lines appears to be longer. The same illusion prevails in two human figures:

Which Line Is Taller? Which Is Longer? *We are surrounded by optical illusions, some interesting, some odd, some puzzling; but many of them fool you unless you know all about them. Which line is taller? Which line is longer? They're exactly the same, but the vertical line on the right, and horizontal line on the bottom appear to be longer. This illusion is caused by the inverted arrows at the ends of these two lines, in contrast with the regular arrows at the ends of the two other lines.*

Which Figure Is Taller? *Which man is taller? Which woman is taller? They're the same size, but the man in the top hat looks taller because his hat goes far up; and the woman in the horizontal striped dress appears to be shorter and fatter than the woman wearing vertical stripes. Such optical illusions can be incorporated in fine arts paintings. For example, you may have painted a figure that looks too big, and you don't want to scrape it off and do it over. You can usually make it appear smaller than it really is by changing just a few colors or values or the direction of a line in the figure.*

if one wears a tophat, the other a flat strawhat, the man with the tophat seems taller, even though he is of exactly the same height as the other figure. The reason for the illusion is simple: we perceive the total height, or length, including the upside-down arrows, and the tophat, instead of observing the lines or figures themselves.

Another well-known optical illusion refers to two women, one of whom wears a vertical-striped dress, the other a dress with horizontal stripes. The woman with the horizontal stripes looks fatter and shorter. The illusion lies in the fact that vertical lines guide our eyes upward (as in a Gothic cathedral), whereas horizontal lines seem to be spreading, widening. The understanding of this particular illusion is of great importance to tall and thin women who'd like to look shorter and fleshier; and to short, plump girls who'd rather look taller and slimmer without going on a diet.

Who hasn't seen the optical trick of a white square on a black background, and a black square on white background? The white square on black appears to be bigger, although it's identical in size with the black square. The result is the same if you work with a bright yellow or bright green, and a dark purple or a dark blue combination of squares and backgrounds. A bright spot on a dark surface always seems to expand, while the dark spot on a light backdrop is visually compressed by the light color around it.

If you paint a night scene with a house, in which one window is brightly illuminated by a lamp inside, make the window smaller than you want it to appear. Other-

wise, it will look much too big on the dark wall of the house. Some portrait painters like strong contrasts, but if you want to paint a light-complexioned, blonde girl against a very dark background, paint the face smaller than lifesize. Otherwise, the head will look like a giant. A lifesize portrait looks lifesize when painted against a fairly light background.

Another optical illusion is that the same color appears lighter on a dark surface than on a light surface. A light gray star, for example, looks almost white on a black background; the same star seems to be darker on a white material. Here again, you get a similar effect when you work with a light pink star, or any other shape, on a dark maroon background, on which the star appears to be almost white. Put it on a white background, and it will look darker. Since all paintings are configurations of colors and shapes, it's helpful for the artist to understand these optical effects. Let's say you are painting a landscape with a light yellow house. If you place the house right in front of a pale blue hill in the background, it will look very light indeed. Paint a few darker green trees and bushes next to the house, and it will seem to be much brighter.

Two Swiss crosses of the same size (each arm of equal length and width) look different if the center square of one is eliminated. The cross on the right appears to be larger, because it's completely filled, and thus looks massive. The cross on the left is weakened by the square hole in the center. This optical illusion, too, can be utilized in your painting. If any object seems to be overwhelming, compared with the rest of your picture, you might be able to make it appear less huge by merely breaking it up with a lighter, or darker section. A very big wall of a barn, for example, could be broken up by adding a window, or an open door, or a couple of planks leaning against the wall.

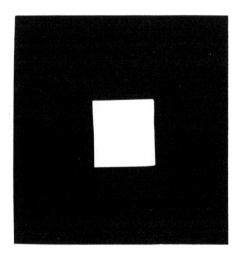

Which Square Is Bigger? *Which square is bigger: the white square on the black or the black square on the white background? They're exactly the same, but the white on black seems bigger. A light color on a dark backdrop appears to expand, to break into the dark background; on the other hand, a dark spot on any light backdrop seems to be constricted, and thus looks smaller.*

Which Star Is Darker? *They're of the same color, but the star on the white ground appears to be darker. It's important to realize the tendency of colors to look darker on a light background than on a dark background. That's why you shouldn't mix colors on your palette, but on your actual painting, where each color can be related to its neighboring hues.*

Which Cross Is Larger? *Which Swiss cross is larger? They're the same, but the solid cross, on the right, seems larger, as it isn't broken up with a square hole in the center. You can utilize this fact in your painting, by making any part appear to be less overwhelming than it happens to be. Merely cut it by painting something in front of it, in one place or another.*

Effect of after-images

Have you ever looked at the glowing orange setting sun? When you look away, you see purple and green suns jumping in front of you. Similar spots act like jumping beans of diverse dark hues, when you turn toward a shaded wall, after having looked at a bright, sunlit building. Notice what happens when you stare at a brilliant neon sign for a few moments at night. When you turn toward the dark sky or toward a dark building, you'll see a shape similar to that of the illuminated sign, or to its brightest feature, only in a totally different color. These spots and shapes are called after-images. Among the most memorable ones I've ever seen were purple and dark green sailboats floating in the sky, after I had gazed at a couple of white sailboats, brilliantly illuminated by the sun against a cloudless summer sky, on the bright blue Mediterranean Sea off North Africa.

According to physicists, the colors of after-images are the complementary colors of the original objects. Two colors which give white when combined through a prism are called complementary colors. Greenish-yellow and blue are a pair of such complementaries. Since there are countless colors, there must also be countless complementaries. Let the physicist pair them all. Artists, as a rule, merely see the colors jumping like mad, and the after-image colors are always different from the colors of the actual objects.

The question is: should we, can we, paint such after-images? One celebrated artist who did paint them was Vincent van Gogh. He employed swirling brush strokes, many colors, and, in a later period, he painted spots in the sky. We know from Vincent's letters to his brother, Theo, that his aim always was to paint exactly what he saw, and every now and then he reported with great satisfaction that he had succeeded in doing just that. We must assume that he painted the dark spots in the bright sky because he saw such spots. He literally saw them, even though he knew they weren't actually on the sky. He also saw swirling forms in the almost tropical sunlight of the Arles region, where he lived.

This doesn't mean that we ought to paint such spots, too. We'd only be imitating Vincent van Gogh. But the after-image effect can inspire us to select our colors according to the fact that a very brilliant form might be repeated elsewhere in a very dark color, and thus give the onlooker a sense of life, a feeling of vibration. Surely, a bright sail will look even brighter if you paint the sky just a little darker next to it, and if you paint a less bright sail near it, or if you paint a dark spot, perhaps a clump of land with dark green trees, in the same picture.

Colors and memory

Most painters know the difference between two kinds of yellow; between cobalt, ultramarine, and phthalo blue; between alizarin crimson and cadmium red; between a blue-violet and a red-violet; a yellowish orange and a reddish orange, and so on. But we remember colors the way we remember anything else: vaguely, often incorrectly. There are so many shades of so many hues that it's literally impossible for anyone to recollect each of them.

A smart woman doesn't go to a store to purchase a piece of material to match a specific color without carrying a swatch of the required color with her. We recall with certainty only names of colors, and the fact that they are dark, or light, very dark, or very light. As for color perspective, we recollect only that distant hills we have seen were violet in tone. It's especially difficult to remember changes in colors caused by illumination.

Practically any artist with modest experience knows how to paint an ordinary little landscape, with a bright blue sky, white clouds, brown-and-green ground, a few trees, and a red farmhouse. Depicting a more definite theme from memory, for example an early morning scene, a late afternoon scene, or a landscape as it looks just before a shower, is far more complicated. Usually, when such scenes are painted from memory, the sky, the ground, the trees don't go with each other. Such paintings remind me of a clown dressed in striped trousers, highly polished boots, a torn sweater, a patched-up lumberjacket, a tophat, and a green umbrella. It's fine for a clown, of course, but *you* wouldn't want to be caught dressed like that.

Unless you're truly experienced in painting from memory, or unless you don't mind working like an amateur, make on-the-spot sketches in pencil and in color. Use watercolor, casein, crayon, but have something to refresh your memory when you paint a serious picture. Above all, try to return to the place later and compare your finished, or nearly-finished, painting with the actual scenery.

One of the problems of memory-colors is a lack of variety and accidental flaws, peculiarities you always find in nature, but cannot invent. No wall, no door, roof, rock, tree, or road is perfectly clear, clean, and undamaged. You notice and paint these odd features when working from observation, but you forget them, or misplace them, when painting from memory. An experienced artist can immediately tell whether you had painted a picture from life or from memory. A sound combination of on-the-spot sketches, notes, photographs, and memory will help you paint successfully, and in a professional style.

5. The Meaning of Colors

In his endless search for causes, reasons, explanations, and in his equally endless hope of finding answers to all questions and meanings in all phenomena, man must have stumbled on meanings of colors at an early date. Didn't a blue sky imply a pleasant day? Didn't dark clouds announce a storm or rain? Wasn't the green pasture more pleasing to the eye than the dried-out, dirty-brown vegetation? Wasn't red the color of blood? Wasn't white the purest possible color? Didn't darkness frighten people? Didn't the radiant sun resemble a huge disk of gold?

Later on, certain colors became associated with facts, events, ceremonies, titles. What may surprise us is to find that some colors have different meanings in various parts of the world.

Symbolic colors

We have ample evidence that colors began to have special meanings a very long time ago, and that those meanings were clear to the entire population. One of the most famous edifices of antiquity, the Ziggurat of Ur, built between 2300 and 2180 B.C. in the Tigris-Euphrates Valley, consisted of four main stories. The first story, rising from a white court, was black, symbolizing the underworld; the second was red, representing the earth; then came a blue shrine with a gilded top, symbols of heaven and the sun. We cannot be sure that these colors were applied at the time the Ziggurat was erected; they may have been added later, during a reconstruction. Nor have we absolute proof, right on the spot, of the meanings of the colors. Judging by the use of similar colors elsewhere, though, there can be no question of an accidental, or whimsical juxtaposing of colors. Those hues were selected for symbolical reasons.

What do colors stand for?

Most colors have several meanings, but these are closely connected with each other. Here are a few examples:

Blue stands for sky, heaven, and water.

Green may also be water, but it generally means hope, the color of spring, the renewal of life, feed for animals, and thus, food for humans. Green also means poison, because arsenic, known in the most ancient times, is green, and so are many other poisonous sulphates. In more recent times, many poisons were manufactured in green powder form, in order to differentiate them from flour and sugar. Green also symbolizes jealousy, and fear, both of them deadly poisonous emotions.

Red is the color of blood; hence, it represents courage, sacrifice.

Black is death, the underworld, mourning, desolation.

White is purity, chastity, but it's the color of mourning in the Far East. Isn't white as pure, or as empty as black? It's also the color of surrender, because a piece of white on a pole could be seen from a great distance, and could not be mistaken for any kind of flag. White means cowardice, too, because some people surrender for no other reason than to save themselves.

Gold or yellow means the sun, sungod, wealth. Yellow, however, also represents envy, treachery, cowardice. A yellow flag on a ship signifies contagious disease. In the Western world, yellow is the symbol of a certain type of sensation-seeking, destructive journalism, because the most vicious kind of news was printed on colored (yellow) paper to incite the curiosity of the public.

Purple is emblematic of rank and authority. It's derived from the ancient, expensive dye prepared from the purple fish (*purpura* in Latin, *porphyra* in Greek). Purple robes were worn by Roman emperors and, later, by high-ranking prelates of the Christian church.

Scarlet, a yellow-red hue of very high saturation, is also a sign of dignity and high rank. Originally, it was a kind of Persian broadcloth, used for tents and flags. The textile was often dyed this particular red and, eventually, the name of the cloth became synonymous with the color. Scarlet, however, is also applied in an opprobrious manner, to women of ill repute. This association is due to *Revelations* XVII, 1-6.

Blue, scarlet, purple, and gold are the colors of the priests' garments, as listed in *Exodus*.

Gray means colorless, figuratively as well as literally.

As you can see, a color is unlikely to have *one* rigid meaning. Actually, it may be more accurate to say that a color has a variety of connotations — or *implied* meanings — which the viewer may think of consciously or unconsciously.

Symbolical paintings are not as fashionable today as they used to be. Still, colors have their connotations, and most people have learnt these connotations in their childhood, just as they learn prejudices and superstitions. A great many buildings have their fourteenth floor right above the twelfth, because countless persons consider thirteen an unlucky number, and would not live on the thirteenth floor, or in room number thirteen. To many people, black is invariably the color of death. An

artist may or may not be superstitious; he may or may not believe in actual meanings of colors; but he ought to consider color connotations when he paints. The generally accepted meanings of colors often have a distinct bearing on one's liking, or disliking a painting.

Heraldic colors

As the Roman Empire fell apart and the Dark Ages set in, large numbers of individuals all over Europe established themselves in fortresses, from which they ruled their neighborhoods like small-scale emperors. These were the oligarchs, or robber barons. They needed distinguishing marks for themselves, their families, vassals, and followers. The importance of heraldry grew tremendously. Special artists were needed to design coats-of-arms; emblems, to be applied to every object.

The number of available colors, however, was very small. Even in the great classic civilizations, artists had a small palette, that is, a small selection of colors. These were carried through the dark centuries into the Middle Ages. The colors were combined with a much larger number of linear forms, symbols, and patterns that were logical, understandable abstractions of typical objects, such as castles, towers, lions, horses, rivers, mountains, and so forth. The heraldic colors were: gold or yellow; silver or white; red, called *gules*, from the fur neckpiece, *gole*, dyed red; blue, called *azure*; black, called *sable*; green, called *vert* (*green* in French); and purple.

The colors employed in coats-of-arms were normally used in the clothing worn by knights and their horses; they also became fashionable for the ladies. Ultimately, they evolved into national flags, the colors of which were taken from the coat-of-arms of the ruling family. In the case of important marriages, the coats-of-arms of both families were combined. Free cities, then guilds, universities, and clubs of all sorts, acquired colors, or color combinations of their own. You can recognize the owner of a racehorse, the athletes of a club, or a country, by their colors. In England, a man's necktie reveals his college or university. The meaning of colors is very great in every walk of life. We are so accustomed to them that we hardly notice them.

It may be interesting to realize that the small number of colors used in heraldry are *still* sufficient for the flags of hundreds of nations, including the many new ones established in our own age. Different arrangements of the colors, used mainly in horizontal and upright stripes, but also in many other patterns, and with a diversity of heraldic emblems, enable us to recognize the nations represented by flags, even though many countries have the identical three-color combination. Only orange and a light blue seem to have been added to the heraldic colors of the Dark and Middle Ages — a very small palette, indeed, for an ever-growing number of nations.

Psychology of color

Symbolic meanings of colors have psychological connotations. Nevertheless, colors affect us psychologically regardless of any symbolism. And the psychological

effect of one color can be very different from its symbolical significance. Black may signify mourning, but a black gown or suit, such as a tuxedo, is distinguished and elegant as well, depending upon circumstances. An orange or red gown is loud and flashy, out-of-place, when worn by a woman attending a funeral; but it may be proper and attractive when the same woman wears it at a gala reception or dance.

There is no absolute definition of psychological effects. A few years ago, I was wearing a charcoal-gray suit, a pair of gray gloves, a white shirt, and a subdued necktie. Standing in a subway car, I overheard two simple women whispering to each other: "He must be an undertaker." They shied away from me. They probably imagined I smelled of death. At the same time, I thought I was smartly dressed. After this experience, however, I always wore my charcoal suit with a bright-hued shirt and a very colorful necktie...and without gray gloves.

There can be hardly any question but that people prefer bright, sunny days to dark, rainy ones; a bouquet of fresh flowers is more attractive than a shabby trash-can full of waste; darkness will always suggest danger and mystery; fire and flames will never cease to be fascinating as well as frightening.

As we have become more conscious of the pleasant or unpleasant reactions to colors, we employ our knowledge in a practical manner. We now paint the walls of hospitals and schools a pale Nile-green, rather than the previously universal dull gray or buff or glaring white; we find the soft green hue more relaxing to eye and soul. We've discovered that a small room seems bigger if painted in light tones, and even larger if one of its walls is done in a different hue; the lighter color gives us a feeling of space, while the different color appears to open on another vista.

The Louvre in Paris, and other major museums in Europe, have long since painted the walls of various galleries in different hues: dusty-green, blue-gray, light maroon, and so forth, in order to make them more intimate and diversified. New York's Metropolitan Museum of Art tried the same idea a number of years ago, but people objected to the colors; they were accustomed to the drab uniformity of each gallery. Recently, though, The Metropolitan has redecorated some of its galleries in color and nobody seems to complain, since people have become adjusted to the idea of color. Paintings on colored walls are closer to us, or so it seems. The dry, severe atmosphere of a museum is softened.

Many an artist faces a client who doesn't dare purchase a certain painting, because the client believes it won't go with the color of the wall. This is a completely erroneous concept. The color of the wall has nothing to do with the painting, unless the wall color is absurd — orange, perhaps, with cobalt blue woodwork, or a Kelly-green wall with vermilion woodwork. One doesn't encounter such bizarre color combinations in the average household. On a normal wall, any painting you like will remain attractive, provided that it's in a frame which visually *separates* it from the surroundings.

The effect of colors on our environment, and thus on our psychological well-being, is just as strong on our personal appearance. Colors make a person seem taller or shorter, plumper or thinner. This is true for men as well as for women, but women have a better chance to take advantage of such possibilities. They may wear apparel of any imaginable hue, whereas we don't approve of a man dressed in violet, yellow, or cadmium orange, no matter how much these colors might improve his

appearance. Not so long ago, men were allowed to wear as many colors as women. Dancing the minuet in a great hall, lighted by two thousand candles, must have been a feast for the eyes. Attempts are being made to bring color back to men's wardrobes.

Let me warn you, though, not to go by the names of hues. Not only are there many shades of each, but the effect varies according to surroundings, especially according to the colors next to each other. Whether you buy apparel or have your home redecorated, consider the total effect, the *ensemble* you wear, the furniture and carpet as well as the walls and ceilings. Whatever effect is valid in the fine arts is just as valid in the so-called decorative or applied arts.

Utilizing psychological effects in painting

As I stated before, art is not a haphazard activity. Even if you paint spontaneously, such a painting is based on your knowledge and skill, rather than merely your natural talent. Knowledge and skill are what you learn from teachers, from books, from experience, from practice. If you understand the psychological effects of colors, you can employ them at your will, deliberately. You have a better chance of figuring out the ultimate effect. You can be sure, for example, that a painting executed largely in shades of gray, and much of it in black, with hardly any relief from the dark tones, will have a lugubrious, depressing effect on the average onlooker. If that is what you want, go ahead.

Art is not necessarily a joyful activity; a painting is not great because it's full of happiness; nor is it bad because it happens to convey a feeling of tragedy. This is the same as with theatrical productions: we have tragedies as well as comedies. But if you write a tragedy, you don't want the audience to laugh at it; and if you planned to write a comedy, you are shocked if it makes people cry. You're free to paint a tragic picture, employing all the colors that convey an emotion of sadness or despair.

Understanding all the features of your art is bound to help you in attaining your positive goal. I've seen outdoor paintings the artist wanted to be cheerful. I saw him do the work. But what happened? He painted the light, sparkling blue sky much too dark. He painted the foliage of trees in the background just as those in the foreground, a grayish green. The grass was blue-green; the earth, visible here and there, was almost black, with gray highlights. The tree trunks were all of the same rusty-brown color, in the distance, in the foreground, in the middleground. The entire painting looked dreary, dull, without any depth. It resembled an old, shabby, discolored theatrical backdrop. He missed his mark by miles!

I saw another artist, a very serious one, paint a funeral, showing people standing all round the grave, with their umbrellas open. He thought that funerals must be held on rainy days, the way they are usually shown in grade C films. He painted all the figures, all the umbrellas in black, the sky gray, but the grass was bright green, as if hit by the sun. There was something theatrical about the black silhouette-like figures. The onlooker felt that it was all a fake, a play-acting.

There are artists who know exactly what colors to employ. For example, the artist who paints cityscapes right after the rain. One can see the clouds disappearing; there are some puddles of rainwater, here and there, but the sun is out, and every-

thing looks freshened-up, cheerful. This kind of painting demands absolute knowledge of colors and their effects.

How to judge your color selection

There are two major criteria by which you might judge your selection of colors in any field: in dress, home, or painting. Neither of these criteria is easy, and neither of them is foolproof, but both of them are well worth trying, especially because there seems to be no alternative.

One way you can judge colors is not to look at your work, dress, or home for a few days, until your eyes are fresh enough to be able to see clearly. You can put a dress or suit in your closet. You can turn a painting face against the wall. You can shut your eyes when you're home, or try to look at a small corner only. The best idea is to go away for a while.

A few days later, turn your painting face out; take your apparel out of the closet; turn all lights on in your house, and look, just look. A great deal of self-criticism is possible in this fashion. In paintings, you can also turn the work upside down. You'll find that this simple trick is a help. You'll notice mistakes more quickly in an upside-down picture than in a rightside-up painting.

The other way of judging results is by watching the reaction of other people to your colors. Those people may be friends or strangers, but, preferably, they are people whose judgment you consider satisfactory. Don't tell them anything, just watch them.

Even though tastes are different, most people in your own circle are likely to agree on what is attractive and what isn't. If such general agreement didn't exist, the world would be absolutely unbearable.

Watch people's reaction to your taste and allow them to make suggestions. Listen to them carefully and consider their criticism and advice. But, for heaven's sake, don't permit every Tom, Dick, and Harry to destroy your ego by making devastating, unwarranted comments on your taste and artistry.

Characteristic color combinations

By a natural association of ideas, we think of spring as full of vivid color. Summer, in our memory, lives as a season of heat, without any delicacy of color. Everything is ripe, fully grown. Autumn, in a large part of the world, is a symphony of colors, ranging from still green leaves, through yellow, orange, violet, purple tones, to the dying brown foliage under a clear blue sky. Winter is either depressing with its barren earth, skeletonized trees, and shrubs; or invigorating with its bright blue sky and violet shadows thrown on the pure snow. Winter sports are characterized by gaily-colored apparel.

Dusk, dawn, rain, thunderstorm, snowfall, the sun coming out from behind clouds after a shower, the last orange rays of the setting sun illuminating the sky — all carry certain moods with them. These moods are reflected in the coloring.

Artists have been intrigued by seasons, and weather for centuries. The seasons have often been depicted in combination with the ages of man: childhood and spring; youth and summer; maturity and autumn; old age and winter. There is a challenge in painting the seasons. You can go outdoors and paint from direct observation during the greater part of the year. Few artists paint in the open in the cold season, but one can observe snowy scenery from a house or a shack. One noted New England artist has been painting nothing but snowscapes, and always from life. He drives around in a glass-enclosed studio, complete with heater, and all equipment built on the good, old chassis of a car. He stops wherever he finds inspiration. He doesn't seem to be interested in any other subject. When there is no snow, he takes a vacation.

One serious warning: don't paint outdoor scenes without a thorough observation of reality. Here again, the name of a color is very different from its actual appearance. You cannot paint a meadow glowing with red poppies merely by painting the lower half of your canvas green, and interspersing it with many bright-red spots. The result will look like a red-polka-dotted green textile. There are the usual differences of shades, values, and even colors, because a meadow is hardly ever the same vegetation all over.

We speak of a beautiful blue sky, but just how blue is it? Which blue is to be mixed with how much white in order to give us the blue we so admire? And the blue sky itself is not the same blue from top to bottom. What is the color of a dirt road? What is the color of an interesting rock formation? There is no dirt road color, there is no rock color. Everything has many hues, and many shades of each hue. In general, painting from memory alone is very difficult, and should not be practiced without sufficient knowledge.

Color in photography versus color in painting

Nowadays, we have color photography, a colossal invention, but beware of the colors in such photographs! They are either too blue, or too red, too brown, or too green, too yellow, or too purple. Shadows in color photography are usually much too strong and lack the variety of shades found in nature. Such pictures may be helpful in reminding you of certain basic colors of houses, hills, trees, flowers, but don't ever copy the colors as they are in the photograph.

I prefer black-and-white photographs. They are clearer. Details in them are not obscured by wild colors. I make pencil sketches and take notes referring to colors. If I have enough time, I also prepare a color sketch in watercolor or casein. It's a good idea to take color shots of cityscapes, especially in countries where houses are more freely painted in a much larger variety of hues than in the United States. In Italy and the Near East, there are almost as many colors as there are houses on a long street. In some sections, every floor of a house is painted a different color, and you can see previous colors where the paint is peeling off. Color photographs remind you of such hues, even though in a highly exaggerated manner.

The finest color reproductions of masterpieces give only a vague idea of the original coloring. Place such reproductions next to the originals and you'll have a

shock. The most distressing and damaging difference is between paintings and color slides made from them.

An international manufacturer of photographic equipment has prepared a complete set of transparencies of the famous ceiling frescoes created by Michelangelo in the Sistine Chapel of the Vatican in Rome. The scale of the transparencies is one-tenth of the original. The actual ceiling is about 45 feet wide by 150 feet long. The transparencies are displayed in the shape of the Sistine Chapel. Visitors can stand underneath it, and look up. It's a breathtaking experience, but entirely fictitious. Viewing the real frescoes can only come as a terrible letdown to those who have seen this advertising stunt. Paintings, on whatever surface, don't glow; the colors are opaque. There is no sunlight, or artificial illumination streaming through the ceiling of the Sistine Chapel. The special magic of such transparencies cannot be compared with the solid tones of the painted masterpiece, which has a completely different magic of its own.

Transparencies, of course, are ideal for reproducing stained-glass windows. They give a true idea of windows on a small scale, because windows are transparent, glowing in the light of the sun, during the day, when you view them from the inside; glowing from electric lights, at night, when you marvel at them from the outside. To be sure, there is still a great deal of difference between the magnificent stained-glass windows of a French Gothic cathedral and even the best possible slides. The fantastically divine atmosphere of such a cathedral is impossible to reproduce in slides showing the windows.

Recently, many art organizations have turned to color slides in national exhibitions. Instead of expecting artists to ship paintings and spend much money, without any assurance that their entries will be accepted, certain societies now require entries to be submitted in the form of slides. The judges must be aware that the quality and brilliance of colors in slides is quite different in the actual paintings. Where a color slide glows, the painting is often drab and dull.

But the artist can mail color slides for ten or fifteen cents, whereas shipping his work from a considerable distance, having it crated, uncrated, delivered, picked up, recrated, and shipped back by an agent, costs a small fortune. The idea of requiring color slides, therefore, is commendable. This doesn't mean, though, that you can take a color slide and turn it into a satisfactory painting, unless you have the necessary experience. Such experience takes a long time, and hard work to acquire, no matter how gifted you may be.

Colors in painting versus colors in a room

A painting must be a complete entity, so composed in color and design that it should stand by itself. A "colorful" painting is not a picture executed in all imaginable colors, but one which looks vivid, cheerful, without disturbing our eyes. It isn't necessary to have a painting match your drapery and furnishings in its colors. Whether you're an artist producing a picture, or a layman purchasing one, consider only one question: is the painting you're doing, or the painting you're buying, proper in subject matter for the particular place where it is to hang?

A painting of The Last Judgment, or a naked Leda with a voluptuous swan, or a picture showing the guillotining of men and women in the French Revolution, would not be suitable for a children's room, regardless of any color scheme. You probably wouldn't hang a very dark-toned painting on the wall of a pink-and-peach girls' room. Normally, though, all you have to watch is the right frame.

The frame separates — excludes — the surroundings from the picture. The color scheme of the painting, and the color scheme of the room can thus live side-by-side, in peace and harmony. It's nothing less than barbarous to insist that an artist change certain colors in his painting in order to "match" the colors of a room. I've heard of such cases. Don't let it happen to you, if you're an artist. And don't do it to an artist, if you're a layman.

6. Characteristics of Manufactured Colors

In the first five chapters of this book, I've discussed the history, the theories, terminology, and meaning of colors. I've shown their vital role in perspective; described the many optical illusions caused by colors or color combinations, and how those optical illusions might help artists to avoid visual mistakes, or to achieve interesting results. I've explained the difference between color theories established by physicists and the practical use of colors by artists. Now, I am going into the factual features of colors: the paints with which artists, designers, decorators work. I am going to describe the materials and media, and explain the purpose, the use, the physical properties, potentialities, and limitations of each.

A brief survey of painting media

Prehistoric man noticed that the color of the earth was varied, and, after a rainfall, that wet earth could be smeared or spread on the rocks to imitate the colors of real things.

Later on, he found that fat dripping from roasting meat made the earth easier to use as paint, and that such paint would become permanent. As he began to employ colors on utensils and perhaps on some clothing, too, besides painting on the walls of his cave, he found other sources of paint in fruits and vegetables.

Tempera

At first, man applied all colors with water only. He discovered, no doubt by accident, that eggs — especially eggwhite — became hard, almost unremovable, and that powdered colors mixed with eggs could thus be turned into permanent paints. Eggs could also be used upon already painted surfaces as a protective varnish.

Colors mixed with eggs are called tempera, but similar mixtures may be obtained by combining colors with various gums or glues, such as rabbit skin glue or fish glue. Some primitive tribes are still using pigments — colored substances — mixed

only with water; but most ancient peoples realized that pigments must have a binder, a substance which makes them adhere to the surface on which they are used.

Encaustic

Beeswax, as both a binder and a protective varnish, was also discovered at an early date, probably soon after man found honey to his taste. Man must have noticed how easy it is to melt wax, how quickly it cools and dries, and how well it protects whatever it happens to cover. Pigments (powdered colors) mixed with wax are called encaustics, and have been used in many parts of the ancient world.

There's much overlapping in the development of paints. Wax may have been employed as a protective coat over tempera, before being used as a binder for pigments. Discoveries seem to have been made almost simultaneously in various sections of the world; or skills and knowledge were carried by adventurous persons from one place to another.

Enamel

Enamel, a vitreous (glasslike) compound, probably discovered at the same time as glass, was employed by the ancient Assyrians, mostly on bricks decorating the fronts of temples and palaces. Egyptians used it on pottery. Enamel later became a highly-treasured permanent decoration on metallic objects, in China as well as in France.

At one time, enamel was used almost exclusively on jewelry and objects of art. Now, enamels are utilized on articles and materials exposed to the weather.

Fresco

Fresco painting—really a kind of watercolor applied to wet plaster—was evolved directly from tempera, when workers tried to make white plaster walls look less harsh by applying a coat of watercolor. They realized that water paint is solidified by the drying lime, and becomes waterproof. Fresco was employed by so many ancient peoples that it isn't possible to tell who used it first or where.

Oil paints

Although oil painting, as we understand the term, was introduced in the fifteenth century by the famous Flemish masters, Hubert and Jan Van Eyck, it also goes back many hundreds of years.

Some Egyptian mummy cases appear to have been varnished with an oil, rather than with an egg varnish. The earliest mention of the use of fast-drying vegetable oils in painting is in a book by Aetius, a medical writer, from the early part of the

sixth century of the Christian era. He recommends nut oil for protecting gilt surfaces and encaustics. We have much evidence, from the eighth century to about 1100, of the use of such drying oils in painting and in varnishing. The binders in our oil colors are linseed and poppyseed oils.

Watercolor

Watercolor, as I stated before, was known since the most ancient times. Artists illuminating papyrus scrolls in Egypt, silk and ricepaper scrolls in the Orient, manuscripts in the Dark and Middle Ages, all worked with a water medium, usually of an opaque kind.

Present-day aquarelle, often called transparent watercolor, did not evolve from these forms of painting, though. Aquarelle is the direct descendant of the pen-and-ink-wash drawings made by artists of the Renaissance and Baroque. An English artist, Paul Sandby (1725-1797), is called the "Father of English Watercolor." He must actually be considered the father of all Western watercolor. In modern watercolor, gum arabic (a water soluble glue) is the binder, mixed with very finely powdered pigment.

An important principle of transparent watercolor is never to work with white paint, which destroys the transparency, the charm of the medium.

Gouache

Gouache (pronounced *gwash*) is an opaque watercolor. The pigments usually contain some honey, besides gum arabic; the paint is applied without much water, and you have to mix a color with white if you want to make it lighter. White is used in gouache as in oils. Miniaturists often work with gouache.

Pastel

Pastel is erroneously believed to be the invention of the German landscape painter, Johann Alexander Thiele (1685-1752), but we're sure that at least Guido Reni, the noted Italian master — who died more than forty years before Thiele was born — had already worked in pastel. This medium is pure powdered pigment, compressed into small, cylindrical sticks. Recently, semi-hard pastels have been introduced. These contain a small amount of wax. The medium didn't become popular until 1775, when pastels by the Swiss artist, Jean Etienne Liotard, were shown at the Royal Academy in London.

Casein

Casein is an ingredient of curdled milk, used by cabinetmakers as a waterproof

glue for at least eight hundred years before it occurred to someone to employ it in paint. First, in the 1930s, it was marketed as a white housepaint, and it had a nauseating odor. Later, the odor was eliminated and casein was produced in tubes, exactly like oil colors. It dries rapidly and is quite waterproof.

Casein can be used as a watercolor but, unlike watercolor, one stroke covers another because the color is relatively opaque. Changes and corrections are easy, not as in transparent aquarelle. Today, tempera, gouache, and casein are almost identical. Some artists add eggwhite or the whole egg to casein to make it harder.

Polymer

The latest medium is polymer, the general name for all kinds of plastic colors, which are marketed under various trade names. Prepared mostly from diverse combinations of acrylic and vinyl, these colors are applied with water, but dry almost instantly and dry waterproof. They can be handled like watercolors or oils, in any technique, thick or thin, opaque or transparent. They can be varnished with plastic varnishes, a feature which makes polymer paintings or objects painted in polymer literally scuffproof.

Polymer is employed in commercial fields as well as in the fine arts. It works on any surface, except an oily one. Some plastic colors are produced with an oil soluble base; these have to be thinned and applied with oil or turpentine. The only advantage of oil based polymer over regular oils is that the polymer dries faster.

Pigments we use

Pigments are the coloring matter we need for paints. They must be substances which can be powderized so that they can be mixed with a liquefied binder. There are four sources of pigments: natural, artificial, organic, and inorganic. It's probably simpler, though, to list them as earth colors, mineral (or metallic) colors, organic colors, and chemical colors.

Earth colors

Earth colors are not really made of earth. The name was applied to them when earth was believed to be one of the four elements constituting the world, the other three being air, water, and fire. Needless to say, this belief was completely wrong.

Earth colors are prepared from various iron ores, but we call them earth colors, because they are found practically anywhere, in inexhaustible quantities, and they are obtained on the very surface of the earth. They range from yellow through diverse shades of buff, brown, and green, to red, and violet. The colors may be used as they are, but many of them (like raw sienna and raw umber) can also be burnt, a procedure which gives us such hues as burnt sienna and burnt umber. None of these colors is very brilliant. For example, Indian yellow (an earth color) can never be as

vivid as a cadmium yellow. Earth colors are lowest in price, in all brands, and they are permanent. Most of them are absolutely necessary for every fine arts painter.

Mineral colors

Mineral colors are obtained from metallic elements. White is made from lead, zinc, and titanium. A beautiful blue, and an equally lovely violet, are made from cobalt. Cadmium gives us the most valuable pigments of yellow, orange, and red. Chromium oxide provides us with a brilliant green.

Most colors made from these metallic elements are permanent. Since they have to be mined and carefully processed, they are costlier than earth colors, but are a must for fine artists who cannot afford to work with colors which turn dark or change completely.

Lead chromates, however, from which the so-called chrome colors are prepared, are not permanent. Chrome yellow and chrome orange look like cadmium colors of the same names, but darken very quickly. Don't use them in fine arts.

Organic colors

Organic colors are made from animal or vegetable matter. Many of these were used in past ages. Red, especially, was prepared from animals. Even today, carmines —a kind of red employed in watercolor—come from animal matter. A vegetable substance, madder, is also used in aquarelle. None of these is truly reliable, and manufacturers are trying to replace them with metallic or chemical pigments.

Chemical colors

Chemical pigments are born in laboratories. For a hundred years or so, chemical pigments were unreliable. They looked fine when applied, but faded or changed rapidly, often ruining the whole work. Furthermore, one chemical would react to another one, and destroy the effect planned by the artist. Before World War I, certain colors bore warning labels: *Do not mix with such-and-such colors!*

Today, the major manufacturers of artists' colors, and even of household paints, have chemists to check all qualities of their products. As a result, chemically created pigments are often more uniform in color and quality than natural ones. Mars colors are a notable case. All Mars colors—yellow, red, violet, black—are fully reliable. Reliability, however, doesn't necessarily imply brilliance. If you want truly bright colors in reds and yellows, spend a few extra cents, and buy cadmium colors.

Manufacturers indicate the permanency of each color on the label or in their catalog lists. In a good brand, the lack of *absolute* permanency means only that a certain color is bound to weaken a little if you expose it to the sun for a long period. In normal circumstances, even these colors are quite satisfactory. After all, paintings are normally intended to be displayed in the home, not outdoors.

In our age, all fine arts colors marked *permanent* are absolutely intermixable. They may be mixed with any other color without fear of some adverse chemical reaction. Furthermore, each brand may be safely mixed with any other brand, whether the colors are manufactured in the United States or in Europe. There is only one exception: polymer (plastic) colors do not always mix with other brands. Some do, some don't. You might inquire when you buy them. Or you can test them. If they are prepared from similar ingredients, they'll mix easily with the brush. If their ingredients are not harmonious, you'll find that the paint doesn't mix smoothly; it crawls or curdles a little as you try to brush it.

How colors were made in the past

Until early in the nineteenth century, artists prepared their own colors and other art materials, or had apprentices do that work. The number of colors was limited because only natural pigments were employed. Artists of the Renaissance and Baroque periods, from the fifteenth to the eighteenth century, worked with a palette of six to twelve hues. Artists of the Venetian school hardly ever used a real blue or green; they preferred the golden, warm tones which were in keeping with the luxurious life of that fabled city on the lagoons.

Each school, that is, each group of painters, had its own special likes and dislikes in color. Very often this preference was due to the fact that certain colors were unavailable. Thus, we can usually, if not always, tell where a certain painting must have been painted. The period can also be often recognized by the fact that a certain color — not introduced until a certain date — is employed in the painting. The preparation of colors and varnishes was painstaking. All materials were tested by the master himself. As a result of this loving and understanding care, paintings that have survived are in an amazingly fine condition.

By the middle of the nineteenth century, most artists were producing small easel paintings they hoped to sell to *bourgeois* clients. The days of large paintings and mural commissions seemed to be over. There was neither room nor money, nor a demand for such works on the part of the rapidly-growing middle class, the new patrons of the arts. There were no longer great studios, where a master worked with the help of scores of assistants. Painters now went outdoors and dashed off pictures. They had no time, no space, no patience, no inclination to bother with preparing a few tubes of paint. The labor of making paints was separated from the art of painting pictures.

Craftsmen specialized in producing paints. For a while, there was a deterioration of quality. Colors were not tested in regard to purity, permanence, and mixability. Many chemically obtained colors turned dark or light within a short period. Some colors dried faster than others, and when a fast-drying paint was applied over slow-drying ones, cracking was inevitable. Observe paintings done towards the end of the last century. Most of them are crackled all over.

As the demand for colors grew, manufacturers began to compete for the artists' trade by a large diversification of hues. The roll-up metal tube was invented to replace the clumsy pouches, made of animal bladders, in which paint used to be mar-

keted and kept. There were disasters. The biggest, probably, was the introduction of asphalt black. It was a beautiful, warm black. Unfortunately, asphalt has a very low specific gravity — it floats on water — and, after a while, rises to the surface of the painting. In the passages where the artist originally mixed asphalt with colors to get the right shade, the asphaltum eventually turned everything dark. Many paintings, executed before the turn of the twentieth century, are almost totally black now, with a few white spots glowing in the darkness. These spots remained white because there was no asphalt in them.

After a while, manufacturers and artists realized that this haphazard way of producing paints could not go on. Today, major manufacturers guarantee the purity and mixability of their colors. Many of them list the ingredients on the label of each tube. Others list them in their catalogs, available to all artists. It's now entirely up to the artist to work with the right colors and other materials.

Permanence is, of course, not necessary in the so-called commercial field. Posters and illustrations are made for the purpose of printed reproduction. It doesn't matter if the colors of the originals fade or darken once the mechanical reproductions are finished.

Number of colors

The color charts of manufacturers are much smaller now than they were around the turn of the century, but there are still some sixty colors in oils; about forty in watercolor, tempera, gouache, and casein; about thirty-two in polymer (plastic) paints. Such factory-produced colors are more uniform than the ones you could possibly mix yourself.

What's in a name?

A color by any other name would be the same, but artists and manufacturers all over the world agree on a number of well-established names. The so-called earth colors, such as raw and burnt sienna, Venetian, or Indian red; colors made of metallic elements, such as cadmium, cobalt, titanium; and chemically produced pigments, such as phthalo (phthalocyanine) blue, and green, are known under the same names in Cincinnati and Cairo, Berlin and Benares, Toledo and Tokyo.

For business reasons, though, every manufacturer tries to market certain hues as its own specials. These usually carry the manufacturer's name as the name of the color: Jones Blue or Smith Red, etc. You may be sure that, pretty soon, Jones will come out with a new red, while Smith will advertise a new blue. You may also be assured that the two blues are reasonably alike, and so are the two reds. As for baby-violet, peacock-green, aqua-blue, etc., such names are used by dress manufacturers to promote new shades in the world of fashions. These names are meaningless to artists unless they see swatches of the colors. An experienced artist can quickly mix the same hue from available standard colors — the same colors from which the fashion designer had mixed them.

Inherent properties: opacity, transparency

Regardless of the medium — oil, watercolor, casein, polymer, tempera, gouache, pastel — the main property of each pigment is its opacity or transparency. Certain colors are listed as *semi-opaque* by some manufacturers; others call the same colors *semi-transparent*. In all likelihood, the two terms refer to exactly the same property. It's of great practical significance to the artist to know which color is opaque, which is transparent, which is halfway between the two. Otherwise, he'll waste time and material on the impossible, such as trying to cover black with alizarin crimson, or blue with zinc white. Both alizarin crimson and zinc white are very transparent, without sufficient covering power.

Although every medium requires a different technique of application, basic properties remain identical and have to be remembered. Casein dries fast and fairly waterproof; thus, it's possible to go over one color with an entirely different one as soon as the first layer is dry. Watercolor is called transparent as a medium, because we apply it in washes one on top of the other; but that doesn't mean that each color is transparent. Not at all. The same colors are transparent, opaque, or semi-opaque (semi-transparent) in every medium. Moreover, every color, in each medium, can be transparentized by adding vehicles: water to water-based paints; linseed oil, turpentine, copal glazing medium, or some other liquid, to oils. There are transparentizers, such as *gel*, now available in each medium.

Nonetheless, the inherent opacity or transparency of a color plays an important role in painting. First of all, a basically transparent color may be employed as a glaze (a transparent layer, like colored glass) without any effort. Secondly, it's important to know its opacity or transparency because you cannot make a transparent color opaque, no matter what you do, without changing it. The moment you mix it with an opaque color, it becomes a different hue. It's necessary, therefore, to plan your work according to the opaque and transparent qualities of your colors. Don't think that this will handicap you, that it will destroy your spontaneity. What does destroy an artist's spontaneity, and even his general inspiration, is to find some technical hurdle he's unable to surmount, because he doesn't understand it.

Polymer dries and becomes waterproof in a minute or so. This means that you can go over black with blue, or over blue with yellow, without stirring up the first layer, and messing up the second layer. But you still cannot paint alizarin crimson over black or blue and expect it to look like alizarin crimson. You can, however, paint white over black or blue, let it dry a couple of minutes, then paint alizarin crimson over the white as if it were the original clean support.

In transparent watercolor, artists work with thin, literally transparent, washes. Nevertheless, you can quite easily paint cadmium red, orange, or yellow spots over other watercolors by using very little water and more paint than usual, because cadmium colors are sufficiently opaque. An experienced aquarellist saves himself a great deal of trouble by planning his work according to such possibilities.

In all painting media, the use of transparent colors as glazes adds depth to your work. The beauty of paintings by old masters is due to a very large extent to the fact that those artists executed an underpainting first, often in tempera, then glazed it in oils. Many artists now do a casein underpainting, and glaze it in oils or in polymer.

The degree of opacity also has a bearing on the mixing of colors. Certain opaque hues are amazingly powerful. For example, you would need an incredible heap of white to make cadmium yellow noticeably lighter. On the other hand, the slightest touch of white is enough to turn alizarin crimson into a pale pink, in any medium. (Provided, of course, that you have a strong white, such as titanium or flake, not the very weak, transparent zinc white.)

Some manufacturers indicate the opacity, transparency, or semi-opacity of each color on the label in oil paints. Others offer folders and catalogs, in which such properties are marked for watercolors as well as oils. As I've stated before, the same colors are opaque, the same colors are transparent, in each medium. You'll learn from experience, without looking at labels or catalogs. Observe what you're doing, look at the results. This is the best advice I, or anyone else, can offer you.

Color permanence

As for permanence, responsible manufacturers employ only the most satisfactory ingredients. Oil colors turn yellowish with age, because both linseed oil and turpentine become yellowish. Such a change is uniform, and the total effect of a painting remains the same.

We become accustomed to the golden tone, usually, though erroneously, associated with Rembrandt. All oil paintings acquire a somewhat mellow tone with age; in Rembrandt's works, the sharper contrasts between small, glowing, mysterious lights and much shadow enhance this effect. Like the Venetian artists, Rembrandt favored warm tones. Still, when cleaned, his works are cooler than you'd expect when looking at his age-darkened paintings. The so-called "Night Watch," really titled *The Sortie of the Guard Company of Captain Frans Banning Cocq*, is a "Day Watch" since it has been cleaned.

Certain manufacturers assert they now have a non-yellowing turpentine and linseed oil. Even if time proves this claim to be valid, you'd have to make sure that all your materials, canvas, colors, varnish as well as the linseed oil and the turpentine, or any other liquid medium, is non-yellowing. As long as one single ingredient is yellowing, your oil painting is bound to darken with age. It may take a little longer for it to become quite dark. Because it's inevitable, there's no point in losing any sleep over it.

7. The Colors You Need

Let's state at once that there's no such thing as a one-and-only ideal palette, that is, set of colors. Each artist must decide for himself which colors suit him, his subjects and his temperament best. Some artists use dark colors, others use mostly light ones. Artists' tastes also change in the course of years. It is, however, important to know what colors are generally accepted by professional artists as satisfactory in respect to variety, permanence, brightness, and covering power.

One point ought to be brought up. Manufacturers offer many shades which can be mixed from other colors, because there may be a demand for such extra colors by muralists or decorators. Such artists often have to do large panels and they need big quantities of certain colors. They find it easier, and more reliable, to buy such hues ready-made than to mix them.

Can you work with just primary colors?

The three primary colors — red, yellow, and blue — are enough for the physicist, but don't suffice for the artist. How can an artist work without white? Even in transparent watercolor, where purists never employ white paint, they do use white areas — the white of the paper on which they work. There are some artists who think black is not a color, but how can you obtain certain shades of colors without mixing them with black?

Long before Newton came forth with his theories on light and color, Leonardo da Vinci (1452-1519) knew that philosophers considered white the *receiver of colors* and black as *deprived of color*, but he asserted that the artist needs six colors: white, the color of light; yellow, the color of earth; green, the color of water; blue, the color of air; red, the color of fire; and black, the color of total darkness.

The concept that earth is yellow, water is green, air is blue, fire is red, may sound naive to us, but Leonardo was fundamentally right in his view against the philosophers. Sir Isaac Newton (1642-1727) had enough sense not to impose his theories on artists, but Johann Wolfgang von Goethe (1749-1832), the German genius, denounced Newton's ideas on color with the same blind fanaticism with which

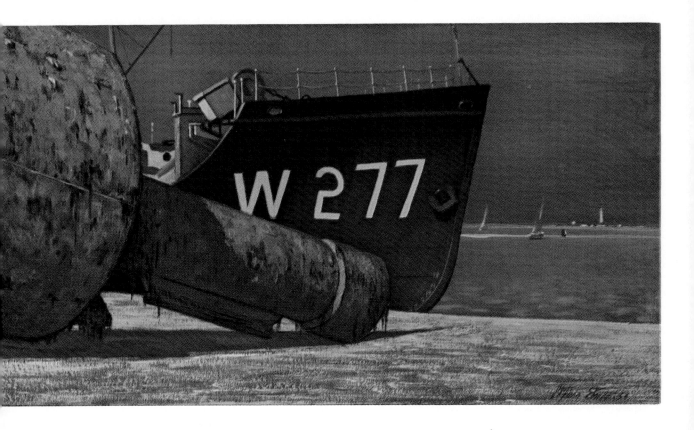

W 277 by Stephen Etnier. Oil. 20 x 40.

This painting might be called a marine still life. The prow of the boat is partly covered by a monumental piece of orange-red maritime mechanism glowing in front of the almost black hull, the dark green sea, and the dark, grayish sky. The composition is simplicity itself; so are the colors. But much sophistication and skill has to go into a work like this which requires a special love for, and understanding of, the sea and the things that go with the sea.

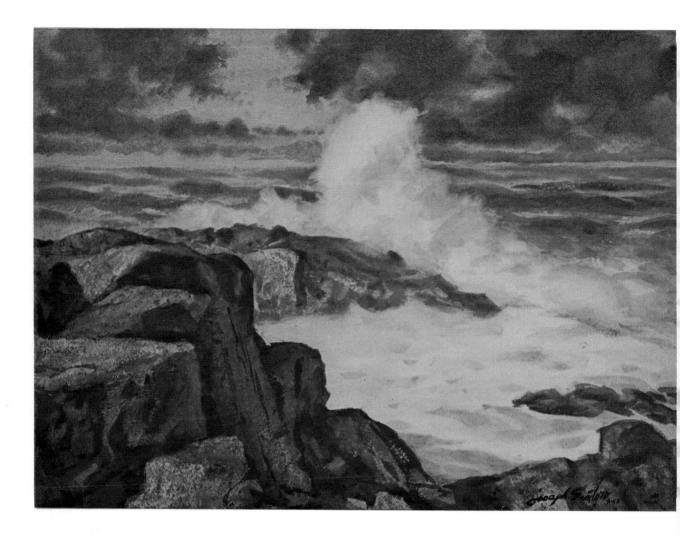

Pounding Surf by Joseph L. C. Santoro. Watercolor. 22 x 28.

This seascape, painted in watercolor, is entirely different from Copeland's (shown on the following spread). Rocks, sky, and sea are more varied in hues, and the viewer is closer to the surf; he appears to be standing on one of the rocks and might get wet. It's interesting to see the similarity between the clouds and the waves. Almost the whole sea is repeated in the sky. The colors are strong and the rocks have fine textural details against the smooth foam of the surf.

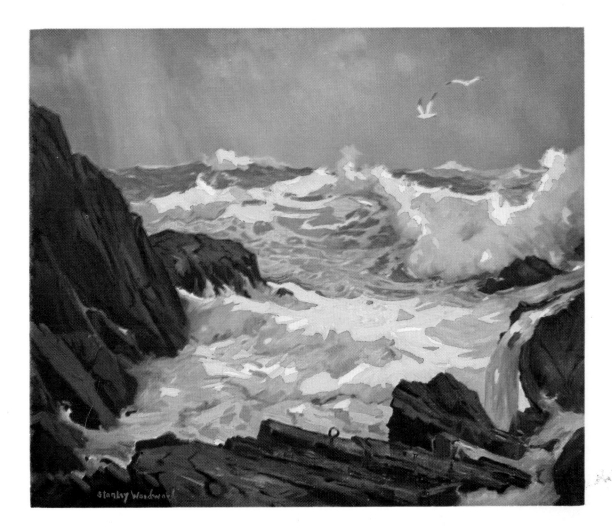

The Conflict by Stanley Woodward. Oil. 28 x 32.

The title of this oil is quite descriptive. The rocks and the heavy waves pouring between them are evidently fighting it out among themselves. The sky is remarkably peaceful, although strange in hues. Two seagulls appear to pay no attention to what's going on below them. The colors of the sky are reflected in the water, in the foam, and in the rocks as well. The brush strokes follow the direction of the surf rolling over the rocks.

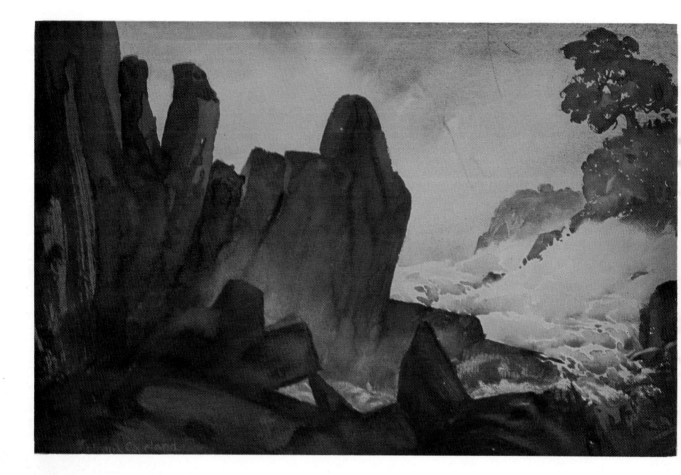

After the Storm by J. Frank Copeland. Watercolor. 14 x 21 1/2.

A startling proof of how dynamic an aquarelle can be, even when applied in transparent washes. You feel you're protected from the onslaught of the waves by a fortress of natural rocks. The waves are done in pink, green, blue, and violet washes. A green tree on a grass-covered rock in the background indicates the size of the rocks on the near side. The yellowish sky glows behind the brown and purple rock formations. Every part of the picture, and every color contributes its share to an impressive aquarelle.

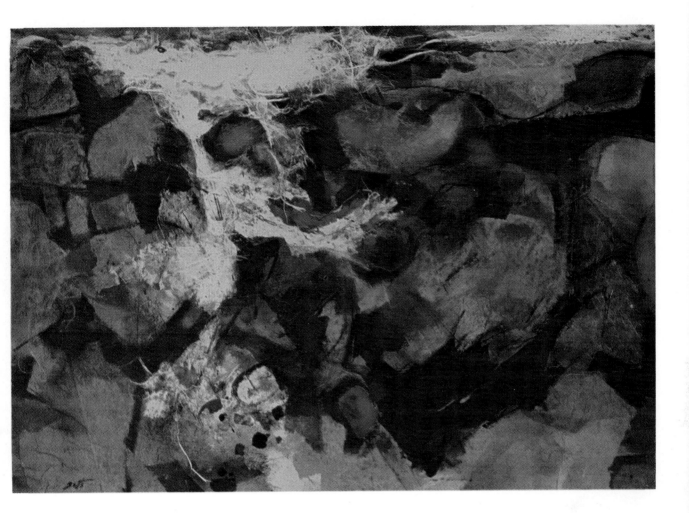

Rocks and Surf by Edward Betts. Mixed media. 23 1/2 x 33 1/2.

This mixed media painting is a symphony in red-orange-yellow rocks, with nearly jetblack crevices, a few spots of green, and the surf attempting to invade, or to destroy them. In a semi-abstract style, the artist renders the same conflict other painters approach in a realistic fashion. The colors are more or less arbitrary. You cannot expect realism in hues, where realism in form is abandoned or minimized. The question in a painting like this is merely, did the artist achieve the effect he aimed at? For those who demand photographic fidelity, he didn't. For those who believe in imagination, he did.

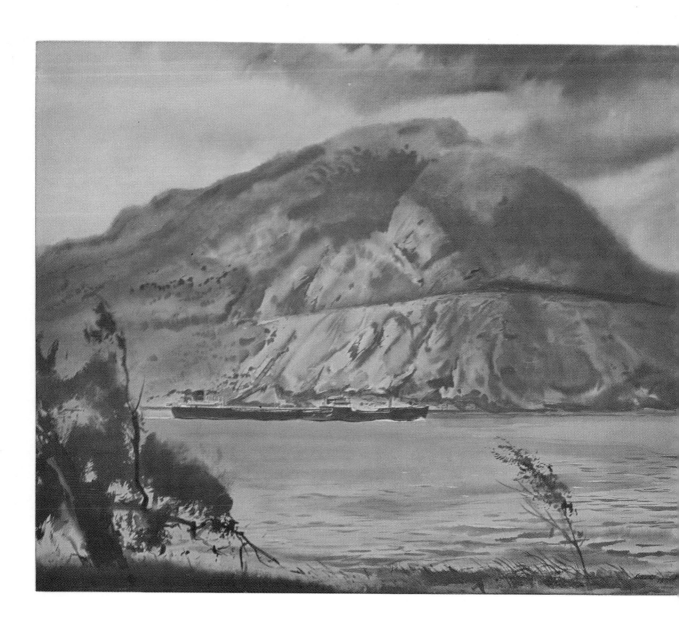

Storm King by John Gould. Watercolor.

This aquarelle makes full use of the wetness of the medium in its depiction of a rainy day. Clouds and the silhouette of the mountain are blurred. Rock formations, the black tanker on the Hudson River, trees on the near shore, are applied with a drier brush and more paint. Despite the grayish haze over the whole scenery, you can recognize the green of the vegetation, the red of the smokestack, and the red waterline showing between waves. Place a piece of pure, bright red next to these, and pure bright green next to the green sections of the painting, and you'll realize that there's a considerable difference in intensity and value of the pure colors from those in the picture.

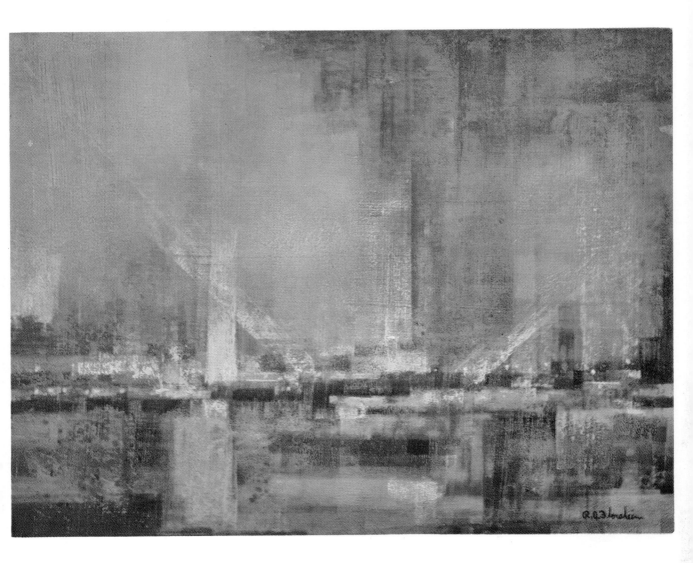

Illuminations by Richard Florsheim. Oil. 18 x 24.

Forms of buildings are applied with sharp brush strokes in this oil. There's no detail of any kind. Nevertheless, you know you're viewing a harbor with docks, ships, a few tall structures. The wide expanse of the sky is ingeniously broken up by colors that seem to be shadows of buildings, aerial reflections. A couple of diagonal streaks of light not only convey the idea of illumination — perhaps by big spotlights — but eliminate the severe vertical aspect of the picture. All tones are pastel shades, but with sufficient contrasts in values and colors to put life into the picture. Collection, Edgar Roedelheimer. Color plates, courtesy Time, Inc.

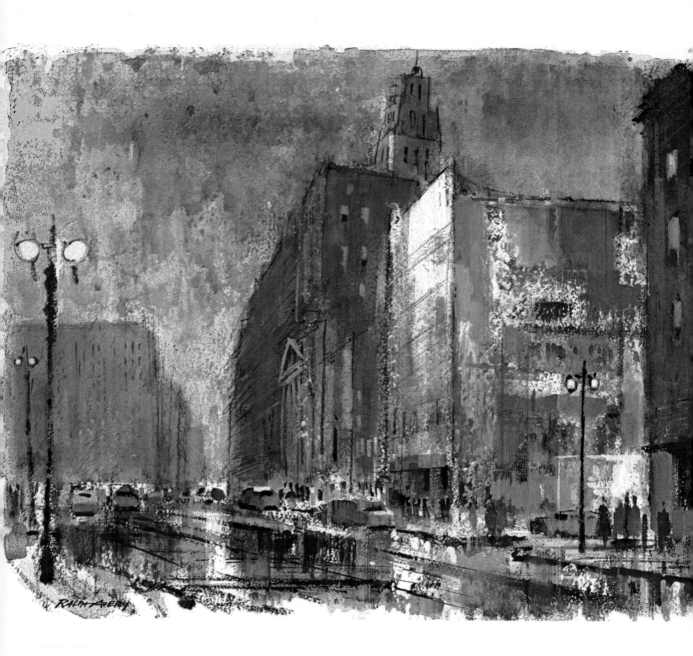

Power Tower by Ralph Avery. Watercolor. 12 x 16.

This watercolor utilizes the whiteness of the rough paper, by allowing it to sparkle in many spots. Color perspective is rendered with the correct values. Dark buildings farther away aren't as dark as nearby, but you still know they're made of dark materials. The most distant houses are only a couple of shades darker than the sky. Vertical strokes indicate rain. The windows are barely suggested, but in such a manner that they look like windows, not like pieces of paper pasted on the walls. Colors of automobiles and pedestrians are varied, but toned down, so that nothing jumps out of the picture. Courtesy, Harry H. Wisner.

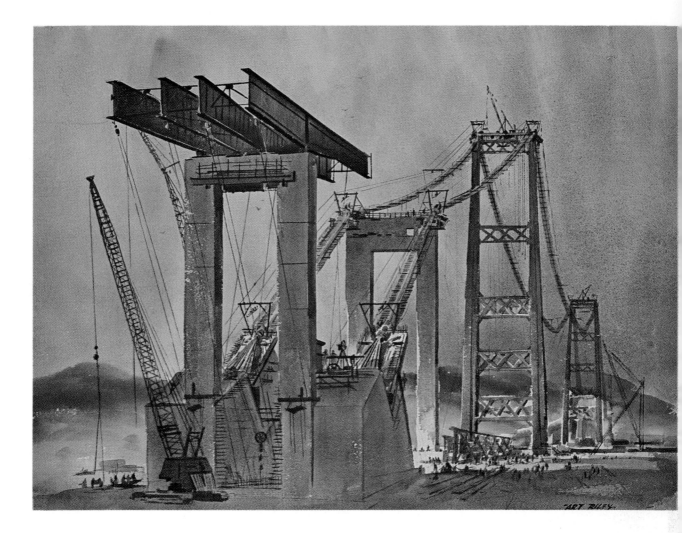

Vincent Thomas Bridge by Art Riley. Watercolor. 21 x 29.

This is an industrial-architectural subject in watercolor. A work of this kind demands a full knowledge of linear perspective. The cold, precise theme, however, is transformed into a creative painting by the dramatic hues. The sunlight hitting the green meadows, hillsides, and the base of one of the steel pylons, enlivens the grayness of the other structures and the ominous sky. There are bright spots among the workers. The smallness of these figures gives an impression of the immense scale of the bridge. No color is used in its pure form. Washes of various hues are evident in every section of the picture.

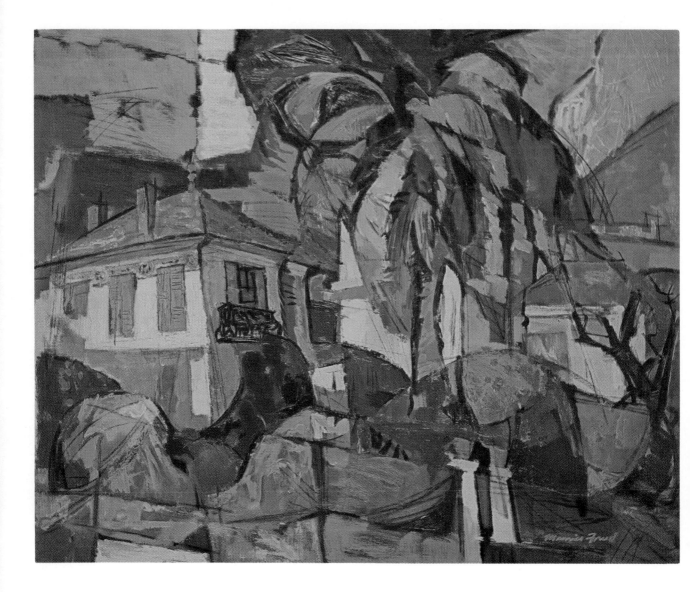

Winter Afternoon, Côte D'Azur by Maurice Freed. Oil. 25 1/2 x 31 3/4.

The word winter *may be puzzling, if you don't know that it refers to the mild climate of the French Riviera. No architectural subject can be rendered without at least some sharp delineations, yet this oil painting is a truly pictorial scene. Each part of the somewhat stylized design contains a wealth of hues and shades. The use of warm and cool colors — blues, greens, grays, and violets, alternating with red, orange, and yellow tones — gives the painting a decisive spatial quality.*

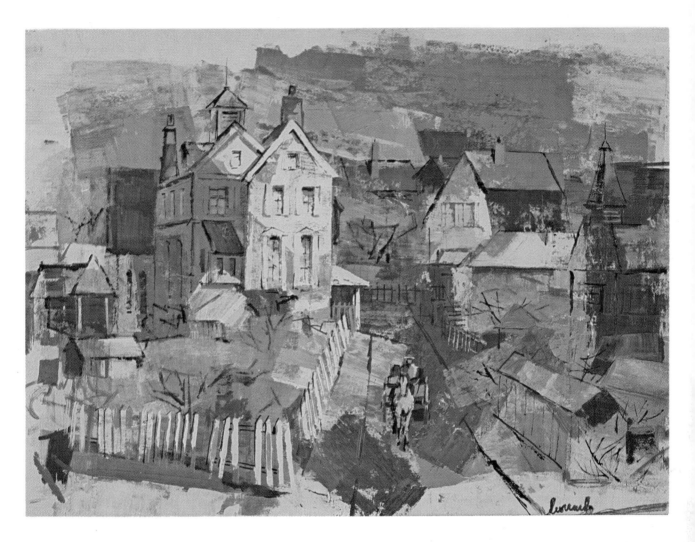

Corner of Nantucket by Jack Leonard. Casein. 20 1/2 x 28 1/4.

Even though this casein painting has no truly dark hues, it offers a variety of soft tones so well selected and correlated that you feel as if you were being driven around the town among quaint, old buildings. You notice a picket fence here, a few windows there, a roof, a couple of trees, and so forth. Again, cool and warm colors alternate, suggesting (rather than actually depicting) lights and shadows. This painting clearly shows that strong contrasts aren't necessary for the creation of artistic interest.

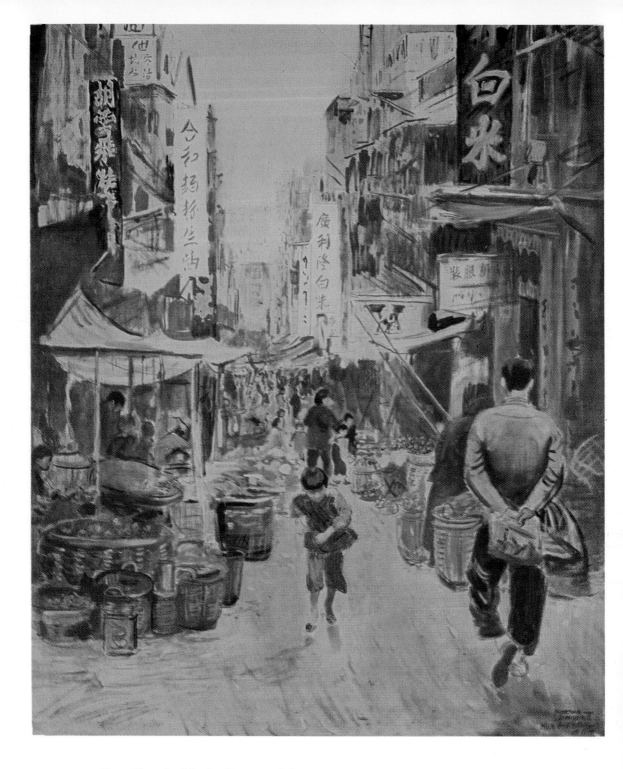

Hong Kong by Martha Sawyers. Oil. 35 1/2 x 30.

If this painting doesn't give the tiny details you expect to find in a snapshot, it does offer something hardly possible in a photograph: motion and atmosphere. Here's a typical market street in the British Crown colony; stalls, fruits, vegetables, people, with the typical Chinese signs. Linear perspective is quickly established by the diminishing sizes toward the back. Color perspective is achieved by painting distant structures a very light blue, only a shade or two deeper than the sky, while objects nearby are in darker, warmer reds and browns.

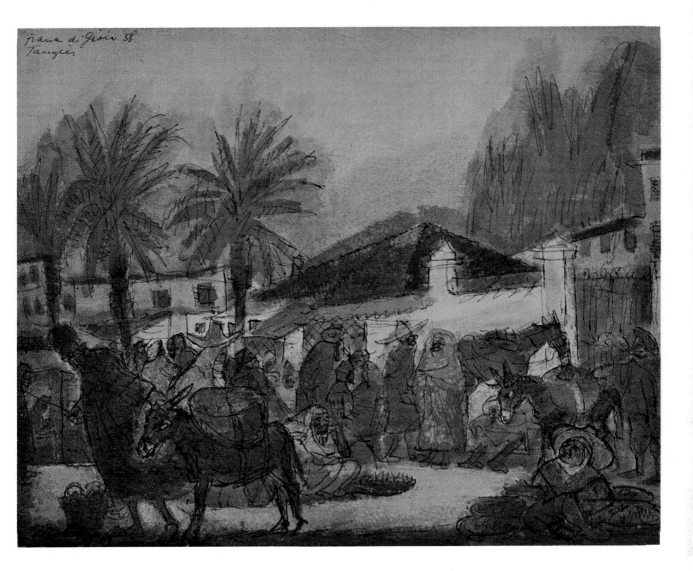

Market in Tangiers by Frank di Gioia. Pen, ink, and watercolor. 9 1/2 x 12 1/4.

Here is a pen-and-ink-watercolor sketch of a crowded Muslim market scene in North Africa. The blue sky and the blue-shaded houses cause the red-roofed white house in the center to stand out with its brightness. The dark, but warm, brownish grays of donkeys, men, and shadows in the foreground add to the feeling of heat. The elliptical path in reddish yellow carries the light to the ground and breaks up the crowd of men and animals.

Cove Hill by Don Stone. Watercolor. 14 1/2 x 28.

This is a true watercolor, done in wet, transparent washes. Note that the white of the paper is left unpainted for the highlights on the snow. The rest of the snow-covered hill is in Payne's gray, and alizarin crimson washes. The sky is applied very wet, in contrasty light ocher and dark gray tones. The youngsters and the sleighs are executed in crisper strokes; the twigs and trees are painted with a fine-pointed, dry brush. Distant hills and vegetation are light blue and lavender. The whole picture is a real symbol of winter.

Haystack at Railroad Ranch by Ogden M. Pleissner. Oil. 40 x 30.

In this completely finished painting, every detail, each color and value is executed. Nothing is left to the imagination. Perfect perspective in line and color, the brilliant highlights on the figures and on the mechanical contraptions, everything is more vivid than a photograph could be. The cloudy sky, with sunlight coming out only to hide again, throws a picturesque mood over the scenery. Red in a man's shirt, in a saddle blanket, in the tractor, and in the shadow of the haystack adds sparkle to the view.

Color in Landscapes with Figures 95

Illustration by Donald Teague. Watercolor.

This is an impeccably detailed watercolor, in which moon and stars shed a mellow light on everything, while a warm light shines through the door and windows of the building. These orange spots and the red-violet coach stand out against the dark blue sky, and the blue-brown buildings. Had the artist painted the coach blue or green, it would have lost its importance. Had he painted it orange or yellow, it would have become too loud. The moonlight effect would have been lost or diminished.

he expressed his admiration for Napoleon. According to Goethe, "Colors are a manifestation of light and dark. There are two fundamental colors: yellow, and blue; one is next to light, the other next to darkness. Red was produced when the two extremes were united." Best known as a poet, novelist, and playwright, Goethe was also a scientist and an artist. One wonders if, as a painter, he ever tried to obtain red by mixing yellow and blue. And what was the result, if he tried?

It's well worth remembering such historical arguments, because they prove what a chasm exists between artistic practice and scientific theory. Some artists do base their work on careful calculations, formulas, the belief in an established law that governs artistic creation and everything else in the world. But the vast majority of contemporary artists dismiss this academic concept, initiated by Socrates, the great philosopher of ancient Greece, who declared, about twenty-four hundred years ago: "Anything that cannot be measured, weighed, and calculated, is nothing. It certainly cannot be art."

His statement may be valid for the precise, idealized art of his own country and age. But who can measure El Greco, Rembrandt, Michelangelo, Cézanne, or Picasso? Great artists don't follow prescriptions. They prepare their own formulas, if any, and the best of them change such formulas, time after time. Theoretical knowledge is a sound foundation, but not the ultimate goal.

It's understandable that the painter, in whatever medium he may work, prefers a comparatively small set of colors. Where would he keep sixty oil colors? What size palette would he need for them? Certain artists preach the use of only the primaries, plus white; others work with six colors: red, yellow, blue, green, white, and black. All paintings I've seen done with such a limited palette seemed to be even more limited than the number of colors. Invariably, they look anemic and dirty, as if they had been kept in a window, exposed to and faded by the sun and dulled by dust.

Why should an artist want to make things more difficult for himself? You don't save money by using fewer colors, because you need that much more of each color. There's no glory attached to working with five or six colors. The sole aim of a genuine artist must be to paint as good a painting as he possibly can. Limiting yourself to just a few colors is the same as if a composer limited himself to just a few notes, or if a novelist limited himself to the smallest possible vocabulary.

When, early in the nineteenth century, England's John Constable and Joseph Mallord William Turner, as well as the French artists, began to go outdoors to paint scenery on the spot, it immediately became evident that the few colors previously employed by artists could not match the wealth of hues in nature. Those colors sufficed as long as artists executed all their works in their studios, with the help of drab classicist formulas.

There are several reds, yellows, blues

The names, red, yellow, and blue, encompass vast territories of colors. There are two fundamentally different reds: crimson (a dark, cool red), and vermilion (a yellowish red of high brilliance). There are at least two very different yellows: a pale, or lemon yellow, and a deep, or medium yellow. A deep yellow mixed with white

will never give you a truly bright light yellow; and a light yellow will lose its yellowness as soon as you mix it with any darker color. It's difficult, if not impossible, for an artist to work without cobalt blue, ultramarine blue, and phthalo blue. Each of these has a noticeably different color, even though each of them is called blue.

It's hardly possible to describe the differences between these hues, just as one cannot describe the difference between three beautiful women whose hair, eyes, and complexions are alike. All you can do is tell their names.

A little experience also makes it clear that a ready-made orange is brighter, purer than any you might mix from red and yellow. It's much simpler and better to start out with a ready-made green than to mix it from yellow and blue. The same is true for a pure violet. The subtle, but vital differences between colors of the same basic name come out most clearly in the mixtures, when you mix one color with another.

Recommended lists of colors

Although the basic principles of colors and mixing are identical in every painting medium, there are differences you ought to remember.

Colors in oil painting

Alizarin crimson	Yellow ocher	Chromium oxide green
Cadmium red medium	Ultramarine blue	Cobalt violet
Cadmium orange	Cobalt blue	Burnt sienna
Cadmium yellow light	Phthalo blue	Ivory black
Cadmium yellow medium	Phthalo green	Titanium white

The above set enables you to mix any possible color and shade, except special chemical colors, such as luminous and metallic ones. Such colors are not normally employed in the fine arts, but might be desirable, occasionally, in commercial art. The commercial artist is free to help himself to such extraordinary paints, none of which is permanent.

It should be noted that there are still artists who believe that black is not a color, and insist that you shouldn't use it. The same persons perhaps believe that seeing the moon over your left shoulder brings you good luck. Actually, black can be of great help to you in mixing.

Colors in casein, tempera, gouache

The palette for casein, tempera, and gouache is exactly the same as the one in oil painting. Names of colors, sizes of tubes are identical, too, and so is mixing.

For commercial artists, however, the list offers illustrators' grays, in several shades, such as 25%, 50%, and 75% grays. These special grays are prepared for artists

doing black-and-white illustrations for reproduction, and are not normally used in the fine arts.

Colors in watercolor (aquarelle)

Watercolorists, using white paper, utilize the white of the sheet wherever white is necessary. If they make a mistake, they scrape or scrub it out, so the paper shows white. To lighten colors, they use water or a lighter paint.

Not every aquarellist is a purist. Many of them use white paint, but only for highlights, never for mixing. If they do use white, they buy only the finest possible kind. Nothing is more catastrophic than to use the wrong white, and to find, a few weeks later, that the pure white has turned gray, yellow, or pink.

With the exception of white, all the colors listed for oil, casein, tempera, and gouache are also needed in watercolor painting. Aquarellists, however, like to have twenty, or twenty-two colors. The reason is that extra colors are easy to handle and to carry, because watercolors are small and light, whether you buy them in tubes, pans, or cakes. The more colors you have, the easier it is to work in this rather delicate medium.

When we distinguish the original type of watercolor from the other water media (casein, tempera, gouache, and polymer), we usually refer to it as transparent watercolor, or aquarelle.

List of transparent watercolors

Alizarin crimson	Yellow ocher	Chromium oxide green
Geranium lake	Ultramarine blue	Violet
Rose madder	Cobalt blue	Raw sienna
Cadmium red medium	Phthalo blue	Burnt sienna
Cadmium orange	Viridian green	Venetian (Indian) red
Cadmium yellow light	Phthalo green	Payne's gray
Cadmium yellow medium	Hooker's green deep	Ivory black
Gamboge (Indian yellow)		

Colors for polymer painting

Polymer is a collective name for all plastic colors, regardless of their brand names.

Alizarin crimson	Ultramarine blue	Chromium oxide green
Cadmium red medium	Cobalt blue	Cobalt violet
Cadmium orange	Phthalo blue	Burnt sienna
Cadmium yellow light	Phthalo green	Mars black
Cadmium yellow medium	Hooker's green	Titanium white
Yellow ocher		

Warning: as I mentioned before, not all polymer brands mix with each other. Try them out. If they mix and can be applied smoothly, without a kind of drag or crawling, go ahead. You'll find that names of polymer colors are not exactly the same in all brands. These colors come in jars, squeeze bottles, plastic tubes, and roll-up metal tubes. The roll-up tubes are the most convenient to use, but the colors in jars seem to be stronger.

Colors for pastel painting

Although pastel is not like regular paint — it's not applied with brushes, and doesn't dry the way you expect other paintings to dry — it's still considered one of the painting media. In exhibitions, it's part of the watercolor section.

Mixing pastels is possible and necessary, but a large number of colors is strongly recommended. You just cannot pile pastel up indefinitely, as in oil and polymer. You'd ruin the paper with too much rubbing, and the pastel powder would soon begin to roll off, because it's held only by the tooth (texture) of the paper. In other media, one layer of paint adheres to the other.

Whenever possible, work with exactly the right shade of the right color. Soft pastels come in assortments (flat wooden or cardboard boxes) of twelve to two hundred and fifty colors; semi-hard pastels in packets of twelve to seventy-two sticks; other shades are available in your art supply store. The paper collar on each stick gives you the name and number of the color. Save these collars or jot down the numbers, so you can buy what you need, without trying to figure out exactly what color it was. As a starter, you ought to have about fifty soft, and half a dozen semi-hard pastels.

8. What Your Colors Will Do

The following descriptions are valid for colors in any medium; exceptions are clearly stated. The descriptions are in a sequence recommended for arranging the colors on your palette: reds, orange, yellows, blues, violet, greens, browns, blacks, and whites. Please note that all qualities refer to colors made by respectable manufacturers of artists' colors.

Reds

Alizarin crimson: a bluish red of low brilliance, very transparent, darker than the deepest cadmium red. Alizarin crimson is excellent for glazing in any medium. In aquarelle, thin it with water; in casein and polymer, add as much water as you wish, but add also a drop of casein or polymer medium, respectively, so that the paint won't lose its adhering power. In oils, mix alizarin crimson with linseed oil or copal glazing medium. Washed or glazed over any color, it lends depth and pulls large parts of a painting together, without obliterating details.

If, in any part of your painting, you want alizarin crimson to look like itself, apply it directly on the clean, white support. In case of mistakes — and we all make them — wipe or scrape off the wrong color before applying alizarin crimson. In casein and polymer, cover the mistake with titanium white, let it dry, then paint alizarin crimson over the white. Alizarin crimson is a must for every kind of representational painting, and desirable in nonobjective works as well. Remember, the slightest admixture of white changes the hue *radically*.

Geranium lake: a very bright red, excellent in transparent watercolor, but not used in other media.

Rose madder: a little closer to red-violet, is another transparent color extensively used by aquarellists, especially for cool reddish washes.

Cadmium red medium: the most practical of the vermilion-type reds. Made of the metallic element of the same name, it's a yellowish red of medium brilliance, absolutely permanent, opaque, with great covering power. You can paint cadmium

colors over any other color, even in aquarelle. Cadmium red glazed with alizarin crimson becomes darker, but cadmium completely covers alizarin. Cadmium red deep is not as bright as the medium red, but may be useful in aquarelle.

Orange

Cadmium orange: a very important color, even though, theoretically, it can be mixed from cadmium yellow and red. You must have the ready-made orange for purity, and intensity. It's very valuable in all mixtures where a warm, but bright tone is desired.

Yellows

Cadmium yellow light and medium: both are needed, because you cannot obtain a brilliant pale or lemon yellow by adding white to the medium yellow. On the other hand, any addition of a darker hue to yellow makes it a different color. Be careful not to add too much cadmium yellow to any other color, as it is extraordinarily powerful.

Yellow ocher: one of the most important earth colors, is of medium opacity. Mixed with a drop of white and/or cadmium yellow, it has a good covering capacity. Applied in washes, or glazes, it's another excellent color for pulling together sections of a painting. For example, you can paint a moonlit, or gaslit scene in detail, then go over the picture with an ocher glaze of the required strength to unify the tones.

Gamboge or Indian yellow: a slightly greenish, or dusty yellow of great subtlety. It's truly transparent; so much so that it is used almost exclusively in aquarelle.

Blues

Ultramarine blue: one of the oldest blues, and still one of those without which no painter wants to be caught. It's called ultramarine, that is, "from beyond the sea," because it was produced from lapis lazuli imported to Europe from Asia. That was hardly an overseas import; most of the lapis lazuli must have been transported overland by caravans, rather than by ships; but it did come from the mysterious East, and was expensive.

It has to be pulverized, and carefully separated into lighter and darker shades. Despite its darkness and visual power, ultramarine blue is a transparent color. A modern variation of it is called *French ultramarine*, a warm blue. Mixed with a little white, this hue has a slightly violet tint, which is especially noticeable when placed next to cobalt blue and next to cobalt blue mixed with white.

Cobalt blue: made from the lustrous, somewhat magnetic metal of the same name, often mentioned in connection with atomic power, and cancer research, is absolutely permanent, semi-opaque. Fine for skies, lakes, and all mixtures in which

coolness is desirable. Like other metallic hues, it's more expensive than earth colors, but no pictorial artist can work without it.

Phthalo (Phthalocyanine) blue: a recent discovery, is similar to Prussian blue, without its overwhelming and dangerous strength. It gives brilliant sky tones, and turns warm colors cool. Transparent, ideal for glazing where an over-all cool bluish tint is required.

Other blue colors have been, and still are available. *Indigo,* one of Sir Isaac Newton's seven prismatic hues, was made from several plants. It's now produced synthetically, is more uniform in quality, and more permanent than the natural dye, but it isn't recommended for fine arts painting. The same color can be obtained by adding a drop of black to ultramarine blue.

Prussian blue: an iron-cyanide compound, discovered in 1710 by a German named Diesbach. It's a deep blue pigment with a coppery luster. A beautiful blue, especially when mixed with white, but so powerful that it "kills" every color with which you mix it, even though it's transparent. Like asphaltum, it rises to the surface, gradually, and where you had intended to have a slight Prussian blue tone, you find a dark blue spot, completely out of harmony with the rest of the picture. I strongly advise you against employing Prussian blue.

Violet

Cobalt violet: a lovely, opaque hue, much cleaner than if you mixed it yourself, although cobalt or phthalo blue with alizarin crimson and a little white ought to provide you with a nice enough violet. Ready-made violet can easily be turned darker and warmer by adding alizarin crimson; lighter and cooler, by adding cobalt blue and a dash of white. Never add cadmium red, because it turns blue into maroon, rather than violet.

Since violet is a sort of in-between hue — not too warm and not too cool — it goes well with almost anything. An earlier generation of students heard art teachers say: "When in doubt, use violet." The advice is still good, but don't overdo the use of violet. Mixed with white, violet should always be applied with a perfectly clean brush and a very clean liquid, whether oil, turpentine, or water. This, by the way, is true for all sensitive pastel shades, because the smallest bit of extraneous color destroys their delicate tones.

Greens

Phthalo (Phthalocyanine) green: similar to the blue of the same name, a cool green of great intensity when mixed with a little white and light yellow. Like the blue, it's transparent, but quite opaque and powerful when white is added. On a hot day, I'd like to sit in a room painted a pastel shade of phthalo green. It's excellent for foliage in the distance. Also, for the cool, pale green sky of a radiant sunset.

Chromium oxide green: a warmer green, semi-transparent. A fine middle-tone

for foliage, and other vegetation. Turn this color warmer by adding orange or burnt sienna; cooler by adding cobalt blue and/or white.

Hooker's green: transparent, used in watercolor and polymer, especially for outdoor painting, when a large variety of green shades is required. Hooker's green differs in mixtures from other greens sufficiently to make it worth your while to have it.

Viridian green: also transparent, is liked by many artists, but I use it only in watercolor and, occasionally, in casein. I find it superfluous in other media, because I can obtain all imaginable green shades by mixing phthalo green and chromium oxide green with various blues, yellows, white, burnt sienna, and literally any other hue.

Browns

Burnt sienna: one of the most widely used earth colors, actually a member of the family of ochers—pigments varying from yellow to red—found in many parts of the world; derives its name from the Italian town of Siena, where it was first used as a color. It is often called *Terra di Siena*—earth of Siena—with a single *n*, the Italian spelling. In its original form, *raw sienna* is a cool, grayish brown. When burnt, calcinated, it turns into a mahogany brown, good for warm shadows on the human figure.

Many portrait painters lay their work out in burnt sienna tones and go over these with the actual flesh colors. A burnt sienna underpainting is less dangerous than the black-and-white underpainting Leonardo da Vinci did for his *Mona Lisa*, in which the black has bled through, especially in the shadow under the chin, causing it to look almost black. Only the lovely hands have retained their full flesh tones. Leonardo probably used better pigments in that part of the painting, or went over the underpainting with more glazes than he did in the face and chest.

Burnt sienna mixes well with many colors, although too much of it in face or figure causes it to look kind of bloody. Both raw and burnt sienna are transparent. I find raw sienna superfluous, because I can obtain the same hue by adding a little blue or black to the burnt sienna.

Raw umber and burnt umber: two other earth colors highly favored by many artists. The pigment originally comes from the Italian region of Umbria, but the word *ombra* happens to mean *shadow* in Italian, and some people think that's the meaning of the color, because it's good for certain shadows. I don't recommend either of the umbers, because I find them too strong. Everything mixed with burnt umber looks like something made of, or covered with, chocolate sauce. You can obtain the same color by simply adding black, blue, or green to burnt, or raw sienna.

Gray

Payne's gray: a pleasant, transparent, dark gray, available in most media, and favored by artists who are prejudiced against black. It's very handy in aquarelle

when you want to make other colors slightly darker, especially in the form of an over-all wash.

Needless to say, grays of any shade can be obtained by adding more or less black to white, and modifying them with the addition of a touch of red, blue, green, or any other hue.

Blacks

Ivory black: sounds odd, doesn't it? Ivory is anything but black. The reason for the name is that this color is made of bone carbon, not necessarily from elephant tusk. It's transparent, so that it can be used as a wash or glaze when sufficiently diluted. It's a cool black which mixes well with any color you'd like to tone down to what we call a "dusty" shade.

Whatever purists may say about black not being a color, I personally don't know what I'd do without it. I don't paint large surfaces plain black, to be sure, but I do employ black in most mixtures.

Lamp black: a warmer black of very light specific gravity, and not much covering power. Add a touch of burnt sienna to ivory black, and you have the identical black hue, but you obtain a considerably stronger paint. In transparent watercolor, though, lamp black is useful, because the specific gravity of a color is immaterial in that medium. I don't recommend it in any other kind of painting.

Mars black: the best available black in polymer. It looks just like ivory black. It's prepared from synthetic, uniform, fully permanent oxides.

Whites

Flake white: until shortly before World War II, this was the favorite in oils; many oldtimers still stick to it as a matter of habit. Made of lead, it's opaque and smooth, with excellent covering capacity.

Unfortunately, it has two serious drawbacks: it turns yellow, pink, or gray within a relatively short time; and you can get lead poisoning if it goes into cuts or scratches in your hand, or if you have the dreadful habit of putting brushes in your mouth.

Zinc white: made of the metallic element of the same name, zinc white is harmless and stays pure white. It is, however, so transparent, so weak in covering power, that you need a great deal of it to make a color lighter. It also dries more slowly than most other paints, and this is a handicap in oil painting, where uniform drying time is a safeguard against cracking. In the past, technically well-informed and conscientious artists worked with flake white, but covered sections, the whiteness of which was essential, with zinc white, after they dried. The slower-drying zinc white did not affect the faster-drying, or already dry colors on which it was applied.

In some cases, the yellowing or darkening of white sections in an oil painting may be of no importance. It may even lend the painting a kind of softness by elimi-

nating harsh contrasts. As a rule, though, an artist likes his colors to remain unchanged. You accept the inevitable, but why accept something bad that could be avoided? Thus, there are valid arguments for both flake white and zinc white.

Titanium white: the most recent discovery, fills the need for a new white. Made of titanium — the metal employed in producing light, but extra-strong steel for aircraft — this is the most powerful as well as most permanent white known today. Painters accustomed to flake or zinc white have to adjust themselves to this stronger white. Artists, like other people, are often slaves of their habits. I suggest that you try new materials and techniques. You might find something that's just what you'd been dreaming of.

White should be bought in larger tubes (or jars) than other colors because you need more of it in every medium, except in aquarelle.

For the many non-purist aquarellists, and the innumerable commercial artists who need retouching white, I advise you to buy the finest white, nothing but what is guaranteed to remain white. Such whites come in tubes or in small jars, and may be diluted with a drop or two of water. You can verify their permanence by applying a few strokes on a piece of cardboard and exposing the card to sunlight for a few days. Cover half of the strokes with another card, so as to be able to compare the change, if any. The so-called Chinese white is usually the best.

Texture and impasto

Nothing is new under the sun. This saying was probably old when King Solomon uttered it. Prehistoric man was ingenious enough to utilize the natural bumps on his cave walls when he painted the massive, roundish bodies of animals — bison, mammoth, boar, and so forth — right over the bumps, thus giving them a three dimensional aspect. Human and animal figures in the surprisingly varied and realistic murals of the Cretan civilization were executed in the form of plaster reliefs, then painted in bright, unshaded colors. The relief created its own shadows when the light hit those murals from one side or another.

In the Early Christian era, halos, crowns, crosses, gold ornaments on holy and royal or imperial personages, were often carved into the woodpanel on which the painting was done. Such three dimensional decorations were covered with gold leaf, while the rest of the picture was painted very smoothly. The painting technique remained smooth, both in tempera and in oils, all through the subsequent periods. Still, it isn't unusual to find a thicker application of paint, where it serves a functional purpose. Rembrandt's *Man in a Gold Helmet* is a beautiful example, showing *repoussé* work on armor done with thicker paint.

In modern times, *impasto*, a heavy application of paint, has become a widely accepted technique. Some artists make their impasto so thick that it looks like a veritable bas-relief. Until recently, impasto was possible only in oil painting, since linseed oil dries very slowly and retains its adhesive power forever. The binders in watercolor, gouache, tempera, and casein, on the other hand, cause the respective paints to adhere to one surface in thin layers only. If you apply such colors in heavy piles, they'll soon crack and fall off. Polymer, although applied with water, is an

exception. The plastic binders allow you to heap paint upon paint, without the danger of peeling off.

New materials

The desire for impasto has grown so remarkably that new materials have been introduced which make it possible to achieve impasto effects in any painting medium. Here they are:

Underpainting white or texture white: a recent addition to artists' supplies; a quick-drying substance, available for water media as well as for oil painting. You can use it as white paint, mixing it with any color, and develop all kinds of forms and textural effects. Or you can execute the entire work by applying the underpainting white by itself, all over the support. You can have thorns sticking out of your painting, if you wish. Create figures, flowers, fruits, trees, rocks, and anything else. Wait until the underpainting dries — a couple of hours in an oil underpainting white, but much faster if you work with polymer — then paint over it as if you were working on the regular support.

Underpainting white mixed with other oil colors, makes the colors dry much faster, so that you can quickly build up a picture to any thickness. Build up gradually, however, not in one big heap in order to give each layer a chance to dry a little.

In all cases, read the directions on the label or on the sheet normally given with such whites. Don't take it for granted that you know how to work with any new material.

Modeling paste or extender: a great new substance introduced by manufacturers of polymer. It's even better than underpainting white, because it dries faster, remains flexible, and takes any medium. You cannot work on an underpainting oil white with anything but oil colors. The polymer modeling paste — or extender — is good for watercolor, casein, tempera, gouache, oil, and, naturally, polymer. I recommend the polymer modeling paste or extender very highly.

Gel: another medium to help you in impasto is *gel*, a vaseline-like substance known to artists for several generations, but now prepared in a scientific manner, so that it won't darken or crack. It used to be good for oil painting only; now it may be mixed with water media as well.

Gel may be applied whenever thickness is required. It adds volume and transparency to any color, without diminishing its intensity. Mix orange with three times its volume in gel, and it will still be as bright as it came from tube or jar.

There is a gel made for polymer. This may be applied to any part of your painting where thick paint would look right. Pile it on with your painting knife, an old brush, or even chopsticks, if you wish. Let it dry, then paint it. You'll also find that polymer gel absorbs any color upon which it is spread, within a few hours, so that you needn't even paint it, if it absorbs the color you want.

Which one should you use: underpainting white, modeling paste, or gel? The answer is simple: try 'em all, and see which one suits your style, subject, and personality or temperament best. Textural effects are not merely fashionable. They are

really pleasing, interesting, occasionally staggering. At any rate, you ought to integrate your textural effects with the subject. Don't employ impasto just to show people that you can do it. Use it when and where it helps you esthetically and technically.

In an age when more and more artists seem to work in what we officially call "mixed media," underpainting materials are of genuine value, especially as impasto is now possible in any medium.

9. Mixing Colors

Practically everyone knows how to obtain secondary colors by mixing two primaries. Mixing these *seems* to be a waste of time, since even the small, introductory sets of colors — in any medium — contain them.

Why mix colors?

Artists and art students, however, know that there are countless colors and shades in the world around us and in the private world of an artist's imagination. They also know that a forest is not all the same green, that the earth is not the same brown all over, that there is no single color for depicting lakes, seas, rivers in all kinds of weather. They also realize that colors change visually, according to distance, atmospheric conditions, the endless play of light-and-shadow.

It's also obvious that no manufacturer could produce the innumerable hues artists need. And if one did, where could we keep so many thousands of tubes, jars, pans, or cakes of paint? How could we place them on our palettes? This is why color mixing is necessary, and this is why we cannot work with more than a comparatively small number of well-selected basic colors.

Even though techniques differ according to media, the general principle of color mixing is the same in all media, with one main exception: transparent watercolors. Transparent watercolors are made lighter by diluting darker hues with the right amount of water. The more water and the less paint, the lighter the shade. You can also purchase lighter shades of the required colors. This procedure is better than the adding of a lot of water to a darker shade, because a ready-made light hue has greater brilliance than a color which is mostly water. In all other media, colors can be made lighter by adding lighter hues or white.

Most paintings have so many colors that art students at first wonder if it's really possible to mix all those hues from the recommended fourteen or fifteen colors. At the same time, almost without a single exception, students think of colors as what their names imply. They believe that orange is for painting oranges; yellow is for painting lemons, grapefruit, or a canary; blue is the color of sky and calm water.

Before starting to paint figures from life, many students go to an art supply store and ask for "flesh color." What flesh color? Why, the color of flesh!

Seeing color differences

It takes time for students to discover that members of the same race have a large variety of skin colors. As a matter of fact, each individual body varies in color; upper arms, lower legs, thighs, stomach, shoulders, chest, cheeks, temples, hands, feet are all slightly, or not-so-slightly, different in hue. Then there are the shadows and highlights, which depend upon the light and the surroundings, too. In an abstraction, you may change any, or all the colors according to your taste. Still, you must know what you're doing, and how best to achieve the planned, or envisioned effect with the help of color as well as design.

Art students frequently make the mistake of mixing a big batch of colors for the background, for a piece of drapery, for a table, or for whatever large surfaces they intend to paint. "Isn't this a good match?" asks a student. The color does in fact match the object's so-called local color — the color it has by nature, or the color given it in the factory — but it doesn't look like the real thing. The difference between the dye used in coloring the material, and the material's actual appearance in space is tremendous. We know it has a certain color, let's say dusty-green, but that dusty-green looks brighter, more yellowish in the upper left corner, than in the upper right; it looks bluish in the lower left and reddish in the lower right, depending on illumination and on nearby objects reflected in it.

Watch a wall on a day when the sun plays hide-and-seek behind clouds. The wall looks brighter, warmer when the sun is out; it turns gray, cool when the sun is hidden. The very common idea of painting a whole background one solid color, then adding the objects on top of it, is a major mistake among beginners. At best, it offers a *poster* effect, with pleasing flat colors.

You have to learn to observe. Look, look, and look again. Look with your eyes, not with your preconceived notions. Everything is right in front of you; there is no mystery attached to seeing colors. Gradually, you'll realize that colors are meaningless by themselves; they must be correlated with other colors around them. You can hit one single note on the piano and know what note you hit, but it's merely a sound, an accidental sound. You have to surround the note with others, so to speak, before you obtain what can be called music. The same relationship exists between colors and art, as between notes and music.

Actual mixing of colors

Few colors in nature are visually pure. In all likelihood, you'll find a color slightly bluish, reddish, or yellowish. Pure colors are normally used in posters only, or in dyeing textiles.

Let's say you need a very dark red. Take the darkest you have — alizarin crimson — add a little blue, green, or black, or a drop of each. By "little" I mean that all

you do is touch green, blue, or black with a corner of your brush, and mix it into the alizarin. Add more, if necessary. (I advise you to look every time you do anything in art, and ask yourself if you're doing the right thing.)

Suppose you want to obtain a lighter red. Is it to be brilliant or mellow, warm or cool, pinkish or yellowish? Don't just add white to make it lighter. White turns alizarin crimson into pink, a rose color, while it makes peach out of cadmium red. You may have to combine alizarin, cadmium red, orange, and yellow for a warm red of high intensity. By adding white, instead of yellow, you'll have an equally light and bright, but cooler red. Whatever you mix, test every brush stroke before adding more paint.

To mix or modify any light shade, begin with the lightest hue close to it. For a pale green, take white and add a touch of phthalo green. If this isn't the right shade, add a pinpoint of cobalt, phthalo blue, or ultramarine blue, whichever gives you the desired effect; if it isn't bright enough, dip a corner of your brush in light yellow, and stir it into the green. Colors are stronger in some brands than in others, and artists don't work like pharmacists, weighing each ingredient on a scientific scale according to a prescription. Mix the colors on your palette, but the final proof is in the painting. Look at each color as you place it next to, or on top of, other colors.

It's possible to mix a pint can of household paint with half a can of another color, but this isn't the way in the fine arts.

You aren't preparing a pail of paint for painting your kitchen, where you must be sure to have plenty of paint, thoroughly mixed in order to prevent dirty streaks. In fine arts, you can always change a mixture if it isn't just right. The wrong color won't kill the painting the way an incorrectly filled prescription might kill the patient. One of the beautiful features of working in color, in any medium, is to experiment, to watch the results, to see how the smallest bit of another color can help or harm your painting.

Exercise in color mixing

Here's the most practical and sensible method of finding out what color mixing really means: take a six- or eight-inch wide strip of canvas, paper, or whatever support you like, and paint an inch of every color you have. Go from top to bottom, leaving about an inch of space between colors. Rub a small amount of white into each color, but leave about one-third of each stripe intact. Compare the mixtures with the original hues. As I've already said, alizarin crimson becomes pink; cadmium red turns into peach when white is added; you have to add a great deal of white to cadmium yellow before you can notice the difference; white creates entirely different shades out of every blue. The same varied effects occur when white is mixed into any green, yellow ocher, burnt sienna, cobalt violet, or any color you may have. Rub in an additional amount of white into each color, and you'll see further interesting variations.

Now mix every basic color with all the other colors. For instance, add cadmium yellow light to all your colors; cobalt blue to all your colors; phthalo green to all your colors; and so forth. A vast array of colors and shades is at your disposal,

opening up a vista of a sumptuous world of color. After some experience, you'll be able to obtain every imaginable shade of every perceivable color.

Making colors lighter

One of the pitfalls to watch is the use of white. Don't assume that white is all you need for making a color lighter. White often makes colors quite different from what you'd expect. More often than not, it's wiser to make a color lighter by adding some other light hue, such as yellow and orange to burnt sienna, light yellow to orange or green. The lighter color you add must be *related* to the color you're trying to make lighter. Naturally, if you add yellow to blue, it will become green; if you add a light green to ultramarine blue, you get a greenish blue, not a light blue.

Use your eyes for judging the result. Some artists may have a better sense of color than others, but anyone can, and must, develop this sense. You should reach the point when you no longer call a hue by its popular name — for example, sky blue, or sea green — but describe the color as a very light cobalt blue, or as phthalo green mixed with a dash of white and a little yellow, etc.

Making colors darker

Making colors darker also has a pitfall. Your first idea may be to add black. Although red, blue, green, and brown can be made darker by adding a little black, try to add another dark hue: ultramarine blue to red or green, alizarin crimson to blue.

Even if you do add black, it's usually better to mix it with a drop of some other dark hue too. Yellow *can* be made darker by mixing it with yellow ocher, but it will no longer be really yellow. Black turns yellow into a dirty-green. Ocher can be deepened with burnt sienna and a bit of black.

Using black and white properly

Brought up on the tradition (or superstition) that black is not a color, but a lack of all color, many artists work without it. Nobody recommends the use of plain black over large sections of your painting; not even Goya's famed "black paintings" in the Prado Museum in Madrid are jet black.

Add a little red, blue, or green to make your black warmer, or cooler, and to take away that flat, papery appearance it has when applied to a large spot. A black dress is not truly black all over; it has lights, shadows, and reflections that break it into many different shades.

Too much white in any color makes it what we call "chalky," a fully descriptive expression, because such colors do appear to have been smeared with white chalk.

Too much reddish blue in a dark color will cause an "inky" impression, as if you had spilled ink on your painting. Such a spot appears to be a big hole in your picture, something that doesn't belong there. Watch out for such exaggerations.

10. Color Effects

A good artist can paint a picture on any surface, in any size, from an ivory miniature to a huge wall or ceiling. He can make the picture look like a real scene of nature: humans, animals, in any kind of action, cities by day or by moonlight, fruits, vegetables, articles of any sort. He can paint pictures with no describable or obvious meaning or theme, just for the sake of decoration. Whatever his purpose, the painter works with colors and he has to know how to apply and how to organize those colors so well that the final result should be exactly what he had planned. A composer must know not only how to jot down the main idea of his composition — be it an oldfashioned melody or a modern work of total dissonance. He must also know the sound and capability of every musical instrument he plans to employ; he must know when, where, and how best to utilize these sounds in order to achieve the right final effect when an orchestra performs his composition.

The painter, too, has to know the proper technique of his medium. But he also has to know what each color, each shade, and every combination of these, can do for him. The painter, like the composer, has a number of ingredients and tools with which to work. If we have sonatas, symphonies, fugues, operas, operettas, and tone poems, we also have landscapes, seascapes, cityscapes, still lifes, and figure paintings. Above all, we are not supposed to merely copy someone else's work. We have to create our own, and we have to put something of ourselves into our creations.

The painter, like the composer, has to study all possible effects that are already known, so that he might be able to achieve something original. The first step in painting is the testing of simple, everyday effects, and trying to figure out how these are obtained, what they mean to artists in general, and to yourself in particular, and how they can lead to the understanding of more impressive, more complex effects.

Exercise in color effects

You can perform a simple and valuable color test with a package of assorted construction paper, and a few pieces of real or artificial fruit. The paper comes in

9" x 12", and 12" by 18" sizes, usually fifty sheets in ten different colors to the package. It's available in art supply stores, stationery stores, and stationery departments of bigger stores at very little cost; and it's most helpful in trying out color combinations for any purpose. Also buy three golden apples, or bright yellow bananas, three red apples, and three green pears.

Set red, yellow, and green construction paper next to one another on a table, and place one yellow fruit on each sheet. The fruit will look "normal" on the red paper, unimpressive on the yellow, and quite brilliant on the green sheet. Replace the yellow fruit with red apples. Now, the red apple is hardly noticeable on the red paper; it's bright on the yellow paper; while it looks flat, but jumpy, on the green paper.

Remove the apples, and put a green pear on each sheet. It's almost invisible on the green paper, extra-bright on the yellow, and rather disagreeable to the eye on the red sheet. The brightness, the dullness, the jumpy, or disagreeable effects depend upon the shades of red, yellow, and green in the paper. It's a good idea to try the same fruits on lighter and darker shades of red, yellow, and green paper. You might as well try other colors, both in paper, and fruits.

Don't observe only the general color effect. Consider the reflections in the fruits. Most fruits have a slight sheen, similar to that of the human skin, and the colors of paper, background, or foreground are reflected in each fruit to a certain extent. The bottom of each fruit reflects the hue of the construction paper in about the same manner as if you mixed the color of the fruit with the color of the paper. Thus, the yellow reflection in a yellow fruit is hardly perceptible, but the bottom of the red apple turns orange, and the bottom of the green pear becomes yellowish on the yellow sheet. The red paper noticeably affects the yellow and green fruits, while the green paper alters the red and yellow fruits.

Continue the exercise by placing three different fruits on each sheet of paper, in the same arrangement. The visual effect is so dramatically different that you don't even believe you're dealing with the same fruits. Try dark blue, light blue, pink, orange, gray, black, white, brown paper, too. The changes will surprise you, if you've never seen such tests before. You might develop the idea into a parlor game.

The moment you place three different-colored fruits next to each other, they also affect each other's hues. Depending upon the closeness of the items, and the sheen of their skins, they reflect each other as well as the colors around them. Even if you aren't a traditional artist, observe these effects, because they're exciting. Moreover, it's only after you've acquired sufficient knowledge that you can decide what to omit, what to retain, what to emphasize, what to subdue in your painting, no matter what your style and subject may be. Many beginners think it's a sign of individuality to omit not only small details, but major forms and color effects. Remember that you cannot learn shorthand before you know how to write correctly in longhand.

While working with paper of assorted colors, you can discover which goes well with all the articles you're testing. It's easy enough to achieve a strong effect by placing colorful items on a black background, but fine artists avoid such flashiness. Subtlety is as important in painting as in diplomacy, and the most obvious color combinations are not necessarily the best. A soft hue might bring out the variety

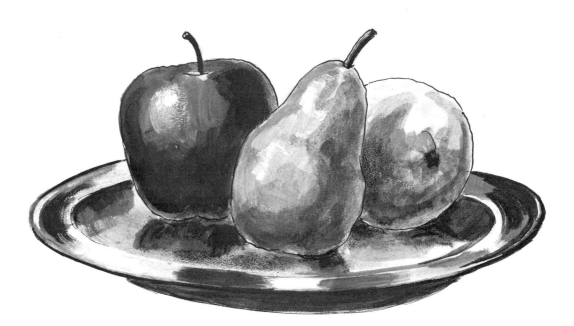

Values of Lights and Shadows. *Fruits on a shiny metal plate have shadows, lights, highlights, and reflected lights, as well as reflections in the plate. Observe the value of each color, light, or shadow. Not even the darkest shadow is ever black; nor is the lightest spot ever white.*

Shadows or Holes? *If you paint shadows too dark, as in this apple and pear, the shadows look like holes or black paper pasted on. Highlights painted too light seem to be pieces of paper accidentally attached to the picture.*

of colors in your fruits in an esthetically satisfying fashion. I am talking about fruits because they're easy to obtain in practically identical colors and shapes, and because you can eat them after the test. Books are also easy to handle, but they may be too bulky for an exercise. You can very well work with balls of wool or cotton of the required colors.

The purpose of a test like this is to familiarize yourself with a number of facts valid in every type of painting:

1. The same hue appears to be different when surrounded by, or juxtaposed to, different colors.

2. Colors literally affect each other by reflecting hues that surround them, including natural, or artificial light, both of which cause considerable differences in all colors. The degree of such reflection depends upon the surface of objects. The glossier an article, the brighter the reflection. A fuzzy peach doesn't reflect colors as much as a polished apple. A suede shoe or a dirty shoe, doesn't reflect colors and lights the way a highly shined shoe does.

3. Serious representational painting cannot be done without observing the diversity of hues in all items you depict. The understanding of colors and color effects is vital in nonobjective painting, too, but not in the same sense. There being no subject, no recognizable theme in such a painting, the colors have to speak for themselves.

Harmony and disharmony in color

According to dictionary definition, harmony is musical consonance, tuneful sound. Disharmony or discord is a combination of musical sounds which strikes the ear harshly; dissonance; noise of conflict, argument. There is a relationship between music and painting, expressed in similar terms. Composition exists in painting as well as in music; a composer can paint, depict a mood, or give an underpainting in music. On the other hand, a painting can sing with color, and have rhythm in its pattern of forms and hues. The word *chromatic* refers to music no less than painting. We have high and low colors, just like high and low notes.

In painting, harmony is the juxtaposing of colors which go well together. Disharmony is a combination of colors which clash with each other and appear to be jumping out of the picture. One is acutely conscious of such disharmony and wonders why the artist, the interior decorator, or anyone else should have assembled those colors.

Definitions are meaningful only to people with the same general knowledge. The most precise definition of a piano wouldn't be grasped by a member of a primitive tribe never in contact with a civilization in which the piano is an established article. As for colors, it's unquestionable that people in most parts of the world are aware of them. National costumes, folk arts of many kinds flourish in the darkest and farthest corners of the earth, in proof of a truly universal love for artistic expression. Love for art is normally as great as love for music and dancing.

There's also a great deal of similarity between color combinations, although

designs and national motifs are often quite different. One nation can appreciate, and even imitate, the art of another nation or tribe, despite the ancient saying that tastes are different, or that one shouldn't argue about taste. We find ample evidence of the effect of Hellenistic art on the art of India, where it was carried by the victorious armies of Alexander the Great. The barbarians of northern Europe bought Greek pottery in ancient times. Tastes may differ, and change, but, generally speaking, the same kind of people accept certain standards of taste, even though they often object to any change in the prevailing taste.

Nature offers us many instances of lovely, harmonious color effects, and also many odd, absurd combinations of colors. The exquisitely beautiful plumage of hundreds of birds in the bird house of a big zoo serves as an inspiration for all artists, decorators, fashion designers. Consider, on the other hand, the parrot, with its loud, dissonant coloring. We deride a person who is "dressed like a parrot."

The easiest way to harmony in colors is to stick to shades of one-and-the-same color. I used to know a man who wore a blue suit, with a light blue shirt, blue necktie, black socks and shoes, a blue-gray fedora, one day. The next day, he'd show up dressed in a dark brown suit, buff shirt, brown tie, socks, shoes, and hat. He was harmonious all right, but without any distinction or elegance. I've known women, too, who felt secure only when each part of their apparel and accessories was merely another shade of the same hue.

True harmony may, and should, be found in different colors arranged in a pleasing manner, so that your eyes glide from one hue to the other without stumbling or without feeling jarred. Such harmony is often achieved by selecting different shades of several colors, some of higher, others of lower values. A cadmium red stripe looks jumpy between stripes of a very bright green. The same red, however, is quite harmonious between stripes of a medium, slightly-grayish, green. And this is a much more interesting combination than, let's say, lighter and darker red, or lighter and darker green stripes would offer.

Exercise in color harmony

Cut 2 1/2" or 3" squares of the following sheets of construction paper or cardboard: cadmium red, yellow, orange, burnt sienna, black, ultramarine blue, and purple. Place them next to each other, in a row, in the order listed above. You'll find these seven squares quite pleasing to the eye.

Rearrange them as follows: cadmium red, black, yellow, purple, orange, ultramarine blue, and burnt sienna. The colors are the same, but they appear to be jumping all over the place. Look at them for a few minutes, in a strong light, then turn away from the light. You'll see purple, green, and orange worms wiggling in front of your eyes. If you cut several of each square, you might arrange them in other sequences as well.

Another test requires a living person — man or woman — or a good, preferably lifesize color picture of a man or woman. You'll also need a number of different scarves, or swatches of textiles. Place a piece of textile round the neck of the person, or on the neck of the person in the picture, close to the chin and cheek. Notice how

the color affects his or her appearance. Each of the scarves or swatches will have a different effect on the same face. One color may turn a good complexion into an ugly or repulsive one, while other colors are flattering.

When you receive many compliments from friends and acquaintances, you can bet that the color you're wearing is responsible for your success to a very large extent. And when the usual compliments are not forthcoming, look into the mirror, and see if another scarf, shirt, suit, or dress might not be the answer. A chic woman can make herself attractive by throwing a scarf of the right hue round her neck. Believe it or not, a necktie may do the trick for a man.

The total effect of your painting can be changed as easily as your appearance, just by changing one color. One bright hue in the wrong place, or one dark spot where it doesn't belong, and everyone feels something is wrong with your painting. Any color combination may be transformed into a harmonious one by subduing a tone here and there; by making one hue warmer or cooler; by giving the picture an over-all glaze of the right shade. Only the parrot is helplessly, hopelessly attached to its own feathers.

What's a color scheme?

You want to decorate your home or office, and decide to furnish it according to a plan which includes colors as well as furnishings and equipment. Color has grown very important in every field. Kitchens and bathrooms were once drab. Offices once had light-buff walls, a brown, or maroon floor, dark furniture, gray cabinets. Now these rooms are colorful, designed by specially trained decorators.

I've already spoken of persons who believe that various shades of the same hue are a safe and sound combination. Others, however, think that the oddest color combination becomes perfectly correct, if you repeat the colors in other objects.

For example, somebody purchases odds and ends at auctions or second-hand stores over a course of time. As a result, he has chairs upholstered in green, violet, blue, red, and yellow, one of each; he has a black table with a bright orange mica top; a white porcelain lampbase with a purple shade, and a sofa covered in a fancy gold brocade. He now has the walls of the room painted cobalt blue, the ceiling yellow ("to give a cheerful effect," as he calls it), the woodwork mahogany brown. He also has a violet wall-to-wall carpet. In order to create harmony among all these colors, he throws yellow, and orange pillows on the sofa; puts one white candle and one purple candle in a double-headed brass candleholder, to match the white and purple in his lamp. On top of the bargain, he buys curtains of a textile printed with flowers which include all the colors in his living room. Such a person believes he has a sensational home. Sensational it is, all right...sensationally hideous.

It's not the repetition of colors that makes a good color scheme, but the arrangement, the massing of a few colors, *where* you place *what*, and how much of it. A good color scheme is the one in which nothing jars your eye. A few bright spots may enliven a dark, somewhat formal room, that's true. A room filled with nothing but bright spots, however, is a distressing hodge-podge. There's a very big difference between artistry and artiness.

11. Color Effects by Natural Light

Natural illumination is provided mainly by the sun. The moon merely reflects the light of the sun with a soft glow, which is harmless to the eye, although Old World superstition warns you not to gaze into the full moon, lest you lose your mind. The stars never hurt your eyes. You can see fairly well by moonlight as your eyes become gradually accustomed to it; and you can behold a vast panorama on a clear, starlit night. You can paint the effects of moonlight, and starlight from memory, based on observation, but you cannot paint by moonlight or starlight.

Variations in sunlight

The power of the sunlight depends upon the season, the weather, the time of day, the much-talked-about air pollution. Our large cities are constantly covered by smoke and dirt in the air, so that the sun, the moon, and the stars are never as bright over them as in the open country, especially in a dry climate, such as North Africa or Arizona.

The color of sunlight varies with the weather, and the time of day. On a cloudy, rainy day, everything is veiled by a grayish tone. The morning sun is a cool yellow; the noontime sun is a warmer yellow; the afternoon sun becomes reddish; the setting sun is orange, and casts an orange glow on everything it illuminates.

Shadows cast by the sun

The light rays of the sun radiate in every possible direction, but we see only the rays that hit our planet. The sun, however, is at so colossal a distance from earth, and our planet is so small, compared with the sun, that the rays of the sun reaching our globe are parallel as far as we're concerned. This means that the shadows cast by sunlight are all in the same direction on as large a section of the earth as we can possibly see. (Perhaps astronauts, hundreds of miles above the earth, can notice the fact that the shadows are not the same beyond a certain perimeter.)

sun

earth ●

The Sun and Our Planet. *The planet earth is so small compared with the sun — and compared with its tremendous distance from the sun — that the sunrays hitting it are parallel, to all intents and purposes. Thus, the shadows on any part of the earth go in the same direction. The direction changes, though, as the earth moves. You may start your painting in the morning, when the sun comes from the upper left, and continue to work into the afternoon, when the sun is on the opposite side. Make sure that the shadows in your painting are all on the same side!*

Sunlight moves with the earth. Thus, if you paint outdoors, especially during seasons when the days are shorter, shadows change considerably within a couple of hours. The light may come from the upper left side in the morning, so that shadows are on the right side of each object. By noon, the sun is almost directly above your head, causing objects to have small shadows only. By mid-afternoon, the light comes from the opposite direction and shadows are consequently reversed. They also grow longer and longer toward evening as the sun goes lower.

If you make the mistake, quite common among art students, of finishing one part of your picture before going to the next part, you may find yourself doing just about the oddest imaginable thing. You will have a painting in which some shadows are on the right, others on the left, still others in-between. I've seen this happen, especially in cityscapes: shadows under roofs, eaves, balconies, windowsills were different on every house.

The correct procedure is to lay out all shadows and lights at the same time, when you believe they're most satisfactory from an artistic viewpoint. Paint them that way, regardless of the motion of the earth and the continuous changing of the shadows. Or work only for a couple of hours and return to the same place the next day, at the same time, and, naturally, in the same kind of weather. Shadows and lights change according to atmospheric conditions. They are clear and sharp on a sunny day, hazy, indistinct on a cloudy day.

Painting daylight streaming through a window

Who hasn't exclaimed "How beautiful!" at the sight of sunlight streaming into a room through a crack in the curtain or windowshade? A slanting shaft of such light illuminates billions of particles of dust dancing or floating in its path, from the window to the floor, where the light creates an image similar to the opening through which it enters the room.

How can you paint so marvelous a sight? The answer is: observe and render the light without any exaggeration. The slightest overdoing would ruin the effect. The sunlight is something vibrating, ephemeral — a spirit, rather than a tangible substance. You feel like putting your hand into the light to see whether you could break it. Your hand glows in the light and its shadow is clearly seen on the floor.

Don't paint such light as if it were a solid plank or beam of wood in a bright color. Show the opening through which the light comes and the spot where it hits the floor or where it hits any other object. Connect the two ends with a glazed, completely transparent tone that doesn't obliterate the space the light traverses, but merely makes it visible. As you know, glazing is now possible in any medium, but requires care and skill. It's a challenge worth accepting.

Squint when observing the shaft of light. Compare the value of this light with the value of each object next to it: furniture, carpet, wall, whatever you may see in the room. The shaft of light is bright, comparatively, but not actually. In other words, such a light is not like an electric spotlight searching for planes in the night sky. The contrasts are gentle and mellow.

Painting sunset colors

Sunset is one of nature's most gorgeous spectacles. It's one of the most universally appreciated splendors of the world, too. A sunset over a calm lake, with the countless hues of the sky reflected in the water, is especially breathtaking. Many an artist and Sunday painter has tried to render such a scene. It's difficult to paint the delicate hues, ranging from the palest yellow, through shades of green, turquoise, and violet, to orange, purple, and cobalt blue. It's a vast array of colors, and what colors! Yet the dazzling display is never gaudy. Subtlety is paramount in depicting a sunset. Don't copy picture postcards of sunsets. Such cards, at best, represent some horrible conflagration, the burning of Rome, or the Great Fire of Chicago. At worst, they're nightmarish or ridiculous.

The true colors of sunset are inspiring, not only because they represent a sunset, but because they point the way to abstract or nonobjective arrangements in painting. The extreme intensity and purity of the hues also pose a challenge to your technical ability and patience. The slightest mistake in colors makes your sunset muddy. Work with clean colors, clean oil, turpentine, water, or any other medium.

Also watch objects silhouetted against the sunset sky, such as clouds floating in mid-air, the shoreline, perhaps a few tall trees. None of these objects is black or even a dark gray. They may seem to be dark against the glowing sky, but, actually, they're only a few shades darker than the sky itself. Don't paint them as if they were

cut out of black paper. Show the three dimensional quality of each item by painting the edges illuminated by the glow of the last rays of the sun, very bright, but without leaving hard edges. The clouds, especially, have soft, fuzzy outlines, and what makes the clouds look dark is the fact that they are a cool gray-blue, whereas the backdrop, the sky, is vibrant with light hues. Practice painting sunsets over and over until you achieve subtle, yet rich colors. These will enhance your landscape paintings greatly.

Painting shiny metal effects

Shiny metals are attractive to man in real life, and they are just as attractive in painting. There's something rich and enticing about all shiny metals, not only about gold and silver. Metal objects are especially fine for still lifes. Most beginners in art think that gold, silver, brass, and chromium articles can only be painted with gold or silver paint. This belief is supported by the fact that metallic paints are available in art supply stores. Such metallic paints come in jars, powder, cakes, tubes, bottles, and in various media. Faced with the project of a still life containing highly-polished metal utensils, the art student is ready to rush to the nearest art supply store for what he believes is an absolutely necessary metallic color.

The fact is that metallic colors are manufactured for decorative purposes. You can paint a raw wood frame in gold or in silver. You might paint metallic stripes on doors, tables, shelves. And, naturally, such paints are excellent for giving your radiators a new look. But nobody will ever believe that such articles are made of real gold or silver. Except, perhaps, the kind of person who pays good money for a brick painted gold.

Shiny metal objects are easily recognized by the way they reflect all colors and images in a somewhat silvery or golden tone, depending upon the basic color of the metal. They're also recognizable by the way they reduce the sizes of reflected forms and pictures, and by their very strong, sharp, shiny highlights. What we see in such metals is not really the metallic color by which we know them, but the colors they reflect and the manner in which they reflect them.

When painting such an object, observe the reflected images and hues, their comparative sizes, and more or less distorted shapes. The degree of distortion depends upon the form of the metal itself. Flat metals are almost like mirrors, and change an image only if the metal is not absolutely flat. Roundish shiny metal articles, however — such as bowls, vases, or pitchers — distort images as drastically as distorting mirrors found in amusement parks do.

There's no trick to painting shiny metals. It merely requires acute observation and faithful rendering of whatever you see in such articles: every color, size, shadow, highlight, image, the peculiar kinds of distortions. A concave section of a silver vase reduces an apple to the size of a cherry. A convex part of the same vase enlarges a cherry to the size of an apple. Highlights on metal are mirror images of the light source, such as the window, but the shapes of highlights depend upon the shapes on which they are seen. In gold or brass articles, all hues have a golden quality. In silver or chromium, everything has a grayish tone.

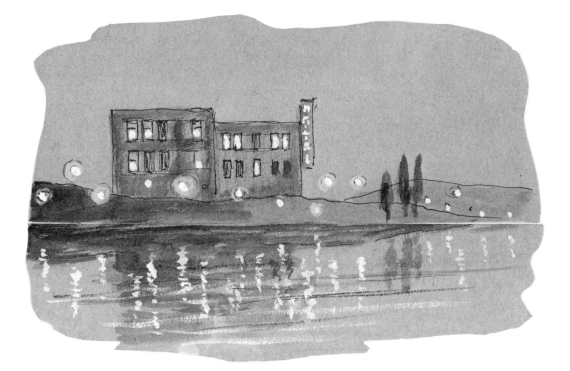

Reflections in Water. *Reflections of lights are as far below the water line as the actual lights are above it. Lights nearer to you are larger, more brilliant, with halos. The farther away they are, the smaller, the cooler they are. Lighted windows, signs, and so forth, are also reflected in the water. Even when the water is very calm, the reflections are slightly rippled. Observe the main values of the sky and water — which is lighter, which is darker. There's no definite rule. Usually, the water is lighter right after sunset. The hills, shoreline, and buildings are but a few shades darker than sky and water.*

Painting reflections in water

Painstaking observation of values is perhaps even more important in the rendering of reflections in water, especially when lights of one kind or another, such as illuminated windows or lamps, are involved. If your subject is a lake or river shore, decide what is lighter: the sky or the water. Normally, the water reflects the color of the sky, but rippled water changes the color considerably. Reflections in choppy, stormy water are never clear. Only the crests of waves reflect some of the sunlight or lamplight; the rest may be greenish-brown or bluish-gray. By sunlight, the water is likely to be somewhat darker than the sky; but, toward evening, the sky may become darker than the water. Don't take anything for granted. Look, and look again.

Reflections of objects, such as houses, trees, bushes, persons are directly underneath the actual objects, seen in the same perspective. Each reflected image is as far below the water line as the actual item is above the water line, provided that you are on a low shore. If you look at reflections from a higher level, a hill or a tall building, the reflected images may not be visible. Here, too, go by what you see. Although

water can be mirror-smooth for a little while, it usually has ripples, at least close to your own shoreline, so that reflected images are not absolutely clear. The edges normally become zig-zaggy. You might paint the reflections fully, then pull your brush across the reflections in order to give them a feeling of wateriness. Make sure to ripple at least the bottom edges, which are, of course, reflections of the top part of each item, because images are turned upside down by water.

Colors in reflections are similar to the actual hues, but softer, slightly darker, as if a very thin green, blue, or gray veil had been thrown across the entire reflection. Reflections of the setting sun or of the moon are often painted, because they're attractive subjects. Such reflections are vertically below the sun or the moon, but never straight-edged. What you see are ripples, one ripple below the other, dancing according to the waves or ripples in the water, in a color similar to the reddish sun or the yellowish moon, but always a little less intense than the sun or the moon. The brightness of the rippled reflections can be enhanced by painting violet or purple spots or thin lines between ripples.

The water is seldom, if ever, the same color all over. Normally, you'll find that one corner is a little darker, and the opposite corner is a little lighter, than the rest of the water. Lamps, electric signs, illuminated windows are also to be painted on the basis of observation. Reflections of lights are directly below the actual lights, again with ripples one below the other, dancing on the crests of waves. Such reflections go all the way down, but are usually farther from each other towards the bottom of the reflection.

All reflections of lights are softer, cooler than in the actual lamps or signs. They're also lighter and smaller farther away, in reflections as well as in the real lights. The lamps on the shore have halos, if they're near enough to you. The rendering of such lights and halos is explained in the next chapter.

12. Color Effects by Artificial Light

It's practically impossible to think of an artist who'd never be faced with the task or necessity of painting by artificial light. If you paint by artificial light, you must know what effect such light has on everything it hits. Even if you've no intention of creating a painting in which candlelight, a campfire, or neon signs play a big role, you ought to know how to handle your work by any kind of light. You may want to have light effects of your own. Rembrandt had them. He painted strange, perhaps super-earthly lights, that touched or illuminated a face here, a hand there, giving the picture an aura of mystery.

Limitations of artificial light

Artificial light is any man-made light: flaming wood, oil lamp, candle, gas, acetylene, electricity, fluorescent and mercury lamps. Some kind of artificial light seems to have existed in all corners of the earth, since the most ancient times. By multiplying even the simplest type of light, the candle, man was able to produce quite satisfactory illumination so that he was not forced to go to sleep as soon as the sun had gone down.

No matter how brilliant artificial light may be, it has serious limitations as compared with the sun. First of all, it is effective for short distances only and fades out gradually as you go farther and farther from it. You can read by artificial light as long as you're near enough to the lamp. Its second limitation is that different kinds of light have different colors, ranging from a bluish, harsh white to a reddish ocher. (We aren't thinking of colored bulbs, which have definitely planned colors, such as red, green, orange.) Objects look different in every kind of light, and no artificial light is exactly like the light of the sun.

A third limitation, in art at least, is that artificial light casts stronger shadows than sunlight does, except for fluorescent lights which diffuse shadows to the point where shadows practically disappear, thus causing objects to seem rather flat. Finally, artificial light casts shadows in every direction, all round the source of light. A lamp hanging from the ceiling hits every object in the room at a different angle.

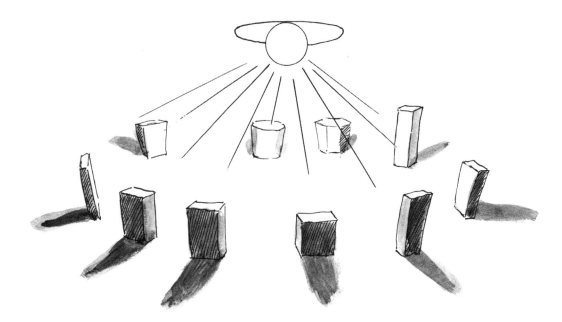

Shadows Cast by a Lamp. *A permanently fixed lamp doesn't move, so that the shadows it casts are always the same.*

Good features of artificial light

On the other hand, artificial light has good features, too. One is that it remains in one-and-the-same place, unless you deliberately move it. Lights and shadows created by such a light will also remain the same, whereas lights and shadows created by sunlight change with the position of the sun. Even though different types of lamps have different colors, the color of a specific kind of lamp is known in advance and remains unchanged. It isn't affected by weather, the time of day, the seasons. You can always count on the exact hue of any artificial light.

Gaslight is yellowish, almost like the moon; mercury lights are greenish, unflattering to most women, but entrancing for scenery; candlelight has its eternal fascination. Fire has a fantastic, often terrifying effect on whatever it illuminates; its color depends upon the material which is burning. How do we paint such lights?

Should we paint by artificial light?

Many artists are forced to paint by artificial light, because they have no time during the day. Few art schools have skylight studios and they cannot depend upon the constantly changing natural light. Artificial light is reliable; you can turn it on or off anytime. One thing to remember, though, is that a painting must be finished by the same light in which it was started.

It's literally impossible to match colors by another light. Begin a painting by sunlight, continue it by fluorescent light, then by daylight bulb, and look at it again by sunlight: you'll find it a mess of incredible patches. Hues you thought were exactly right when you applied them by one form of artificial light, prove to be

darker (or lighter) than you had planned. They're also completely different colors and values. What you thought was the right shade of pale blue turns out to be a greenish gray, at least a couple of shades darker.

Should we use phosphorescent colors?

Radium paints have been outlawed, because they have proved to be harmful even in very small doses. Luminous paints are fine for posters, or spooky Hallowe'en "novelties." All these paints merely glow, luminesce in the dark, without actually casting any light, whereas true light illuminates at least a small circle of space.

Bright colors, no matter how pure, expensive, or brilliant, never illuminate anything. You might paint a cityscape at night, full of glowing neon signs, and street lamps, creating a full illusion of reality. Yet, try to show the painting in a dark room, and it will be invisible. What we can produce in a painting is the appearance, the picture, of an illuminated place. Don't be deceived into thinking that phosphorescent colors, because they glow in the dark, can actually create light in a painting. A painting remains an illusion which you must create with color.

Paint light by showing its effect

Light is recognized by its effect. Turn your flashlight on in a dark hallway; its lens is a brilliant spot, of course, but painting such a spot will never look like a flashlight. In order to create the illusion of a flashlight, you have to paint the floor, steps, door, and whatever else in the hallway is hit by the beam of the flashlight.

Every major source of light is so well known that we recognize it by its effect. Pretend you were whisked away to another part of the world, blindfolded, with no idea where you were being taken, or during what time of day. Pretend that you find yourself in a strange room that has a window. When your blindfold is removed, you'd immediately know whether the room is lit by electricity, by the sun, or by a candle. You'd know, by looking at the window — without seeing the sky, the countryside, or street — whether it is a sunny day, a cloudy day, morning, afternoon, evening, or night. You recognize the source of light by the color, intensity, the contrasts between lights and shadows caused by the light.

If you want to render any of these lights, paint objects just exactly as they look in that particular light. Paint all colors and values correctly, and anyone should be able to tell what kind of light is depicted in your painting.

Painting a cityscape at night

Street lamps and brightly illuminated store windows cast stronger shadows than sunlight, because artificial lights are much closer to the objects casting the shadows and because, with the exception of fluorescent lamps, artificial lights don't diffuse as softly as sunlight. Also, there are as many shadows as there are sources

Pattern of Shadows. *When there are various sources of light, as in a street scene at night, each light casts its own shadow, forming interesting patterns of a geometric nature. These shadows are darkest where two or more of them overlap each other. The stronger a light, the deeper its shadow.*

of light. A window-shopper is hit by the light of the window, the street lamp on the corner, headlights of passing cars, flashing electric signs. Lights and shadows cross each other and interfere with each other's effects.

The lights of different lamps are also different. One side of your face may be orange-red, because there's a big red neon sign on that side; you look as green as a leprechaun on the other side, because you're hit by a brilliant green bulb.

Naturally, you cannot paint a picture in which lights go on and off, unless you construct a kind of pop-and-op art, with real electric light bulbs. You can, however, depict the variety of hues, reflections, and brilliance of lights. You can also suggest their motion by applying spots of bright colors in a soft, undefined manner. Impasto is most helpful for this subject. Build the various colors up in small spots, and leave the paint quite rough. This rough surface will catch the outside light and thus create a really sparkling effect.

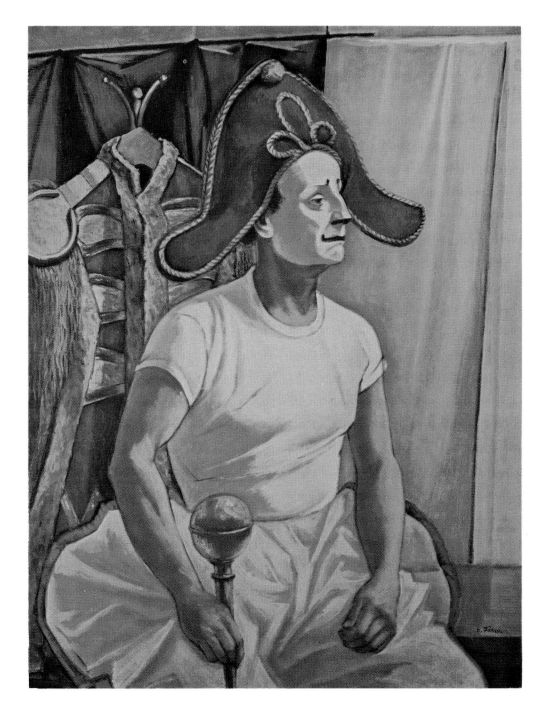

The Clown by Ernest Fiene. Oil.

A perennial theme in all the arts, the clown can still be done in a new, individual manner. The colors in this painting seem to be so natural that you wouldn't give them a second thought. Yet they're not accidental. The gold-braided red headgear is balanced with the matching coat on a hanger behind the clown; the white face is counterbalanced with the T-shirt. The cool, light blue and green curtains set the other colors off to the best advantage.

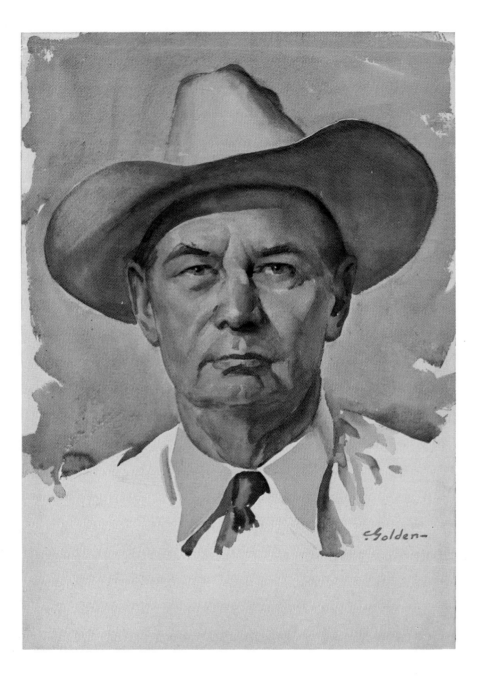

Ben by Charles Golden. Watercolor. 19 x 14.

This portrait is as earthly and comprehensible as Nana is spiritual and mysterious. Yet, both portraits show great strength of character. Both of them are executed in all imaginable detail, too. The effect, however, is totally different. Golden's watercolor is crisp, snappy, truly colorful, spontaneous. The shirt is done with a couple of washes, leaving the paper white where necessary. The face has all the subtle shades one expects to find in a realistic portrait. A comparison between Ben and Nana shows how diametrically different the concepts, the approaches of various artists to the same subject can be.

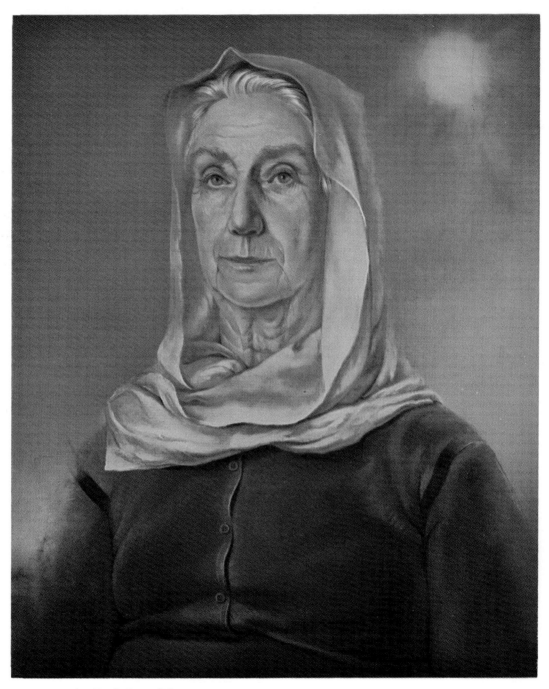

Nana by Ruth Ray. Oil. 24 x 20.

All the details in this realistic portrait are pitilessly observed and rendered. There's a surrealist overtone in the picture: the mysterious light in the upper right-hand corner, casting a soft glow on the canvas. This mellow tone imbues the precise — even dry — lines and forms with a spiritual quality. The painting is almost monochromatic. Only the blue eyes are basically different from the buff-and-brown hues, but there are countless delicate shades in face, head-kerchief, and heavy dress.

In the Park by Albert Gold. Oil on gesso. 26 1/2 x 18 1/2.

Genre pictures are no longer as popular as they used to be, but illustrations, or story-telling pictures, are still in vogue. Not only in our magazines and books, but many people still like to see them on their walls. Skill and knowledge must go into such work, because the picture has to convey a message to be understood by the simplest people. A realistic image demands realistic coloring. Here's a conversation piece, well drawn and painted with a full grasp of color perspective and values.

Mrs. Gideon Nachumi by Keith Shaw Williams. Oil. 36 x 30.

This is a sensitive portrait in oil. The intellectual and beautiful face, the graceful, yet capable hands, the nicely curving back of the sofa, all form a pleasing composition. Textural differences — flesh, dress, hair, wood, upholstery — are exquisitely rendered. Above all, the realistic portrait is turned into an extraordinary picture by the coloring. The warm fleshtones, warm hair, and background are counterpointed by the lovely turquoise dress. Every hue seems to be just right. It's impossible to imagine the same woman wearing a red dress in this picture.

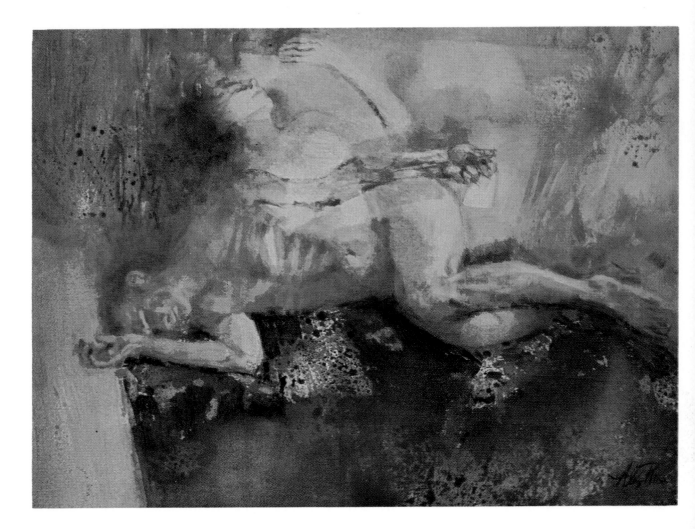

The Birth of Eve by Alex Ross. Watercolor. 20 x 27 3/4. (above)

This is a sort of dream picture. Eve is growing out of the rib of the sleeping Adam, but this is no literal illustration of the biblical story. It's a fantasy that might be childish or even ludicrous if it weren't for the inspired composition and the lovely, appropriately mysterious colors. The contrast between the reddish-brown lower part — a combination of earth and couch — and the green-gray figures melting into a background of the same shades, constitutes a haunting image, an apparition. The technique of allowing colors to crawl and flow into each other contributes to the eerie, yet emotionally moving quality of the painting.

Standing Nude by Robert Philipp. Oil. (left)

Somewhat in the fashion of the Venetian artists of the Renaissance and Baroque, a golden tone pervades this nude holding a rather heavy piece of drapery. Neither the blues and greens, nor the reds and yellows are applied in a pure state, as they come from the tubes. This subdued tonality is in keeping with the pensive face of the woman. The number of main colors is deceptively small — flesh, red, green, gold — but there are innumerable shades of each.

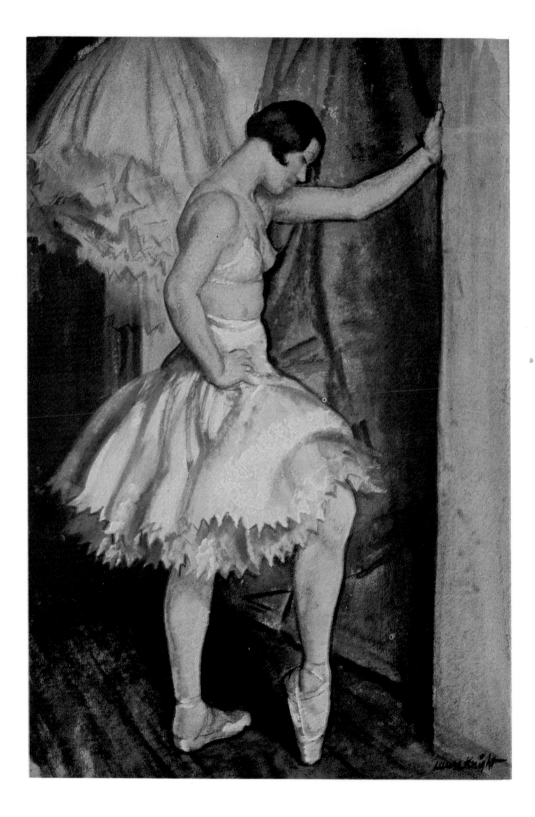

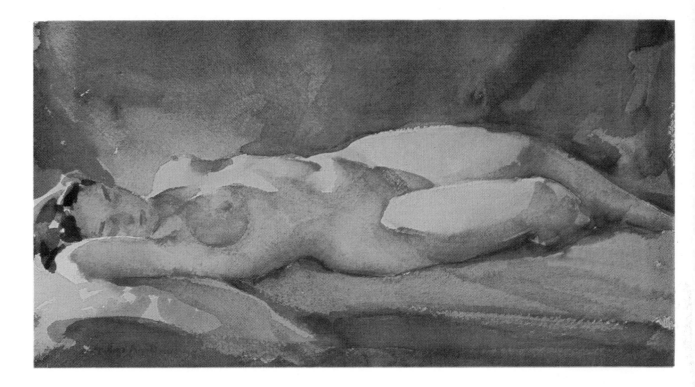

Nude by Tore Asplund. Watercolor. 8 1/2 x 16. (above)

Life figures are perhaps more difficult to do in aquarelle than in any other medium, because corrections or changes are almost impossible. Any scrubbing or scraping would damage the surface of the paper, affecting the human figure painted on it. The artist did this particular nude in thin washes, over a good layout. He took advantage of the white paper for highlights and employed only a few colors. The brown, red, and violet washes in the couch and in the background enliven the subtle fleshtones in the reclining woman.

Ballet Girl by Dame Laura Knight. Oil. (left)

This oil painting depicts a muscular dancer. The gracefully poised girl is dramatized by the very dark background and floor, and the equally deep shadow cast by the pillar against which she is leaning. Once again, an old story is told in a new way, and thus transformed into an original creation. The originality lies partly in the novel composition and partly in the color contrasts, which are far from the pastel shades customarily — almost automatically — employed in, and associated with, ballet subjects. Courtesy, Studio Publications.

Color in Portraits and Figures 137

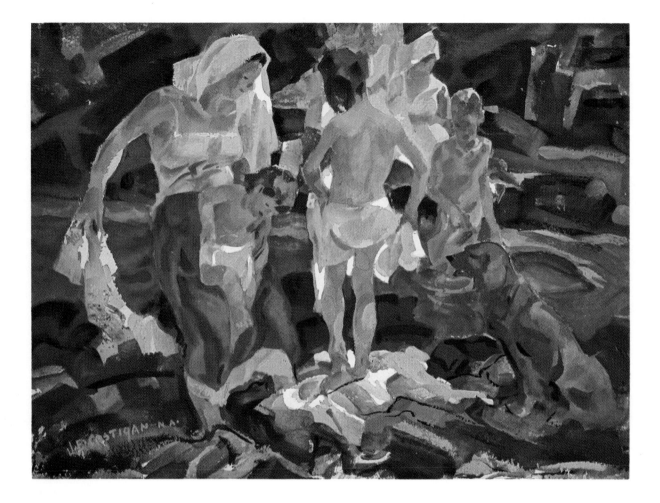

Group of Bathers by John E. Costigan. Watercolor and gouache. 20 x 27 1/2.

The artist has dedicated most of his career to similar groups of adults, children, and domestic animals. White plays an important role in this picture. It's the criterion by which the artist as well as the onlooker can judge the values of other colors. The dark blue-brown-gray background, with the white pieces of clothing, gives the work a dramatic quality. The bathers seem to be protagonists in a vitally important activity, as if their lives depended upon this bathing project.

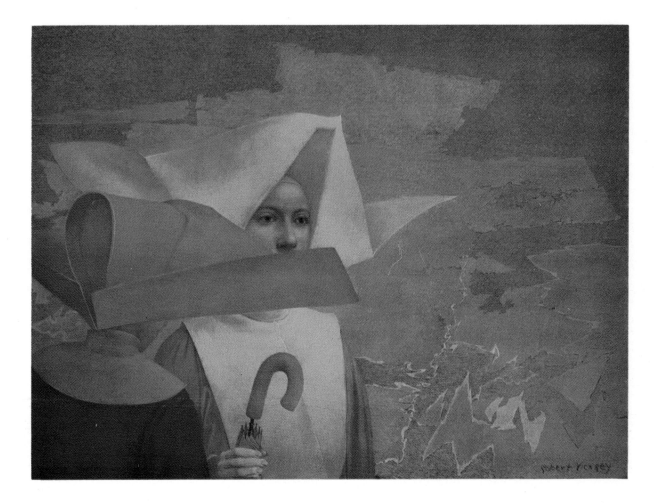

The Umbrella by Robert Vickrey. Tempera. 16 x 20.

A master craftsman proves that a contemporary artist may render every photographic detail, yet create a fully individual work of art. All he needs is an unusual, perhaps whimsical idea and a novel composition or arrangement. The delicacy of this particular subject is matched by the delicate colors. But, whether an artist employs pastel shades or bold, dramatic colors, the basic principles remain the same: cool and warm hues must be juxtaposed — in order to obtain a spatial effect — and values must be observed, lest a part of the picture look like a hole or a piece of paper, or band-aid stuck onto the surface. Collection, Ralph Gerstle. Courtesy, Midtown Gallery.

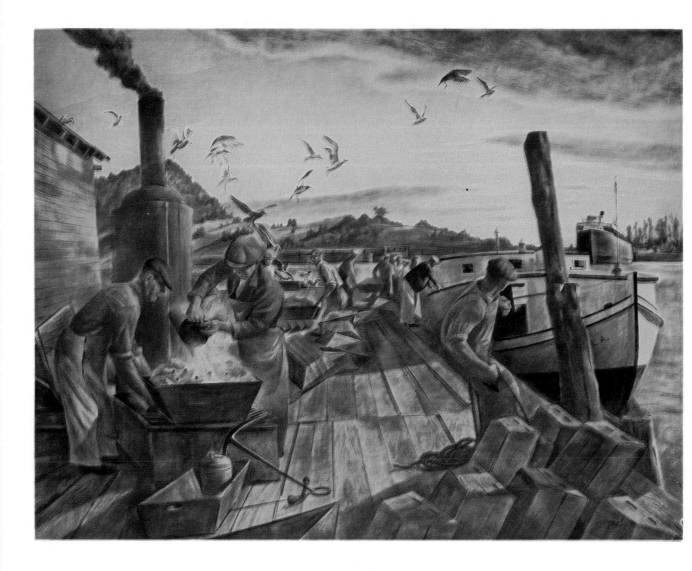

Fisherman's Morning by Zoltan Sepeshy. Tempera. 28 x 36.

Although the scene is almost like a snapshot, it differs greatly from a photograph by its power, and the deliberateness of every detail. Depth is enhanced by strong contrasts between sharply-outlined geometric forms — such as planks and vats — and the action-packed human figures. The gray-brown hues of wood, the cool tones of water, sky, and boats, are all counterbalanced with the reddish colors of shirts, faces, and arms. Well-defined shadows give the picture a kaleidoscopic effect. Courtesy Midtown Gallery.

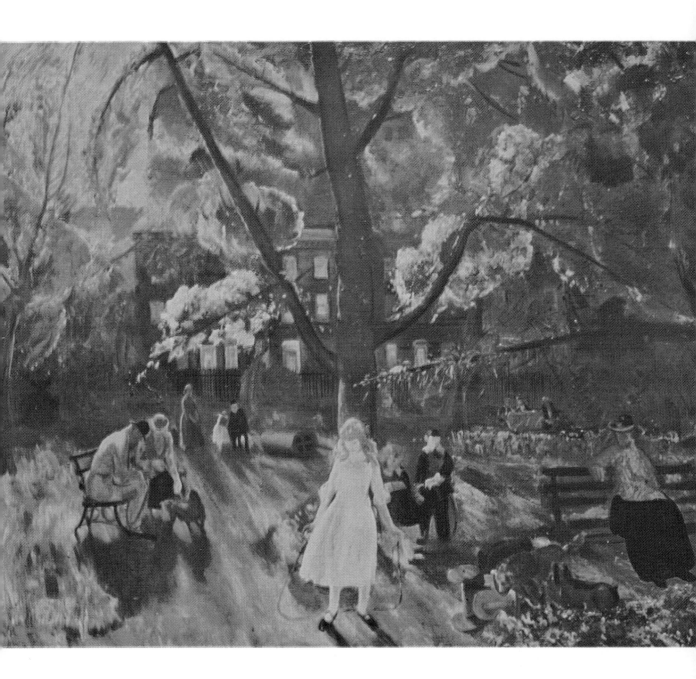

Gramercy Park by George Bellows. Oil. 34 x 44.

As recently as the 1920s, this work by a member of The Eight was considered revolution-
ary nonsense, "ashcan" art. Today, we appreciate its over-all effect of the afternoon sunlight
streaming through the foliage of the elegant little park. Cool greens in the shade; warm, orange-
tinted yellows in the light; violet tones in the houses, trees and in the shadow on the ground
characterize this nostalgic scene. The fashions in clothing are quite different now, and the trees
in Gramercy Park are much older and bigger, of course.

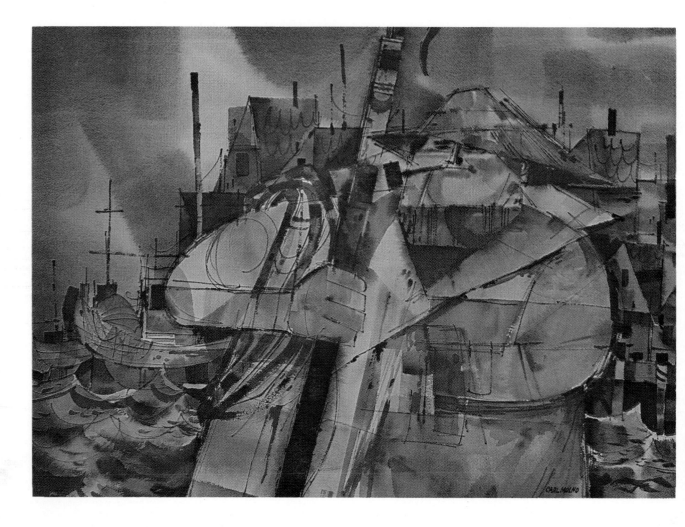

Captain Jack by Carl N. Molno. Watercolor and ink. 21 x 29.

This is a brilliant pen-and-ink watercolor in a contemporary vein. The captain, in his yellow-orange coat and storm hat, is surrounded by a blue-and-turquoise backdrop in which structures, clouds, and waves are worked into a sort of frame, with a few gaily-colored boats dancing on the water. The artist evidently enjoyed doing this picture. He was more interested in designs and bright color effects than he was in any realism.

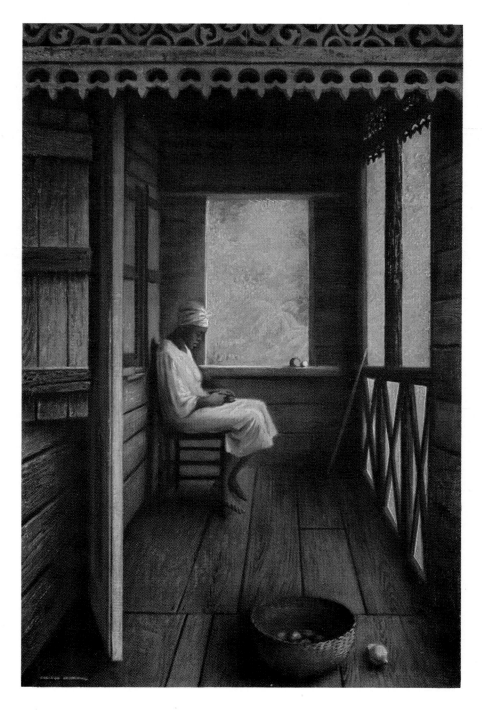

Green Afternoon by Colleen Browning. Oil. 30 x 20 1/2.

The dull, unpainted wooden structure in this painting is surrounded by bright, green vege-tation. There are only a couple of brilliant spots in the whole picture: a lemon on the floor, a red fruit in the basket, a red fruit, and a yellow fruit again on the window ledge. The unusual contrast between darker and lighter gray-browns in the house, the very intense greens in the distance, and the white-clad figure sitting on the veranda give a mood of rustic tranquility.

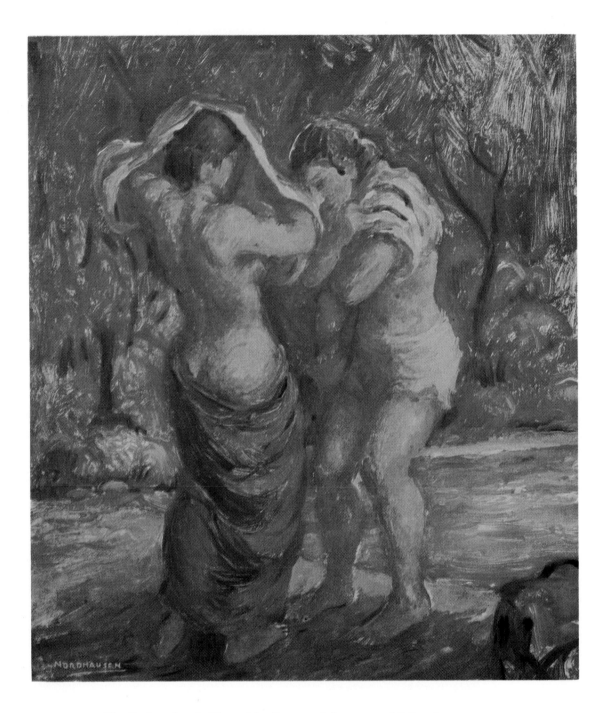

The Bathers by A. Henry Nordhausen. Monotype. 6 7/8 x 6.

This print depicts two well-built women just out of the creek or swimming hole, vigorously drying themselves with towels. The robust figures look bright and warm against the cool blue of the water and the dull greens of the vegetation. The repetition of the warm pink of the bodies in the ground makes it clear that the two semi-nudes and the scenery are combined to form a cohesive picture. The violet skirt on one of the women emphasizes the importance of violet as an intermediate hue between warm and cool colors.

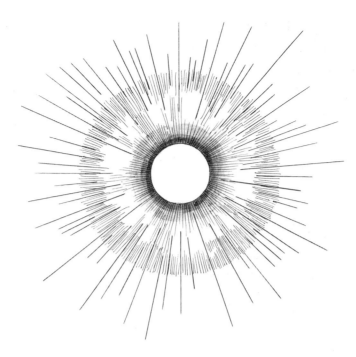

Halo of Light. *Every source of light — natural or artificial — has a kind of halo, usually several rings of different hues. The ring closest to the light may be lavender, purple, blue, or green, depending upon the color of the light and the color of the surroundings. Observe these hues carefully.*

The importance of careful observation

Spend a little time observing electric lights, mercury lamps, signs of all sorts. Look at them with both eyes open, then squint-eyed, and with one eye closed. You'll notice that none of the lights is just a dab of paint of a definite hue. Rather, each light has a multiplicity of colors, almost like a diamond which breaks the light into all the hues of the rainbow.

You'll further notice that colors round the lights also change. Something like a halo forms around certain lights, often with bright rays shooting out in all directions, like a big star, crossing the rings of rainbow hues. Remember that children always draw or paint the sun as a yellow disc, with yellow rays all round. Children don't see the discs or rings around the light. Yet there they are, those lavender or purple discs, softly blending into green, or blue-green hues outside the halo. Observe and jot down the names of the colors on a simple pencil sketch and try to paint the effect by broad daylight.

Let me admit at once that this isn't easy. You'll have to try, and try again, with darker, and lighter tones, softer, and bolder contrasts, until you achieve the appearance of glowing lights. The next problem is to render people, cars, walls, windows by these lights. Basic colors remain recognizable by artificial light, but the differences are great.

Exercise in perceiving color by artificial light

Take construction paper, cardboard, fabrics of all sorts in different colors and shades. Cut them into the same size, about 5" square. Mark the names of the hues and shades on the back of each piece; or number them and keep a list of what each number signifies.

Look at each piece by candle flame, by a small, yellowish electric bulb, by a white bulb, by white fluorescent light, pink fluorescent light, by the light of a blue bulb, a red bulb, an orange-colored bulb, a green bulb. Almost any household can easily provide these different lights, or at least some of them. You can buy colored bulbs and insert them in the same socket, one after the other.

Try to determine each color, each shade by each of these lights. You'll be able to tell, in most instances, whether a color is red, blue, green, or yellow, but you won't ever guess the actual shade of each. You might turn this exercise into a parlor game, too.

Painting indoor subjects by artificial light

Indoors, the problem is similar but more comfortable. It's easier to observe objects indoors than outdoors, where things move and you make yourself conspicuous, even suspicious, by sketching, taking notes, acting like a spy. In your own home, you can light a candle and watch its flame. The flame of a candle is not a plain yellow tongue connected to the candle by a wick. The flame usually has a blue-violet core, almost elliptical, surrounded by lighter and darker shades of yellow, turning into the lightest possible green round the edges. There's a bluish crimson disc all round, broken by close-knit lines of yellow or yellowish green. A few longer lines radiate from the center of the flame in all directions.

The small candle flame illuminates nearby articles, throwing on all of them a yellowish tone, brighter near the flame, fading into darkness gradually. It may be reflected in a glass-covered picture, or in a mirror on the wall. The dark mass of a piece of furniture may be discernible against the somewhat lighter wall. Everything in the background is dark, yet never jet black. Nor is anything pure white or yellow. The brightest spot can only be the flame itself. Use that as your standard; compare all other colors and values with the flame.

In rendering such a scene, your best bet is to paint only the major forms, omitting details. Don't paint what you know is there; stick to what you actually see. There's a big difference between the two ways of painting. You know, for instance, that the cabinet in the background has doors, doorknobs, and certain decorations, so you want to paint them. The fact, however, is that you do not, you cannot possibly see those details in the darkness.

Candle light cannot give sharp edges, ever, because it flickers incessantly. This softens all outlines, all shapes. You can achieve the effect by going over your painting with very transparent glazes of yellow ocher, making the glaze somewhat brighter near the candle. If your painting is based on actual, careful observation, and if it is rendered with skill, it will look like a picture of a candle-lit room.

Diagram of Candle Light. *A candle flame is not merely a yellow tongue cut out of paper. It has a light lavender core, as a rule, and various shades of yellow. Its halo can best be noticed if you squint while looking at it.*

Painting a fireplace scene

An open flame, concentrated in a fireplace, casts large, flickering shadows in a semi-circle. The light comes from much lower than normal light, so that the illuminated parts of people and objects are practically the reverse of what they'd ordinarily be. For example, the bottoms of chins and nostrils, the lower eyelids, the upper lips on each person are bright, the rest is dark. Almost like a photographic negative. It's weird and romantic to find such a reversal of everyday appearance. Even if you paint such a scene without showing the fireplace itself, everyone will know what it is by the reversal of lights and shadows and by the warm red glow that prevails.

In a view looking from the rear toward the fireplace, figures and objects are silhouetted with glowing outlines, but the dark forms are still not pitch black. Fine nuances must be observed. Notice the reddish reflections here and there. If you fail to depict these subtle variations, your painting will look as if you had pasted figures cut from black paper on an orange or yellow sheet of paper. It will be a poster, a flat design, not a three dimensional picture.

Light Can Change Your Face. *Light can change the appearance of a person to the point where you can hardly recognize him. On the left is a woman, illuminated by normal light, coming from slightly above. Shadows are under her eyebrows, nose, chin, and upper lip. The top of her hair is hit by the light; the bottom is in shadow. On the right, the same woman is illuminated by the light of a fireplace, or any light coming from below. Her forehead, upper cheeks, and upper part of her chin are in shadow; there is light under her eyebrows, on her upper lip, and on her neck under the chin. Her hair is dark on top, and illuminated on the bottom.*

Campfire Shadows. *In a campfire scene, people sit in a circle, their backs silhouetted against the fire, their shadows cast in all directions like the spokes of a wheel. The figures are not jet black; they aren't cut out of black paper. You can see glowing outlines, indicating forms of figures and clothes.*

Painting a campfire scene

A campfire scene is almost like a fireplace, except that figures sit all round in a circle. Of course, you could only see and paint a complete view from a hilltop or from some other higher level. If you're one of the people sitting on the ground, you can only see a few other people. The light in a campfire scene radiates in all directions and so do the shadows, like the spokes of a wheel. Perspective and foreshortening play a big role in such a subject, but the ultimate effect is achieved by the colors: the right hues, right highlights, right shadows, in the right places.

How to achieve brightness

Don't for a moment think that dropping a bright spot on a dark background gives the effect of glowing light. It will only be a bright spot on a dark ground, like an accidental splattering of a piece of paper.

Generally, a cool light looks brighter on a warm background, a warm light is more brilliant on a cool background. Thus, a blue neon sign is literally bluer and brighter on a dark red-violet than it is on a dark ultramarine blue; orange has more intensity on deep blue, or on blue-green than it has on a bright red ground. You can make any spot appear like an electric light by outlining it with a pale blue, a pale green, a pale pink, or a pale orange, depending upon the color of the spot and the color of the background. Experiment with various combinations.

As I mentioned before, impasto can be most helpful in this subject. A thick, roughly applied dab of paint, especially when varnished, catches the outside light. Fireworks and fiesta scenes are greatly enhanced by impasto.

In watercolor, you have to paint the brightest spots first, with the cleanest paint, brush, and water. Add the rings or halos of the required hues, blending them before the aquarelle dries. Then paint the darks around the brilliant spots.

Many aquarellists use frisket, masking compound, or just ordinary rubber cement, to block out the sections which have to be bright. Any of these substances forms a protective film that can be rubbed or peeled off without any trouble. Paint the entire background across these blocked-out waterproof sections so that the aquarelle doesn't affect them in the least. When everything around these sections is finished, rub off the spots of frisket with your fingertips and paint the bright hues.

It's important to watch the highlights on any color. Don't just paint a drop of white in the center of any object. The highlight may be off-center, depending upon the shape of the article and the position of the light source. As for the color, the highlight may be white on yellow; pale green on orange; the palest blue on red; a very light green on a blue surface.

Experimentation is worth more than any formula. Spend a little time testing effects of all kinds, either with paint or with construction paper. Paper may not come in all the subtle varieties of hues obtainable in painting, but it offers you an easy, quick method of comparing. Instead of construction paper, which has a dull finish, you might try to get glossy paper in a number of colors. Glossy paper is closer to most pictorial effects than dull paper.

Exercise in glowing light effects

Take construction paper or glossy paper in the following colors: lemon yellow, light green, dark green, light blue, dark blue, light violet, dark violet, and dark red.

A. Cut seven discs from the lemon yellow sheet, each 3/4″ in diameter.

B. Now make seven different discs of each remaining color — excluding the yellow. Draw circles with a compass, each circle of a different diameter: 1 1/2″, 2 1/2″, 3 1/2″, 4 1/2″, 5 1/2″, 6 1/2″, and 7 1/2″.

C. Cut out the discs with sharp scissors, knife, or razor blade in a safety holder. If you work with a knife or razor blade, place a thick piece of cardboard underneath the paper. Otherwise, you'll cut the table and ruin your knife, or blade in a few seconds. The discs needn't be perfectly circular. You're planning an artistic exercise, not a precision instrument.

D. Arrange the seven largest discs (seven different colors) in a row; place the next largest discs upon these, then the next largest, and so forth, until you have seven full piles of discs of seven colors each, ranging from the biggest at the bottom to the smallest on the top. Each set is to have a different sequence of hues. Reading from the bottom up, they should be as follows:

1. Dark red, dark blue, light violet, dark green, dark violet, light green, dark green.

2. Dark green, dark red, light green, light violet, dark blue, dark violet, dark red.

3. Dark blue, light violet, light blue, dark violet, dark green, dark red, light green.

4. Dark violet, dark green, dark red, light green, light blue, dark blue, light violet.

5. Light violet, light green, dark violet, dark red, light green, dark green, light blue.

6. Light blue, dark violet, dark green, dark blue, dark red, light violet, dark violet.

7. Light green, light blue, dark blue, dark violet, light violet, light blue, dark blue.

Place one of the small yellow discs on top of each pile and observe the total effect from a distance.

You'll notice that the yellow appears to be different on each pile of discs, ranging from a very bright yellow to a yellow which is almost like a dull ocher. To make the exercise complete, cut seven small discs of white — with a paper punch, if you have one — and place one white dot in the center of every yellow disc. The brightness will differ even more in each group of colors.

Does this sound like an awful lot of work? It really isn't. You'll probably find it fun and exciting, too. Furthermore, you might omit a couple of discs, if you wish. Also, since you have the same number of discs of the same size in all the hues, why not vary them in more ways than I've suggested above? The whole thing is no more difficult than playing solitaire with a pack of cards. And you cannot lose, as you mostly do when playing solitaire.

Important and exciting shadows

There's no light without shadow, but we usually think of shadows as something unavoidable, rather than pleasant. Yet, shadows can be as beautiful, as monumental, as exciting as lights are. They can also be more mysterious. When there are several sources of light — as in a street scene at night — each light affects everything differently, and every item has as many shadows as the number of lights hitting it. The shadow is darkest where several shadows overlap each other, often forming interesting geometric patterns.

Observing shadows in diverse lights is important not only in realistic painting. It's perhaps even more intriguing to see what shadows can do for you in the realm of mystery and imagination. Danger lurks in the dark. Huge shadows are frightening or ominous to adults and to children.

The artist has to have a storehouse of effects, a kind of art vocabulary, for use in any possible subject matter. Art has always been associated with magic: beliefs, superstitions, spooks, ghosts, mental, spiritual, or spiritistic adventure, the eternal magic of romance and make-believe. Art can also be an excellent story-teller, even if few artists practice that kind of art in our times, except, of course, in book illustrations. But that's a great branch of art, too.

Light can be placed in unusual positions

For mysterious shadows, it's often necessary to place the source of light in an unusual position. In Rembrandt's most entrancing works, we often encounter such lights, coming from an unseen part of the picture, or from outside the frame, perhaps from another world. These lights softly illuminate unexpected features and introduce transparent, but deep shadows, in which we sometimes can discern forms of humans or objects.

A light on the floor creates a threatening shadow, because any article so illuminated has very tall shadows, especially when it is on, or close to, a wall. Put two lights on the floor, one a little to the right, the other to the left. A short person, or even a little doll, or any innocent article near these lights will appear to have two huge wings on the wall behind. Small lights coming from directly above may create a feeling of a face, or the upper part of a figure, floating in midair, because the lower parts are in shadow.

The colors of shadows and lights may be realistic or imaginary, but they must never look as if they had been cut out of paper and pasted on the support. Beware of painting even the deepest shadow pitch black. Employ other colors: ultramarine blue with alizarin crimson gives you a dark, yet translucent color. Such a mixture has more depth than a spot painted pure black. The difference is similar to having two black things next to each other: a sheet of black cloth hanging from the wall, and an opening in the wall (of exactly the same size as the black cloth) leading to a completely dark room or cavern. Even from a distance, you'll notice that one darkness is flat, whereas the other darkness has depth. Try to remember this when you want to convey depth in your painting.

Ominous Shadows. *Cleverly placed lights can result in mystifying or ominous shadows. In the drawing on the left, a doll is illuminated by two lights on the floor, one a little to the right, the other to the left of the doll. In the drawing on the right, the same doll is attached higher up on the wall, with two electric bulbs above its head, right and left. Such effects can easily be incorporated in imaginative paintings.*

Exercise in perceiving black

Take a shoe box and cover its whole inside with black paint or black paper. Draw two 4" squares on the cover of the box, leaving a 2" space between them. The cover of a normal shoe box is about 6" x 13". Cut out one of the two squares with a sharp knife, and cover the other square with black paint or black paper. Stand the box up and walk away. Look at it from a distance of about ten feet. You'll immediately see a very big difference between the flat black square, and the open square, through which you see the inside of the box, painted black. You may be inclined to believe that black is black, but you'll notice that one of the squares is flat, the other one has depth, without finding it necessary to put your finger through the square hole.

13. Optical Effects in Color and Design

Whatever is visible to the normal human eye must have color as well as form and size. We say that water and clear glass are colorless, but that's true only in physics or when we use a nice sheet of glass in a window or in a picture frame. Even in these cases, a truly perceptive eye notices differences between objects seen through the glass, and the same objects viewed without the glass.

Color of glass and water

Above all, both glass and water reflect the colors of their surroundings. In large masses, they also have colors of their own. You may not see from a distance whether a clear glass contains water or not but you do see the glass. You couldn't see it at all if the glass were really colorless.

You see water in rivers, lakes, the sea, and in swimming pools. As a matter of fact, such masses of water are quite colorful, because they change according to the sky, the sun, and the clouds. They also change according to the depth of the water, from light green to deep blue. The physicist takes a drop of water and calls it colorless. You can, however, paint a drop of water spilled on the table. How could you, if that drop of water were colorless?

There's a big difference between the visual appearance of colors and the basic, original, what we call *local colors* of objects. This is true in the same way that there's a big difference between the visual appearance of forms as opposed to the diagrammatic shapes by which we remember the same forms. Thus, a cube painted light blue is a geometric object with six square sides of the identical size, all painted exactly the same light blue. Yet, when you look at such a cube from an angle, you never see more than two sides and the top or bottom; and none of these three visible sides is square, visually. Neither does the light blue color appear the same on those three sides. In a normal light coming from one source shadows are created on two of the three visible sides.

This, of course, is the foundation of traditional Western art: painstaking observation and rendering of visual facts, an understanding of perspective, light and

shadow, proportions, so that the result is a completely three dimensional appear-ance of figures, scenes, and objects depicted. It's not the only kind of art, though. For the past hundred and fifty years, the West has gone through a great many dif-ferent styles or schools of art, some of which eliminated many of the traditional principles until certain artists painted absolutely unrecognizable, nonexistent forms. Perhaps as a reaction to the seemingly — though not always actually — haphazard types of painting, the 1960s saw the introduction of what's generally called Op art.

What is op art?

Linear and color illusions are all around us. A suit, or dress makes its wearer appear to be less fat or less slender than he or she really is. We see dark spots jump-ing like mad when we turn to the shady side of the street after having looked at the bright, sunny side. We look at two houses in a project — where each house is exactly like the other in size and shape, but the colors of the doors and roofs are different — and we believe that the light yellow door is bigger than the dark green door, al-though they are the same in size. These are everyday illusions, playing tricks on our eyes.

Painting itself is a great optical illusion. Many of the large murals created dur-ing the Renaissance and the Baroque are so absolutely lifelike that you think they're the real things. It seems as if you could walk up the stairs, behind the tables, be-tween the columns and shake hands with the people depicted in those paintings. While artists have employed optical illusions for centuries as integral parts of their subjects, op art deifies the optical illusion itself, and makes it the supreme goal of art.

The op artist works with color as well as line and pattern. He adds the color il-lusions to the linear illusions known since the age of ancient Greece. One of the best known of these artists, Josef Albers, painted a series he called *Homage to the Square* — paintings consisting exclusively of squares: a few squares in one painting; many of them in another, bigger and smaller squares, in various colors, diverse patterns; squares closer to, or farther from each other; squares closer to one side than to the other. He succeeded in creating peculiar illusions. The squares appear to be mov-ing or sliding; some appear to jump forward, others go back and forth. You feel you're in a tunnel with doors and windows opening and closing in front of you. There are moments when you're sure one of the squares changes places with an-other. Albers manipulated these illusions with the help of colors, sizes, and spacing.

This isn't easy to explain. For some baffling reason, cool colors seem to float, for example. The danger of painting blue lies in this optical fact. According to a clever anecdote, Sir Joshua Reynolds, who had very positive opinions on all sub-jects, preached to his students never to use blue for an important section of a paint-ing, because blue floats. Thomas Gainsborough, who had a running feud with Sir Joshua, heard of this and promptly dashed off the full length portrait of *Master Buttall*. The young man was painted in a blue garment to prove that blue may well be used as the main color in a painting. We now know this painting all over the world as *The Blue Boy*. (We also happen to know that this work was done ten years before Reynolds ever declared that blue must not be employed, but it's a good story,

anyway!) And it's quite true that blue seems to float forward, while many other hues recede. What the anecdote fails to tell you is that Gainsborough used a dark, somewhat subdued blue, not a light and bright shade of blue.

Importance of repeat patterns

When the eye is fixed on a pattern in which two main forms, designs, and/or colors alternate, the eye tends to see only one of the forms; or the two forms seem to be in a kind of constant motion or vibration. An example of this optical illusion is a stairway, drawn in linear perspective in such a way that the tread and riser of each step are visible. Stare at the drawing for a few seconds, and you'll begin to wonder if the steps are going down or up. You aren't sure, ever.

Upstairs or Downstairs? *As your eyes go one way or the other, the stairs appear to go up or down; you never know just which way. Actually, this stairway is not going anywhere. No matter where you start, you'd come back to the starting point. Such bizarre effects can be avoided if you know enough about perspective not to draw stairs or streets (especially streets on a hillside) incorrectly — unless you want onlookers to wonder where your street or stairway starts and where it ends.*

Rings and Crosses. *Repeat patterns can play tricks on your eyes. In this design, consisting of rings and crosses, you may think that the crosses predominate, or that the rings are the main features, or that rings and crosses appear to be changing places, jumping in and out. The effect is greatly enhanced when slightly different colors are employed, such as pink crosses and pale blue rings.*

Notice the pattern of a metal fence consisting of rings or discs, and crosses with arms of equal length. One viewer sees only the rings or discs; another person sees only the crosses; still another alternately sees crosses *and* rings. If the discs or rings are painted a light yellow and the crosses are pale blue, the two motifs will seem to be coming in and out, crossing each other, depending upon the angle from which you look at them, or according to the way you just happen to be observing the pattern. Any other color scheme would cause the same result, provided that the two colors are basically different.

To use the idea of Josef Albers, let's look at squares drawn and painted within one another. Depending upon the arrangement, you can create the feeling of considerable depth — a tunnel, a box, a room, something standing still, or something in motion. Triangles also lend themselves to such optical illusions, and there's no reason why other geometric forms, such as circles, ellipses, hexagonal and octagonal shapes should not play the same optical tricks on you.

Some artists work with undulating lines, stripes, or shapes so ingeniously that the onlooker feels dizzy. The color effects discovered since Turner first painted turbulent waves and clouds, and since Monet exhibited his *Impression du soleil levant*, have logically led to the point where color and motion are the main ingredients of much of our art. Criss-crossing lines, in various light and dark, warm and cool colors, appear to be weaving in and out, and you can't tell which set of stripes is closer to you, which is farther from you, until you go close to the painting and realize that all of them are done equally flat on the same big panel.

Optical gadgets and toys

Some forms or gadgets of optical art have been employed in window displays to attract the attention of passers-by, years before artists did "op art." One of the best known of these attractions was, and still is, the wavelike spiraling design, reaching from floor to ceiling, revolving on a pivot. It gives the sensation of something being drilled into the ceiling, or into the floor. The sensation depends upon

Squares in Squares. *Squares can make you feel you're in a tunnel or corridor, with an exit at the far end. Sometimes you feel that you can get straight out; at other times, you feel that the door is closed.*

Triangles in Each Other. *Triangles and other shapes have similar optical effects of depth, or jumping in and out, depending upon the colors as well as on the design. Such optical illusions can be utilized in the fine arts. After all, painting is an optical illusion in the first place.*

Waves and Bulges (top left). *Wavy repeat patterns create a feeling of movement, a kind of bending in and out, or up and down. Such illusions are interesting and helpful to you whenever you depict objects in motion. There are many such possibilities: clouds, vehicles, and so forth.*

Criss-Cross Depth (bottom left). *Criss-crossing stripes and forms, painted in light and dark hues, create effects of depth without needing any shading. If you paint three pine trees next to each other, each of them a couple of shades lighter than the other, they'll seem to be farther and farther away, even though of the same size and shape, without lights and shadows.*

Into the Ceiling? Into the Floor? (right). *Spiraling patterns have long been used as advertising stunts in store windows. Reaching from floor to ceiling, such spiral gadgets revolve on a pivot and seem to be drilling into the ceiling or floor, depending upon the angle from which you observe them. These spirals seem to be moving continually. In painting, you can achieve the effect of motion by painting the spiral in a sketchy way, without sharp outlines.*

which direction happens to attract your eyes first. One side of the spiral is one color, the other side another color. Toys of a similar nature, appearing to be driven like a corkscrew, in one direction or the opposite direction, are also known. Such gadgets seem to be screwed into each other or pulled out from each other, again depending upon how you happen to look at them.

There's something fascinating about such seemingly endless motion, even if it's meaningless from an esthetic viewpoint. It's not necessarily meaningless, though; it may well serve an artistic purpose. And that's where the painter comes in. The painter ought to be wide awake and see what's going on in this ever-changing world. Neither optical illusion nor the idea of motion is new to painters.

Painting motion

The impressionists tried to paint motion by working in a sketchy manner, without definite outlines. They left their forms blurred to indicate people and carriages passing by. The Futurists, early in the twentieth century, emphasized motion. They depicted it by showing persons and animals with many legs and arms, each arm and leg in a slightly different position; wheels of carriages would be shown as overlapping circles or ellipses, if seen from an angle. Their idea was very much like the multi-exposure camera, which takes a large number of pictures over a period of a few seconds on one-and-the-same film.

In advertising and comic strips, artists indicate speed, or running with the so-called speed lines: shorter and longer lines drawn across the person or animal in the opposite direction from the one in which he is dashing.

Perhaps you'll discover a way to utilize the revolving effect of the spiraling forms in your painting. You might have a subject in which this spiral would fit. One never knows. As I said before, the artist should accumulate all kinds of knowledge, material, and skill so that, when the time comes, he should be ready to act promptly and well. Artists make sketches of odds and ends. They may never use some of these sketches, but it's good to have them. They may give inspiration in some unexpected direction.

I advise you to study the intricacies of op art, trying to incorporate some of them in your own paintings in a logical as well as artistic fashion. Do this not for the sake of doing something different, or for the sake of showing to your friends that you're up-to-the-minute. Do it for the sake of doing something good for your own art. If a square appears to come forward, and another square seems to be going away — due to the selection and placement of colors — you might find it possible to create similar illusions, or better ones, in a realistic picture.

The Impressionists taught us how to observe colors in real life, instead of learning about them in a studio. The Impressionists proved that colors are innumerable, that they can be made to sparkle, that they can create a feeling of space and air, that we can show in colors at what time of the day a painting was executed. Op art might teach you how to paint more striking effects. It can show you how a slight change in size, shape, color, and value might make the difference between a fine and interesting painting and a poor and dull one.

14. Expressing Yourself in Color

There can be hardly any question about the fact that man wants to express himself. Psychologists, psychiatrists, and psychoanalysts all over the world deal with this problem. We know through the efforts of these professionals that some self-expression is ugly, some is beautiful. Art, of course — every branch of art — is considered a wonderful way of expressing yourself, because it's creative work, based on your personality as well as on your knowledge, skill, and temperament.

Is color a medium of self-expression?

We find pure line drawings on the walls of prehistoric caves and lines scratched by prehistoric artists into flat pieces of bone. Man used geometric patterns in his artifacts, based on previous construction methods. Clay pots, for instance, were decorated to resemble basket-weave. At the height of Athenian civilization, magnificent vases still had rows of such basket-weave designs. In the aboriginal art of New Zealand, lines evolved into admirably graceful spirals that vie in artistry with any decoration created in any of the world's greatest civilizations.

Obviously, man was always able to depict objects in lines, but he also liked colors and added them to his images at an early age. Unquestionably, color was meant to be realistic in recognizable forms and figures, with the sole exception of the Etruscans. Those people loved color for its own sake, and employed it in a cheerful, often witty manner. For example, they painted every part of a horse in a different hue. The colors of the Etruscans might well be considered a true form of self-expression. They expressed their joy of life, their belief that we ought to take advantage of all the beauties and pleasures of this earth while we're alive.

The ancient Egyptians, on the other hand, believed that whatever paintings and sculpture they placed in their tombs — depictions of slaves, fruits, cattle, boats, musicians — would be real in the hereafter. Their aim was to paint as many of these as possible, neatly, but diagrammatically, with all important features shown.

In all ancient civilizations, including Greek and Roman, statues were painted in realistic colors. In Japan, this custom survived until modern times. In the Western world, statues were colored through the Gothic period, and, very often, dur-

ing the Renaissance as well. In ancient Rome, good children, who practiced ancestor worship, had to repaint the often unsurpassed portrait busts of their parents every other year, the way good landlords are supposed to repaint apartments at regular intervals.

Self-expression in art is a new idea

Neither line, nor color inherently expresses personal emotions or feelings. The idea that art, especially painting, is self-expression, is very recent and quite misleading. It's true that painting is self-expression, but so is everything else we do. The way we sit, stand, walk, or recline; the way we eat, talk, act, and behave, is all self-expressive. Words, oral or written, are the most complete form of self-expression. It's surely easier for an articulate person to express his ideas, opinions, thoughts, and beliefs in words than in painting.

Jackson Pollock is credited with the introduction of automatic art, also called abstract expressionism, or the New York School. This is a kind of painting in which paint is dripped, hurled, or squirted on the support, without any advance idea, without any composition or subject matter. Hans Hofmann is generally credited with, or accused of (depending upon which side you're on), having introduced the now often-heard motto, addressed to art students: "Don't worry about drawing, perspective, composition, and other old-fashioned nonsense. Just express yourself. Paint the way you feel!"

The concept that art and self-expression are synonymous has spread far and wide. Many lay people now believe that prehistoric man painted animals in his caves just to express himself, and "to express his decorative sense, his innate desire for beauty." Psychologists and anthropologists, however, studying primitive tribes, have concluded that art has evolved for discernible reasons, such as magic, pacifying or warding off spirits, and had nothing to do with self-expression as we understand the term today.

Art and psychoanalysis

Certain psychoanalysts assert they can tell your character and your complexes from the colors you employ and the manner in which you apply them. If you use much green and purple, working with a big palette knife, leaving hard edges and ridges all over the painting, you supposedly reveal that you hate your mother. If you work with blues, grays, and yellows, blending them softly into each other, this supposedly divulges your innermost secret, that you wish you were shorter than you actually are. A psychoanalyst would charge you fifty dollars a session for discovering what deeply-buried, ancestral problems cause you to paint spots, and curlicues, or tall, thin figures, or long bananas, and big golden delicious apples. Naturally, I am speaking of the vaudeville-type psychoanalysts, not the real, professional ones.

The fact is that inspiration *may* be spontaneous; that is, you may suddenly get

an idea for painting or any other kind of art. But the execution itself is never haphazard. It must be deliberate. A genuine artist does everything for an esthetic purpose. His subject, colors, technique are all deliberate. If he prefers one way of painting to another, that's because it intrigues or inspires him, not because he has a complex. He has his own personality, to be sure, and he's likely to select his favorite subject matter and technique accordingly. Nobody can be more temperamental than Michelangelo was. He resented the Pope's order to paint the ceiling of the Sistine Chapel, and accused his enemies of having caused the Pope to force him to do a job he wasn't equipped to do. Yet, enraged though he was, he created a masterpiece.

An artist probably won't start a gay subject when he happens to be in a depressed mood. He may very well give vent to his feelings in his work, but it must still always remain under his firm, artistic control. Even artists working in the abstract expressionist idiom know what they're doing. Their colors, the way they squirt or throw them on the support, cannot possibly be totally automatic. Such artists have the training to heap paint upon paint with a certain skill, artistry not found in a beginner or an amateur. It's quite true that a child can throw paint on top of paint, but the result is not likely to be artistic, either in color combination, or in technique.

We all have complexes and, often for reasons unknown to ourselves, we dislike certain hues and favor others. I used to know a surgeon, a highly cultured man, who had to look away whenever he saw a rainy picture. "I hate rain and the color of rain!" he exclaimed, and began to sniffle. He was literally allergic to such paintings. I can well image that there are artists who, for some reason or other, don't like rainy pictures or sunny pictures or some other subjects, and don't paint them out of their own free will. Everyone has a right to preferences and dislikes.

Identify yourself with your art

A good artist, like a good writer, identifies himself with the mood of his subject, without losing himself in it. Years ago, I watched a terrific downpour from my studio on New York's Washington Square. The rain really came down in buckets. Although it was afternoon, the day turned almost dark as night. The rainwater was cascading down the panes of my casement windows. I was thinking of artists of a past generation, living in leaky garrets. My studio wasn't leaky. I felt safe, but I also felt like a prisoner. The steel frames of my windows truly resembled the bars of a jail cell.

The next morning, I painted the scene and it turned out to be a most interesting, though surely not a pleasant picture. Strangely enough, seven years later, someone fell in love with it and purchased it. The buyer took it to Central Europe, and showed it to a relative of mine I hadn't seen in a great many years. This relative was being psychoanalyzed at the time. After one look at my painting, she wrote ma a letter, desperately urging me to dash to the nearest psychoanalyst; I needed immediate help, she wrote. "This painting reveals the most dreadful mood of depression. You feel like a man in jail. A good psychoanalyst might still help you get out of this terrible feeling of hopelessness and frustration if you act promptly!"

Well, I didn't need any psychological care. As a matter of fact, I was proud that several years after I painted the picture, and many miles away, someone could look at it and find in it the exact mood I recreated in it. I had expressed my mood. That isn't despair or sickness of the mind. It's art. I identified myself with my subject, even though I didn't like my subject, If I had been painting nothing but downpours for the past twenty years, that would be a different proposition.

People respond to colors differently

Nobody can deny that people respond to colors or color combinations, but different kinds of people respond differently to the same color effects. An all-day rain is depressing to city-dwellers, for many reasons. They cannot go out, they cannot get a taxi; they don't like to go to a party, smelling of rain. It's also depressing, by an association of ideas, to be surrounded by shades of gray, unrelieved by a single bright spot. A radiantly sunny day and fresh, green vegetation make you feel happy and peppy in the city. For a farmer, on the other hand, rain may mean literal salvation and gray may be a relief from the glaring colors he sees much of the time. A flower garden in full bloom is much more pleasant than a cemetery with gray tombstones, neglected graves. But lovely old trees, flowers, bouquets, in a well kept cemetery, a blue sky peeping through the foliage, can change the aspect of the graveyard and lend it a feeling of peace, calm, and security.

In other words, colors, like everything else, are more complicated than one might surmise, especially because individual differences in our reactions to colors are quite frequent.

Similarities between opposites

There are odd similarities between our mental and physical responses to diverse causes. If you feel angry, you want to hit, tear, or crumple something; but you may become just as vehement and destructive when you're overjoyed. It's easy to assume that an angry artist will slash paint on his canvas in huge heaps, using only the strongest hues and dynamic strokes, while an artist in a mellow mood applies paint gently, using pastel shades. But why shouldn't an artist in a wonderful frame of mind slash bold colors on his canvas?

How can you tell from strokes and colors whether the artist was in a joyous or a nasty mood at the time he did that particular work? This is like assuming that a good-natured author could never write a story about war or the Wild West; and that a temperamental writer could never produce a sentimental novel. One cannot overestimate the power of creativity in an artist. A true artist establishes his own mood, regardless of circumstances.

Testing responses of non-professional painters

For some years, I've taught painting courses for education majors at The City College of New York. (The public school system of New York requires that ele-

mentary school teachers know a little about every subject.) I've always felt sorry for these eighteen to twenty-year-old girls, because most of them lacked artistic talent. They constantly worried about failing this course. I succeeded in proving to them that any intelligent person can learn some basic features of painting. All the girls managed to produce pictures representing bowls of fruits, vases of flowers, a picnic in the country, done in the most naive perspective, but fully recognizable, often genuinely charming.

The greatest success, however, was the project of "expressing themselves." I told them to paint hatred and love, for instance: the way they feel under the stress of such emotions. I gave them complete freedom. Working on poor quality paper, with children's poster colors and brushes, the students went all-out on this project. The results weren't exactly artistic, but they were interesting, sometimes puzzling or amusing, often quite revealing, and not at all uniform in concept.

Expressing hatred and love in color

Hatred was most often signified by black and/or green, with a streak of yellow lightning, or a yellow arrow. One student painted red spots all over the paper, with a snakelike black stripe in the center. Another girl used red spots and a black heart. To both of them, red spots meant drops of blood. Several students painted yellow and red flames for hatred, but black was almost always included in one form or another.

Love was also often symbolized by flames, but blue replaced black or green. Drops of blood meant love to some, hatred to others. A red heart, pink, and light blue swirls, and yellow discs appeared as expressions of love. Many students painted a sort of explosion — black and green for hate, red and blue for love. They never included green and black in expressing love.

Expressing sadness and happiness in color

Another project in this class was to express a depressed mood and a happy one. Sadness was mostly depicted in black and gray, in big splotches of wavy shapes. But many girls considered blue the true sign of sadness. They explained that blue was inevitable, because one cannot be in love without feeling blue once in a while. I found their logic interesting.

A gay mood was expressed in a diversity of manners. Manifestly, there are more ways of feeling gay or happy than of feeling sad. Yellow zigzag lines with green and orange dots, "dancing" lines in red, light blue, green, crosses or check-marks in bright hues, painted in a big bunch in the center of the paper, were some of the expressions of being happy. One girl painted big red strokes across the paper. "When I'm in a happy mood, I feel like painting the town red," was her explanation.

It was all great fun but, curiously, every student was also anxious to explain her self-expression in detail. None of them believed that her work spoke for itself, without a verbal explanation.

Is self-expression in painting honest?

The question is still in my mind: did my education majors really, honestly express themselves in color? Or did they express standard sentiments, commonplace beliefs, clichés, rather than emotions? Did they express themselves in a personal fashion? Didn't they merely do the expected, rather than the expressive? In many cases, it would have been impossible for me to tell the difference between love and hatred, not because the two extremes may in reality be as close to each other as madness and genius, but because of the *inability* of the students to express themselves in color, whereas each of them was quite able to express her feelings *orally*.

Many artists refuse to communicate

My tests with non-professional painters don't prove that self-expression in painting is impossible. But if there are so many different ways of expressing the same basic human feelings — such as love and hate, joy and sorrow — can there be a complete and absolute understanding of any kind of self-expression, even if produced by a talented, skilled, professional artist?

Furthermore, many present-day artists disclaim any desire on their part to communicate with outsiders. It's against their beliefs even to give some statement about their works to those who'd honestly like to comprehend such art. These artists leave communication to painters whose themes are connected with social consciousness. This, of course, is the kind of strikingly realistic, illustrative art which is often, though not necessarily, some kind of propaganda. In such paintings, the artist can very well express the ideology of his society, regardless of whether he agrees with it or not. But many realistic artists still paint *genre* pictures, often called conversation pieces. These are ordinary story-telling pictures, without any political motivation.

What are we to do with our non-communicative artists? Can we, should we try to understand their works? Or shall we just look at such paintings and shake our heads? Are they expressing themselves the way people who talk to themselves do? Have they a language of their own?

Is art a universal language?

Some people believe art is a universal language. I don't think so. Art is a language, a most eloquent one, but you still have to learn it, just as you learn your mother tongue and any other language.

Subject matter can be mystifying, regardless of its realistic nature. Biblical scenes are meaningless to persons not familiar with the Bible. Scenes of cruel martyrdom can be repulsive to Buddhists, for example, who abhor cruelty. Scenes from the Ajanta caves of India are meaningless, overcrowded, and even ugly to the uninitiated Westerner.

Colors, themselves, have various meanings, as I stated before. Black is a sign

of dignity as well as of death. White represents virginity in the West, mourning in the East. It also means surrender, capitulation. Yellow, the color of cowardice, jealousy, or disease in the Western world, signifies happy springtime in India.

No, art is not a universal language. Rather, it's a group of languages. You have to learn all of them if you wish to understand art and artists, and if you want to express yourself in painting in colors.

Artistic self-expression in the past

Self-expression is a term introduced quite recently. The term has been spread and popularized all over the world to such an extent that a great many people have become keenly interested in expressing themselves. Many attempt to do so in some form of art. This conscious trying is what causes difficulties. Self-expression must be natural, unconscious, or subconscious, the way it existed for centuries, without having had a name applied to it.

Artists of the past did not try to express themselves. They expressed themselves without any deliberate effort, in their works. Their subjects, colors, techniques all revealed their innermost personalities. You hear about the "mysterious smile" of the *Mona Lisa*. That smile isn't hers; it's Leonardo's own smile. He painted every male and female face, except the thirteen men in *The Last Supper*, with exactly the same smile. The *Mona Lisa* isn't a portrait at all. It's a standardized face, the kind Leonardo da Vinci liked, without any individuality. The master expressed *himself*, not the woman.

Didn't Rubens express himself, without any effort, in his plump, prancing, baby-faced, but mature women; in his strong, fat men, and bronzed warriors? Didn't Rembrandt express himself in the tender, completely human forms in which he depicted biblical, mythological scenes forbidden by law in his Protestant Holland? Didn't Frans Hals, Rembrandt's fellow countryman, express himself in the superficial, boisterous portraits and group portraits, in which he treated human beings with as much emotion as he had for silverware, fruits, and a mug of beer?

Didn't Domenicos Theotokopoulos, called El Greco (The Greek), express himself, his early youth in his native Crete, in the elongated, vividly colored images of saints, martyrs, Jesus, the Virgin, the Count of Orgaz, and his equally elongated portraits of Cardinals? Didn't he express himself when he painted himself among other people participating in the scene?

None of these artists had ever heard of self-expression. None of them ever made an effort to be "different" or sensational. Each of them just *happened* to be different, and this fact is expressed in the works of all important artists. They had fewer colors, smaller brushes, but just as many personal problems and complexes as we have.

Despite the smaller number of available colors, the works of these masters can be quickly recognized by an experienced person. Each artist had different color combinations, different esthetic concepts, different likes and dislikes. We analyze not the artists, but their works. We study their methods, their ideas, the novelty, originality of this or that feature of each. We don't know all about those artists;

often enough, we know very little of their personal lives. There are controversies about all of them, too, as about everything else. Unanimity is seldom, if ever possible. Nor is it necessary. Why not contemplate other possibilities?

What we can safely state is this: it's not enough for you to decide to express yourself in color, or in any other medium. You must also know *how* to express yourself, and this is the equivalent of saying that you must know how to paint before you can express yourself.

Don't rely on color alone. There's so much else in art. Learn all you can. Not only how to mix colors, and how to apply paint with brush, palette knife, flitgun, or cake-decorator. You have to know the esthetic concepts, the techniques, and not merely the latest ones, but the older ones as well. What we know is based on what we have learnt. What you will know must also be based on what man has learnt over a period of long years. You are but a link in an endless chain. Be a strong link.

Glossary

Acrylic A man-made, synthetic material used in fixatives and polymer (plastic) colors.

Aerial perspective Formerly applied to the effect of distance, weather, and light on the appearance of scenery and objects. *Color perspective* is the correct, now generally employed, term. *Aerial perspective* refers to the distortions of lines and colors in scenery or objects viewed from a high-flying airplane.

Aquamedia, or **Aqueous media** See *Watermedia*.

Aquarelle Any watercolor in which pigments are mixed with gum arabic; applied to transparent watercolors. Also, a painting done in such colors.

Atmosphere Literally, the mass of air surrounding the earth. In art, the visible effect of air, weather, and light on scenery and objects. Figuratively, the general mood of a work of art.

Baroque The name of the asymmetrical, often vehement, art and period of the seventeenth and eighteenth centuries in Europe. The word is derived from *barrueco*, Spanish for an odd-shaped pearl.

Black-and-white Pictures or drawings executed in black pencil, charcoal, crayon, or pen-and-ink. Also, a general term referring to fine prints: woodcut, engraving, etching, lithograph, etc., done in gray tones. We also speak of black-and-white photographs.

Brilliance The degree of brightness found in colors, ranging from the zero brilliance of black to the maximum brilliance of white.

Casein A white protein found in curdled milk; employed in waterproof glues and paints. Pigments mixed with casein are called casein colors. They become waterproof, even though applied with water.

Chemical colors An important group of artists' colors, prepared chemically. Such colors are often more uniform in quality and more permanent than colors derived from natural pigments.

Classicist or **Classic Revival** The period of art from the second half of the eighteenth century through the first half of the nineteenth, based on the ideology of the French Revolution, reviving the idealized proportions and images of ancient Greece, often in a theatrical manner.

Color perspective The correct term for what used to be called *Aerial perspective*.

Complementary colors A pair of contrasting colors which, when mixed in the right proportions, give a neutral gray. In physics, such colors are combined into white when passed through a crystal prism. In everyday life, we see complementary colors when we look into a strong light, such as the sun or an electric sign, then suddenly turn toward a darker surface, on which we see the same shapes, but in totally different hues.

Composition The design which holds a work of art together as an inseparable unit.

Cool colors Whitish blues and greens are called cool, because they remind us of ice.

Earth colors A large and important group of colors—the earliest known to man—prepared from "earth," that is, from various iron ores and oxides. Earth colors are permanent; they are low-priced, because such pigments are found in most parts of the world.

Enamel A vitreous (glasslike) substance made in any color. Used for coating bricks—in ancient times—and later used on pottery; now, popular on glass, metal, and jewelry.

Encaustic A very ancient medium for painting; pigments are mixed with molten wax, applied while hot.

En grisaille (ahn gri-zay') A painting executed entirely in tones of gray; popular in the Classicist period as an underpainting.

Extender A white paste, made of marble dust, used for heavy applications of paint in any medium. Also called modeling paste.

Façade The front view of a building, usually where the main entrance is situated.

Flamboyant Flamelike decorations, referring to the Late Gothic style, with its restless, wavy ornaments. Also, anything of a flashy nature, in any form of art.

Fresco Painting in watercolor on freshly spread, still moist, plaster. The pigments become chemically fused with the plaster.

Genre Painting or sculpture depicting an everyday story that has nothing to do with religion, mythology, or history. Highly favored by the ancient Romans, it was reintroduced by artists of the seventeenth century, in Protestant countries, especially Holland.

Gesso Plaster (whiting) mixed with a binder, such as linseed oil or polymer, used as a ground for painting or for creating reliefs.

Glaze A glasslike coating applied to pottery; also, any transparent coat, or layer of paint, in the fine arts.

Gothic The period of the late Middle Ages, featuring pointed arches, finials, and flying buttresses. The term was first employed by Italian Renaissance artists, in a derogatory sense.

Gouache (gwash) Opaque watercolor; or a painting done in this medium.

Graphic arts All prints made by artists in restricted, numbered, individually signed editions. Also used in reference to the craft of printing and publishing.

Heraldic Referring to symbols, designs, and colors of coats-of-arms.

Hue The name of a color. Synonymous with *color*. Red, blue, green, brown, pink, etc., are hues or colors.

Illumination Decorations in gold, silver, and bright colors in manuscripts. Illuminations may, but need not be combined with miniatures.

Impasto A thick application of paint in a work of art. Formerly possible only in oils; now, with extender (modeling paste) or an underpainting white, any me-

dium can be used in impasto.

Intensity The strength of a color, usually as compared with gray.

Linear perspective The visual appearance of lines and shapes as distorted or changed by distance and viewpoint. Receding lines, diminishing sizes, parallel lines converging, circles turning into ellipses are features of linear perspective.

Magic realism See *Trompe-l'oeil*.

Medium 1. The substance with which the pigments are mixed — water, oil, casein, wax, etc. 2. The ingredients added to various colors in order to make them more or less fluid, to cause them to dry faster or slower, etc. 3. The material through which an artist expresses his ideas and concepts, such as bronze, marble, enamel, aquarelle, and so forth.

Memory picture Portraying objects and figures as we commonly remember them, from the most characteristic viewpoint. All ancient art — especially in Egypt, Assyria, and Babylonia — contained memory pictures.

Mineral colors The most expensive group of artists' colors, prepared from minerals, metallic elements, such as cadmium and cobalt. Bright and permanent.

Modeling paste Same as extender.

Monochrome Anything done in one color, or shades of one-and-the-same color. Opposite of polychrome.

Mosaic A pictorial or decorative panel made of small pieces of stone, marble, or glass of different colors, placed in slow-drying cement.

Mural Any large wall decoration, whether painted directly on the wall, or executed on canvas or panels, and attached to the wall.

Oil colors or **Oils** Pigments mixed with linseed or poppyseed oil.

Opacity The quality of not allowing light to pass through an object or material. The opposite of transparency.

Optical illusion A misleading or deceptive image; forms, and/or colors so combined that they create an effect which differs from the true forms and colors.

Organic colors Pigments derived from animal or vegetable substances; usually not permanent. Not recommended for artists.

Palette A tablet or any flat surface on which the artist sets up and mixes his colors. Figuratively, the typical set of colors used by an artist.

Pastel Pigments compressed into sticks; also, the work done with them. Pastel pictures are considered paintings, and are grouped with watercolors, as a rule.

Perspective The visual appearance of things; also the means by which an artist can create a three dimensional effect on a two dimensional surface.

Pigment The coloring matter, which, mostly in powder form, is used in paints.

Plastic 1. Anything that can be formed and modeled, such as clay or plaster. 2. In European countries, the word implies a three dimensional appearance. 3. At present, it designates articles, materials of man-made, synthetic resins, such as plastic paints, plastic-coated textiles, etc.

Polymer Any combination of two different plastics. The general term for plastic colors. Also, a painting done in such colors.

Primary colors The three colors which cannot be mixed from any other colors known to man: red, yellow, and blue.

Phosphorescent The property of emitting a small amount of light, without heat, as shown in phosphorus and radium.

Polychrome Anything painted in several colors. The opposite of monochrome.

Prehistoric Pertaining to, or existing in, a period before written history. Depending upon the part of the world, this may be 3,000, 5,000, or many thousands of years ago.

Renaissance Literally rebirth, the period of the fifteenth and sixteenth centuries in Europe, often called "The Golden Age" of Western civilization.

Rococo From the French word, *rocaille, small snail-shells*, a period of fantastic over-ornamentation at the end of the baroque, during the second half of the eighteenth century.

Saturation The degree of intensity of a color; its freedom from any mixture; its full strength.

Scape Added to such words as land, sea, city, town, etc., it designates a view, a scenery.

Secondary colors The three colors mixed from the three primaries: orange (red and yellow), green (yellow and blue), and violet (blue and red).

Sfumato The soft, gradual blending of colors into each other, believed to have been introduced by Leonardo da Vinci in his *Mona Lisa*.

Shading The representation of shadows in a drawing — with lines or tones — and in a painting — with darker colors.

Symbolism The practice or art of expressing or indicating ideas with pictures or colors in a conventional, generally recognizable manner.

Tempera Pigments prepared with the white of egg, or the whole egg as a binder. Applied with water, tempera is a watermedium; applied with varnish and turpentine, it is oil tempera. Also, a painting done in tempera.

Tertiary colors The three colors obtained by mixing two secondary colors: orange with green, green with violet, and violet with orange.

Transparency The quality or state of allowing light to pass. Opposite of opacity. In painting, certain colors are transparent by nature. All colors can be made transparent by adding a transparentizing medium.

Trompe-l'oeil (tromp löy) French for eye-cheater; popularly called magic realism, an absolutely realistic, three dimensional effect in painting, achieved by painstaking craftsmanship.

Underpainting A simplified painting done on the support, then glazed in order to obtain the final effect. Old Masters used tempera underpaintings; present-day artists often prepare an underpainting in tempera, casein, or in underpainting white. Glazing is done in oils or in polymer colors.

Value The relationship of any color to white — the lightest — and to black — the darkest — colors we know.

Warm colors Reddish, yellowish colors are called warm as they remind us of fire and flame.

Wash A transparent coat or layer of color, used with water.

Wash drawing A pen-and-ink or pencil drawing made to look more interesting, or more finished, by applying thin washes of ink or watercolor, over the lines.

Watercolor Usually the same as aquarelle — pigments mixed with gum arabic — but we distinguish between transparent watercolor and opaque watercolor.

Watermedia Same as aquamedia, the general term for all paints applied with water — aquarelle, gouache, tempera, casein, fresco, polymer.

Index

Edited by Susan E. Meyer
Designed by James Craig
Composed in eleven point Palatino
Printed and bound by The Haddon Craftsmen, Inc.